NORMAN ROCKWELL BEHIND THE CAMERA

NORMAN ROCKWELL
BEHIND THE CAMERA

RON SCHICK

FOREWORD BY JOHN ROCKWELL
INTRODUCTION BY STEPHANIE HABOUSH PLUNKETT

LITTLE, BROWN AND COMPANY
NEW YORK · BOSTON · LONDON

FOR MY FAMILY

Little, Brown and Company
Hachette Book Group
237 Park Avenue, New York, NY 10017
Visit our Web site at www.HachetteBookGroup.com

First Edition: October 2009

Little, Brown and Company is a division of Hachette Book Group, Inc. The Little, Brown name and logo are trademarks of Hachette Book Group, Inc.

Library of Congress Cataloging-in-Publication Data
Schick, Ron.
 Norman Rockwell: behind the camera / Ron Schick. — 1st ed.
 p. cm.
 Includes bibliographical references and index.
 ISBN 978-0-316-00693-4
1. Rockwell, Norman, 1894–1978 — Criticism and interpretation. 2. Painting from photographs. I. Title.
 ND237.R68S35 2009
 759.13 — dc22 2008035539

10 9 8 7 6 5 4 3 2

Design by McCall Associates
Printed in Singapore

FRONTISPIECE **Mathew Brady Photographing Lincoln**, 1975. Unpublished
CONTENTS PAGE **The Common Cold**, 1945 (see p. 48)

Contents

ABOVE THE BARTENDER'S BIRTHDAY, 1941
American Magazine story illustration, February 1941

Foreword

John Rockwell

Norman Rockwell was my grandfather. I met him only a few times—he died in 1978 when I was twelve. Growing up in Italy where my father, the sculptor Peter Rockwell, still continues to work, I had little sense of how popular my grandfather was. I came to live in the U.S. when I was twenty and, on seeing my last name, people would often ask me if I was related to him and tell me how much they loved his work. The fondness with which people spoke of him made it seem like they knew him, as if Norman's works were in their family album alongside pictures of birthdays, graduations, and vacations. I began to have double vision when thinking of my grandfather: on the one hand he was my father's father, an important person in the world of my family; on the other he was a famous, larger-than-life figure.

Today I work with my uncle, Tom Rockwell, handling the intellectual property rights of Norman Rockwell through the Norman Rockwell Family Agency. I have come to know my grandfather's work and biography in greater depth, and my double vision has come into sharper focus. I now see the course of my grandfather's career in detail and appreciate how his images have become symbolic of aspects of American culture. We talk about "Rockwell moments"—moments that are accessible, universal, and positive.

These images are stories: the characters and scenery functioning toward a narrative that is both real and imaginary. They are creations that have gone through a complex process from idea to finished product—a process that relied heavily on the use of photography, as this fascinating book makes clear.

I have become more aware of Norman's photography through my association with the Norman Rockwell Museum, in Stockbridge, Massachusetts, and with Ron Schick, who contacted me in 2006 with the proposal for the book you hold in your hands. This is the first book to explore the archive's photographs and the part they played in my grandfather's creations. I find it exciting that the photographs give us a look behind the canvas and reveal how the images were constructed. I hope you do, too. In them we get to see Norman, the storyteller, directing his characters in the scenes he envisioned. Rockwell moments, in a new light.

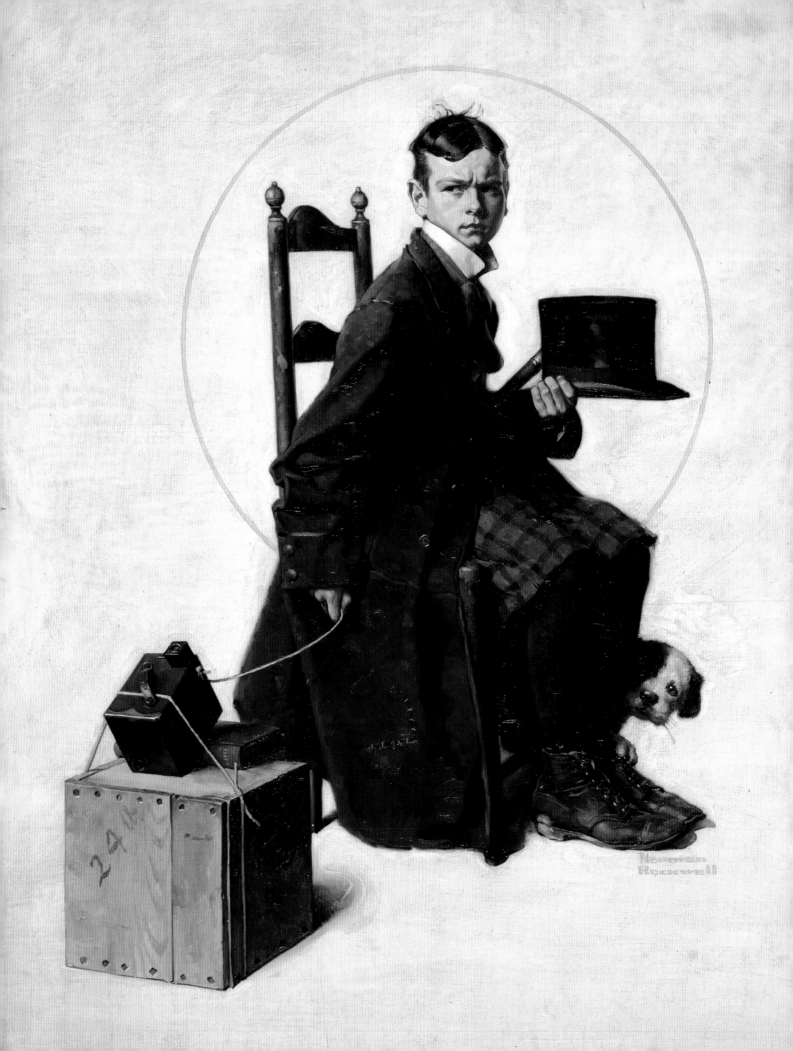

Introduction: The Illustrator and the Camera

I challenge anybody to show me when I started to use photographs.
I've always been known as The Kid with the Camera Eye.

— NORMAN ROCKWELL

Stephanie Haboush Plunkett
Deputy Director, Chief Curator,
Norman Rockwell Museum

Like most creators of art for commerce, Norman Rockwell worked within the realm of both aesthetics and technology. An astute visual storyteller and a masterful painter with a distinct, personal message to convey, Rockwell constructed fictional realities that offered a compelling picture of the life that many twentieth-century Americans aspired to. Anxiously awaited and immediately understood, his seamless narratives seemed to ensure audience engagement with the publications that commissioned his work and, ultimately, with product endorsements that supported the bottom line. The complexities of artistic production remained hidden to his enthusiasts, who were compelled by his vision and content to enjoy his art in the primary form for which it was intended — on the covers and pages of their favorite magazines. What came between the first spark of an idea and a published Rockwell image was anyone's guess, and far more than readers would have ever imagined.

"I love to tell stories in pictures," Rockwell said. "For me, the story is the first thing and the last thing." Conceptualization was central for the artist, who called the history of European art into play and employed the methods of classical painters to compose contemporary tales inspired by everyday people and places. His richly detailed, large-scale canvases offered far more than was necessary even by the standards of his profession, and each began with a single idea. By his own admission "hard to come by," strong concepts were the essential underpinnings of Rockwell's art. From the antics of children, a favored theme of his youth, to the nuanced reflections on human nature that he preferred as a mature artist, each scenario was first set down in a simple thumbnail sketch. What followed was a carefully orchestrated process of image development that demanded the careful integration of aesthetic concern, graphic clarity, and the effective use of technology.

OPPOSITE **Boy Photographing Self-Portrait, 1925**
Saturday Evening Post cover, April 18, 1925.
Private collection

The art of illustration has been, from the start, inherently aligned with visual technology. In America, illustration emerged as a viable profession during the Civil War, spurred on by the public desire to witness the events of the day as they unfolded. The advent of large-scale, high-speed printing presses in the mid-nineteenth century satisfied the desire for affordable, mass-produced images, and artists were hired to meet the demand. Before the 1880s, noted periodical illustrators like Winslow Homer, Edwin Austin Abbey, and Howard Pyle reluctantly accepted that their drawings and paintings would be transformed — for better or worse — by skilled artisan engravers. Wood engraving made wide circulation reproduction possible, but by the 1890s, this waning technology, which translated lines and tones into cuts and grooves filled with printer's ink, gave way to new methods of visual translation.

When photomechanical halftone techniques infiltrated the printing process, the camera replaced the wood engraver and handcrafted plates became artifacts of the past. Tonal artwork photographed through a cheesecloth screen was translated into a pattern of varied dots that were chemically etched into a printing plate, ensuring more accurate representation of images. The new process captured everything, revealing the brilliance and deficiencies of artist creators while inspiring a distinct public preference for realistic pictures. By the turn of the twentieth century, continued advances made the printing of color halftones possible, resulting in mass-produced images in which the artist's hand alone could be seen.

A gift for the artist, advances in technology spurred activity in publishing and established a spectacular showcase for the work of talented illustrators. The abundance of family, youth, and humor magazines and books for children and adults inspired many to enter the field, and during illustration's golden age, artists were in high demand. Pressed for time and eager to take on as many lucrative assignments as possible, many artists drifted away from the classical practice of drawing and painting solely from the live model. "You must draw, draw, draw, draw first, last and all the time, and until you can draw and draw well, you cannot illustrate," advocated Joseph Pennell, an exquisite draftsman who traveled the world on assignment for *Harper's, McClure's,* and *The Century.* The artist's 1896 volume, *The Illustration of Books; A Manual for the Use of Students,* was the first instructional guide for the fledgling field, which advocated, as in fine art, the study of the Old Masters. Illustrators had no such past to guide them, and approaches to the creation of imagery for mass circulation were still in the making. In the early twentieth century, the time- and cost-saving practice of posing and photographing models was becoming a popular, if concealed, ritual.

In book and magazine cover art, as in story illustrations meant to illuminate an author's text, narrative imagery reigned supreme even as painters began to reject it. While illustrators and fine artists explored similar motifs, such as the portrayal of everyday life, illustration emphasized accuracy, technical virtuosity, and anecdote rather than personal expression. The camera captured countless necessary details, from the subtleties of facial expression and body language to the folds of a model's dress. For many artists, its use all but eliminated repeat modeling sessions and high professional fees, an advantage in a deadline-driven field. "Now anybody could pose for me," Rockwell said. Photography's spatial ambiguity, oblique angles, extreme perspectives, and cropped edges offered new ways of seeing, and choice photographic reference could be retained and filed away for future consultation.

Cameras and projection devices have been in use by artists for centuries, sometimes surreptitiously by those wishing to obscure any technical intervention in their process. Artificial support seemed antithetical to creative work, and even for illustrators, whose images were reproduced on a mass scale, such an admission seemed to invalidate the abilities of the artist. Some, like virtuoso J. C. Leyendecker, insisted on abstaining

from the use of photography completely. This classically trained *Saturday Evening Post* cover artist and creator of the Arrow Collar Man made, in Rockwell's words, "endless little sketches from the model — two or three of the hands, a couple of the head, a torso, the eyes, the folds of the dress and the shoes — until he had drawn everything exactly as he wanted it." Twenty years Rockwell's senior, Leyendecker incited, "Are you going to be an artist or a photographer?" Despite his friend's admonition, the creation of photographic reference was an important aspect of Rockwell's process by the 1930s. "I still feel guilty about it," he wrote thirty years later. "But I comfort myself with the thought that many of the great painters used aids to drawing: the camera obscura, the camera lucida, mirrors, et cetera."

Many masters of American illustration took their lead from the likes of Hans Holbein, Albrecht Dürer, Jan Vermeer, Henri de Toulouse-Lautrec, and Edgar Degas, who employed the technology at hand to facilitate their work. Frederic Remington, an eastern artist who rose to fame as an acclaimed reportorial illustrator, brought the West to life for millions of readers who encountered his art in *Harper's, Collier's,* and other prominent publications of his day. George Eastman's original "point and shoot" box camera for roll film, introduced in 1888, popularized photography and made it accessible to the public. The new and improved No. 2 Kodak, which Remington purchased the following year, was a valuable tool for the artist-correspondent, who used it to gather information in the field. Fascinated by the medium and the visual effects that it produced, Remington took his own pictures and asked friends to send him theirs. His dynamic portrayals of galloping horses referenced Eadweard Muybridge's *Animal Locomotion,* a groundbreaking book of sequential photographs published in 1887. Soon after the turn of the century, when Remington moved away from illustration to paint and sculpt solely for exhibition, he claimed to have dispensed with photography, though he "…once found it a great help."

The camera also enabled legendary illustrator N. C. Wyeth to capture the authenticity of his surroundings on the American frontier. In 1904, the young artist traveled west to Colorado from Chadds Ford, Pennsylvania, in search of compelling subjects to paint. He remembered a brief, intense immersion in the lives of cow punchers on the Hashknife Ranch as the "wildest and most strenuous three weeks of my life." Four important works, including *Roping Horses in the Corral,* were painted shortly after in Denver, made possible by the photographs, sketches, and diary entries that were testament to his experience. In the studio, costumed models and an array of props stood in to provide additional support.

A private man with an interest in architecture and invention, Maxfield Parrish embraced the photographic process and devised image-transfer methods that became integral to his art. No good at "the little telling sketch," he preferred to work only from the photographed model and posed family and friends for the assignments at hand. Taken with a four-by-five-inch camera, pictures were developed in positive form on glass plates and projected, allowing Parrish to enlarge and trace all or part of an image for development. Hand-built by the artist in 1925, his elaborate projection device was a precursor of the Balopticon, advertised by Bausch & Lomb the following year. This "still projection lantern" later became an important compositional tool for Norman Rockwell.

In America's midcentury, magazines were richly visual and continued to rely on the abilities of gifted illustrators to engage the attention and emotions of their constituents. Their ingenious, often idealized images delineated a clear path to fulfillment and success. Leaping beyond the constraints of traditional narrative picture making, Al Parker emerged to establish a vibrant visual vocabulary for the new suburban life so desired in the aftermath of the Depression and World War II. More graphic and less detailed than the paintings of Norman Rockwell, who was a

contemporary and an inspiration to the artist, Parker's stylish compositions were sought after by editors and art directors for their contemporary look and feel.

Parker's emergence as an innovative pictorial designer can be attributed, at least in part, to his ongoing use of reference photography. Sessions with amateur and professional models were often arranged against a black ground, as his compositions tended to eliminate distracting backdrops in favor of clean lines, strong simple forms, and recognizable narratives. Like many illustrators and designers working at the time, he almost certainly employed a Lucigraph, a widely used but rarely discussed projection device that streamlined the compositional process by projecting photographs and sketches onto a drawing surface. Still, the artist's creativity, skill, and aesthetic judgment were essential to the realization of effective imagery. Parker's resulting cropped compositions and extreme close-ups inspired by film and by photography, which was a prime competitor for magazine pages at the time, made him the artist to emulate. Coby Whitmore, Jon Whitcomb, Tom Lovell, and their contemporaries employed similar techniques, experimenting with informal poses, bold layouts emphasizing color and form over narrative detail, and high-key palettes that became the visual language of the day.

When the first of Al Parker's famed mother-and-daughter covers for *Ladies' Home Journal* was published in February 1939, his graceful silhouettes skating in perfect unison and in matching outfits created a sensation. The series continued to engage readers for thirteen years, but his last submission, published in May 1952, signaled the end of an era in the magazine's history. After that, the covers of *Ladies' Home Journal* were solely photographic, completing the transition away from traditional narrative illustration that had begun in the latter part of the previous decade. Photography captured the moment for many publications that were striving to remain current, relegating the art of illustration to a more ancillary status.

In the 1950s, too, dramatic shifts in magazine content prompted the movement away from narrative illustration to more conceptual or decorative forms. Fiction, which had previously played a central role in magazines, was sidelined by a plethora of nonfiction articles that inspired a more abstract, symbolic approach to image making. Colorful, personal, and extremely varied in style, these artworks balanced the specificity of the photographic image in publishing and attempted to blur the lines between fine and applied art.

Despite a consensus that narrative illustration faltered because the advent of photography reduced the need for naturalistic pictures, this important American art form has always been about more than just the appearance of things. Through the decades, the art of mass culture has looked deeply into society, reflecting and shaping a rapidly changing world. Though periodicals have made way for new media, the impact of narrative imagery continues to be felt. In today's digital age, we are as happy as our predecessors to suspend disbelief in the face of visual technology, which now has the power to bring the impossible to life.

Created for the covers and pages of American periodicals rather than for the walls of galleries and museums, Norman Rockwell's living icons were an integral part of commercial culture, but they also aspired to a higher truth. Photography, which captured both the essence and endearing idiosyncrasies of humanity, made that possible. To a greater extent than most of us have known, the camera enabled Rockwell to create the images that have become his legacy. And yet, as he wrote of the thousands of photographs that held fast his thoughtfully assembled world, "The essential ingredient in every one of my finished paintings is me." ❧

NORMAN ROCKWELL
BEHIND THE CAMERA

There were details, accidents of light, which I'd missed when I'd been able to make only quick sketches of a setting....A photograph catches all that.

— NORMAN ROCKWELL

NORMAN ROCKWELL'S ART IS UNMISTAKABLE AND AS SINGULAR AS A FINGER-PRINT. A "ROCKWELL" IS AN IMAGE ONLY HE COULD HAVE INVENTED, BUT HIS CREATIONS DID NOT LEAP DIRECTLY FROM IMAGINATION TO CANVAS. AS A PAINTER AND ILLUSTRATOR, ROCKWELL RELIED, TO A SURPRISING EXTENT, ON PHOTOGRAPHY TO HELP HIM REALIZE HIS VISION.

Photographs were fundamental building blocks of Norman Rockwell's art for more than forty years. A brilliant director, he was able to coax his characteristic expressions from well-chosen models for photographs he used as templates for his paintings. A perfectionist, Rockwell required these photographs to portray his ideas exactly and to be fully realized in every detail. As a result, they are pure Rockwell, a newfound treasure of Norman Rockwell images in an unexpected medium, rendered with camera and film rather than oil and canvas. And because the paintings that derived from them are themselves so iconic, his photographs elicit a haunting sense of déjà vu, mirroring his masterworks in a tangible parallel universe.

Photography was an important tool for many illustrators working in the first half of the twentieth century. Camera studies were merely visual notes for most commercial artists, convenient and efficient aids for meeting deadlines. But the thousands of photographs Norman Rockwell created as studies for his masterworks stand alone. A natural storyteller, Rockwell envisioned his narratives down to the smallest detail. Yet at the easel he was an absolute literalist who rarely painted purely from his imagination. Unable to directly paint the pictures "in his head,"[1] Rockwell originally employed studio models for each new composition. "It has never been natural for me to deviate from the facts of anything before me," he said, "so I have always dressed the models and posed them precisely as I have wanted them in my picture; then I have painted the thing before me."[2]

OPPOSITE **Norman Rockwell behind Gene Pelham, photographing Back to Civvies, 1945 (see p. 80)**

In the mid-1930s Rockwell began to bring his ideas to life in photographs. Scouting locations and props, selecting and directing amateur models who brought true-to-life authenticity to his work, he carefully orchestrated each element of his design for the camera before beginning to paint. Staging his photographs like a film director, Rockwell instructed his cameramen when and what to shoot, and rarely tripped the shutter himself. Going to elaborate lengths to compile a wealth of photographs for every new subject, he would then transfer the images, in whole or in part, to his final work.

Norman Rockwell never intended his photographs to be judged on their own, but these extraordinary expressions of the artist's vision are, nonetheless, works of art in their own right. The exceptional gifts for character and narrative that define Rockwell's illustration likewise distinguish his photographs. "Before he lifts a pencil," said former Brooklyn Museum director Thomas Buechner, "he has created a Rockwell."[3]

Perhaps most important, Norman Rockwell's photographs offer new insight into the paintings he built upon them. Comparing a painting with its photographs reveals the features he has selected and, just as significant, those he has excluded. Pinpointing the particular decisions Rockwell made to revise or modify each element further illuminates his aesthetic approach; analyzing the ways in which he distilled the multitude of options photography offered him enables a deeper and richer understanding of his creative process and his enduring appeal.

EARLY SUCCESS

Norman Rockwell was born in 1894 on Manhattan's Upper West Side to a family of modest means; his father, an avid draftsman, worked in the textile business, and his mother was the daughter of a professional artist. Rockwell's artistic talents appeared early and, determined to develop them, he left high school during his second year to study at the National Academy of Design and then the Art Students League of New York. By 1912, at the age of eighteen, Rockwell was already a published artist specializing in children's illustration, and had become a regular contributor to magazines such as *Boys' Life*, the monthly publication of the Boy Scouts of America, where he was soon named art director. Successfully employed in his chosen field, Rockwell assisted his family's move to suburban New Rochelle, then home to a flourishing community of artists.

Rockwell sold his first two cover ideas to *The Saturday Evening Post* in 1916, beginning a forty-seven-year relationship that is the centerpiece of his career. Accepting his initial proposals on the spot was the *Post*'s renowned editor George Horace Lorimer, who, starting in 1899, had made the *Post* one of America's most successful magazines. Lorimer's *Post* was the model for the modern mass-circulation magazine, and by 1929 the weekly boasted a readership of almost three million — an enormous figure for its time.

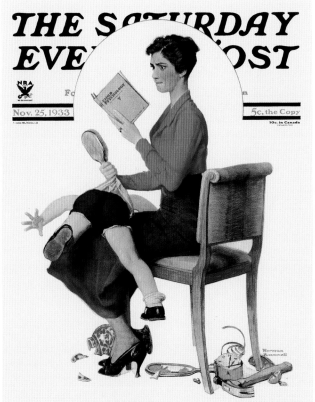

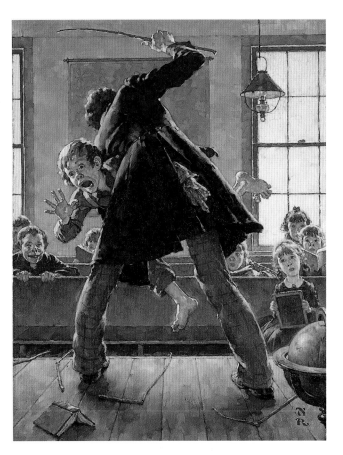

Politically conservative and managerially autocratic, Lorimer strove to shape the ideas and opinions of the American public during his thirty-eight years at the *Post*. His mission was to invent an American mythology that would touch — and influence — its loyal readers, and the *Post*'s artists played a key role. Many of Norman Rockwell's signature themes were formed or influenced by the *Post* in this period. For the artist, his career with the *Post* became a balancing act, tempering his eye for incisive observations of the rapidly evolving American scene with a demand for the traditional values and virtues of an earlier time.

During the Lorimer years, Rockwell became the *Post*'s leading artist, in some years producing more than ten cover illustrations, and his relationship was virtually exclusive. Always "Norman" to Lorimer (who was, in turn, "Mr. Lorimer" to Rockwell), Rockwell felt valued by *The Saturday Evening Post* and its editor. By the mid-1930s, working in his home studio in New Rochelle where he lived with his second wife, Mary Barstow (his first marriage had ended in divorce in 1929), and their three young sons, Jarvis, Thomas, and Peter, Norman Rockwell was securely established in the first rank of American illustrators.

"AN ARTIST OR A PHOTOGRAPHER?"

Rockwell used live models for all of his work and could not paint without them. Early in his career he began hiring professional models to pose for adult characters and enlisted neighborhood children for his popular juvenile subjects. Meticulously costumed and precisely positioned, they had to be in sight constantly as he worked, and for as long as it took to complete a painting. But he had become sensitive

MOTHER SPANKING CHILD, 1933
Saturday Evening Post cover, November 25, 1933.
Copyright © 1933 SEPS

Tom Sawyer. "The master's arm performed until it was tired and the stock of switches notably diminished." 1936
The Adventures of Tom Sawyer, book illustration, 1936.
Mark Twain Boyhood Home and Museum

to the artistic shortcomings of this method, whose inherent drawbacks put a more authentic natural-ism beyond reach. "As the hours passed, the expression would sag or freeze into a grisly parody of glee," he wrote in his autobiography. "There was a limit to the number of sketches I could make; nor could I keep changing the pose."[4] In addition, the fixed physical distance between artist and model in the con-fines of his studio limited creative perspective. And he had effectively run out of models; continually drawing on the same small pool of characters had begun to make his work seem repetitive. Rockwell had reached the outer perimeter of what he could achieve with professional models and it had begun to feel like a barrier.

The solution to his problems was only too well known to him. To illustrators, always on the lookout for better ways to meet deadlines, the camera had long been a natural ally. Many of Rockwell's fellow illustrators had adopted photography as a quick and economical way to create study images, but he had resisted the temptation. Though Rockwell had used a camera to make studies of young children and animals and had photographed models during an eight-month stay in Paris, he had not been willing to take the next step and cross what was, in his judgment, a clear moral boundary. "It had seemed a low form of cheating, a dishonorable crutch for lazy draftsmen, a betrayal of artistic principles," he explained long after the fact. " 'Are you going to be an artist or a photographer?' I'd asked myself."[5]

Eventually, at the prodding of Henry Quinan, art director of *American Magazine* and other peri-odicals, Rockwell overcame his qualms. His first extensive use of photography came with a 1935 commission to illustrate a new edition of Mark Twain's *Tom Sawyer*. Rockwell "turned to the cam-era as a logical aid"[6] to record authentic settings in Hannibal, Missouri, and to make possible poses that were too difficult for a model to hold long enough to paint. Photography transformed Rockwell's work; it instantly unlocked his aesthetic, enabling him to execute whatever he envisioned. The fluidity of the *Tom Sawyer* illustrations, contrasting with the more mannered, sculptural look of his preceding work, derives entirely from the use of photography. (The *Tom Sawyer* photographs, along with most of Rockwell's early camera work, were presumably lost in a fire on May 15, 1943, that claimed his studio, prop and costume collections, and many of the artist's paintings.)

Coming at a time when Rockwell, now in his early forties, felt in danger of his work becoming stale, the *Tom Sawyer* assignment was a turning point in Rockwell's career. The prestigious opportunity to illustrate a classic of American literature, and the creative freedoms Rockwell quickly discovered as he finally accepted photography, set him firmly on the road to become one of America's most famous and successful artists.

Rockwell went public about his camera use in a 1940 magazine article. Nevertheless he confessed to feelings of guilt about using photography as a tool and assuaged himself with the knowledge that the Old Masters had in their day turned to optical drawing aids. Were the Masters alive, he assured himself,

they too would use the camera. Yet two very disparate contemporaries, Edward Hopper (himself once an illustrator) and western artist Peter Hurd, both criticized him for the practice. For his part, Rockwell always insisted that photography could never compensate for the lack of essential drawing and painting skills, but its advantages were immediately apparent. Rockwell had been won over.

The camera freed him to depict his scenarios from above or below, up close or at a distance, and permitted adventurous new angles and perspectives unattainable when painting from a live model. Rockwell's landmark *Four Freedoms* series of 1943 effectively catalogs these opportunities, as the point of view of each successive composition progresses canvas to canvas: from the low vantage point of *Freedom of Speech,* to close-up in *Freedom of Worship,* midrange in *Freedom from Fear,* and wide angle in *Freedom from Want.* Just as important, Rockwell's newly won dynamism allowed him to stay competitive in a field that had seen an influx of innovative young magazine illustrators, such as Al Parker and John Falter, who introduced bold angles echoing the radical viewpoints of the modernist photographers of the 1920s and '30s.

Working from black-and-white photographs — he never used color film — allowed the literalist Rockwell to introduce his own palette into the final work, another freedom he found unexpectedly liberating. Rockwell had been incapable of improvisation with a model posed in front of him. His working method required that he dress his subjects as they were to appear, down to the smallest detail, and then paint exactly what he saw. "If a model has worn a red sweater, I have painted it red — I couldn't possibly have made it green. I have tried again and again to take such liberties, but with little success. But when working with photographs I seem able to recompose in many ways: as to form, tone, and color."[7] Using black-and-white photographs as a pattern for his designs not only freed him to paint each element in his own invented color schema, but eliminated the drudgery of hunting up precise clothing for each new idea.

"HUMAN-LOOKING HUMANS"

Photography revealed its fullest potential in 1939 when Rockwell and his family moved to a new home and studio in Arlington, Vermont, another long-established artistic community. Robert Frost and Rockwell Kent had lived there, encouraged by resident Dorothy Canfield Fisher, author and founding editor of the Book-of-the-Month Club. Rockwell was soon joined in Arlington by fellow illustrators John Atherton, Mead Schaeffer, and the younger artist George Hughes, who together formed a mutually supportive artistic and social circle.

Arlington's artists often tapped the town's local residents as models, and Rockwell, too, enlisted his new neighbors. The genuineness of this richly varied and nearly limitless cast of homegrown subjects — farmers and bankers, children and old-timers — was the answer to his model problems. Their

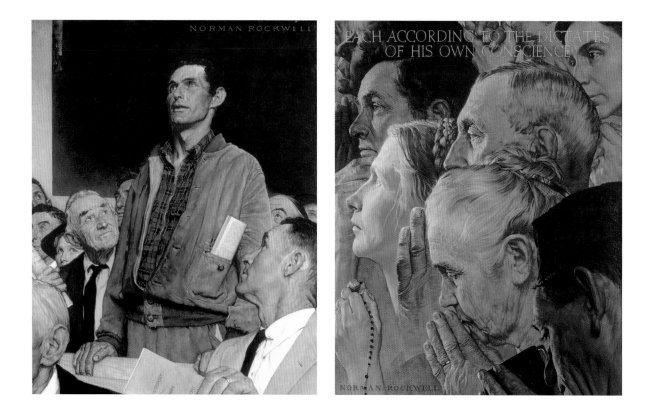

cooperative enthusiasm in front of the camera and unassuming tolerance for his demands enabled Rockwell to capture difficult poses and nuanced expressions more spontaneous than any professional could deliver. "I paint human-looking humans," he said, "and the professional models just don't qualify."[8] Rockwell continued to paint from amateur subjects when the family moved again in 1953 to Stockbridge, Massachusetts, where he lived until his death in 1978 at the age of eighty-four.

The camera allowed Rockwell to use ordinary Vermonters, who could not devote days of their time to pose as a professional could but perhaps might share an hour or two with the artist. "He couldn't really afford to take a lot of time with the Arlington models because they were all working people,"[9] explained Ardis Edgerton Clark, whose family lived next door to the Rockwells. Photography's speed and efficiency also meant that Rockwell was able to capture difficult, contorted, off-balance postures and action poses that could only be held long enough for the camera to record them. Film caught fleeting and spontaneous expressions, and not just one but an entire array of subtly different looks. And it meant that, if he wished, he no longer had to cast characters against type in roles they did not fit; he could "get the real thing."[10]

Photography opened a door to the keenly observed realism that defines Norman Rockwell's art. More than any other element, Rockwell's amateur models — friends, family, and neighbors — imbued his art with an unmistakable naturalism. Today it is a revelation to discover that so many of his most memorable characters were, in fact, real people.

FREEDOM OF SPEECH, 1943
Saturday Evening Post feature illustration, February 20, 1943.
Norman Rockwell Museum, Norman Rockwell Art Collection Trust

FREEDOM OF WORSHIP, 1943
Saturday Evening Post feature illustration, February 27, 1943.
Norman Rockwell Museum, Norman Rockwell Art Collection Trust

"THE KID WITH THE CAMERA EYE"

Photography enabled Rockwell to meet new challenges presented by changes in management and editorial policy at *The Saturday Evening Post*. George Horace Lorimer, in failing health and perhaps sensing the passing of an era, retired from the *Post* at the end of 1936 and died less than a year later. Wesley Winans Stout took his place as editor. While Rockwell's relationship with Lorimer was never especially warm, Rockwell had understood him. Less so Stout, who for six years inflamed Rockwell's insecurity with frequent revisions and criticisms.

In the Lorimer era the *Post*'s cover format had been simple and uncluttered, a strategy that focused attention on the central subject and stood out on the newsstand. But Wesley Stout began moving toward a freer style, gradually replacing the *Post*'s signature white background, circular frame, and silhouetted figures with a bolder use of background color and a more natural treatment of subject.

In 1942, the now faltering *Post* replaced Stout with a new editor, Ben Hibbs. Amiable and unfailingly supportive, Hibbs stunned Rockwell by accepting no fewer than *nine* new covers from him in their first meeting. "Hibbs was neither domineering nor ruthless," Rockwell wrote, "the archetype of the easygoing, good-natured Midwesterner."[11] Norman Rockwell produced his most celebrated work for Ben Hibbs and continued to work with him and art editor Kenneth Stuart until Hibbs left the magazine in 1962, soon followed by Rockwell's own departure the following year.

Since the 1930s the *Post* had vied on the newsstand with a new breed of magazine led by *LIFE* and *LOOK*, whose covers brandished attention-grabbing full-page photographs. Under Hibbs, *The Saturday*

Evening Post's cover format underwent radical redesign with a new, more contemporary logo, confined to the upper-left-hand corner. The layout opened new territory for illustrators to fill with visual information. And, for the first time, the *Post*'s artists were encouraged to explore their individual creative styles.

Images sprawled corner to corner across the cover. Setting, background, and detail became leading players, adding depth to each cover's narrative and advancing its plot. The *Post*'s artists gained a new dimension in which to tell their stories, and Rockwell's visual vocabulary flourished.

Photography was key to the development of Rockwell's style, enabling him to fill his *Post* covers with complex, spatially convincing settings and the profusion of realistic detail characteristic of his art. Writing in 1964, the photographic historian Van Deren Coke considered the medium of photography an interface between eye and canvas, functioning "not as a crutch but as a means of expanding the painter's vision, permitting him to see aspects of a situation previously overlooked, or beyond the range of the human eye."[12] Even though Rockwell boasted he'd "always been known as The Kid with the Camera Eye,"[13] he couldn't absorb all of the visual data he required using only memory and a sketch pad. But the camera could capture it all at once, recording an infinity of minute but revealing elements. With this wealth of subliminal background detail committed to film, Rockwell was able to edit and recombine each feature at will, much in the way that a photo illustrator or magazine art director might work with Photoshop today.

The camera brought the essential elements of Rockwell's art under his direct control. Perspective, palette, subject, and background were now in harmony, guided by the artist's imagination and refined by his painstaking perfectionism.

Norman Rockwell, posing for UNITED NATIONS, 1953

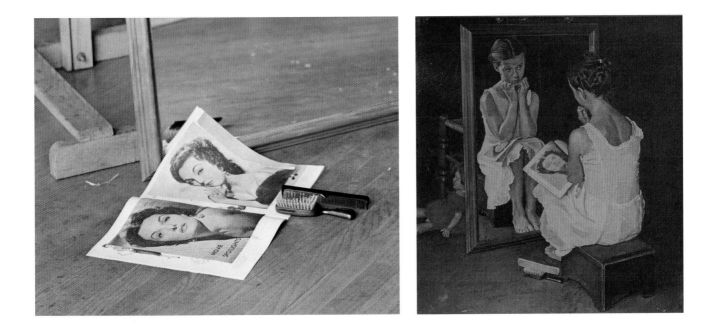

CREATING AUTHENTICITY

In 1946 artist and author Arthur Guptill published the first major study of Norman Rockwell's art, *Norman Rockwell, Illustrator,* subdividing the artist's creative process into no fewer than fifteen separate stages. But, broadly speaking, there are three: concept, photography, and painting.

Rockwell accepted assigned themes for advertising and other commissioned work, and plot lines dictated the subjects of his magazine story illustrations. But Rockwell's *Saturday Evening Post* covers were the artist's own inventions, and those ideas never came easily. "I know of no painless process for giving birth to a picture idea," he wrote. "When I must produce one I retire to a quiet room with a supply of cheap paper and sharp pencils. My brain is going to take a beating — and knows it."[14] Early in his career he followed a routine to help ignite the flashes of inspiration his audience surely assumed came easily to the gifted storyteller. "He would start out by drawing a sailor leaning against a lamppost and see what that suggested to him," remembers his son Peter, "and keep doing quick sketches until he got something that seemed a worthwhile idea."[15] Rough sketches piled up as Rockwell free-associated his way from one idea to the next — a process that could stretch over multiple sessions — until he had his "bell ringer." Sketch in hand, he would then sell the concept by acting it out for his editors.

After his sketches, Norman Rockwell's photographs were the first visualizations of his ideas. From the mid-1930s on, much of Rockwell's creative activity focused on producing photographs for his illustrations. He would begin by collecting exactly the right props and costumes. Each had to be authentic and advance the plot line. "In my opinion," he said, "nothing should ever be shown in a picture which does not contribute directly to telling the story the picture is intended to tell."[16] What Rockwell didn't have on hand he bought, borrowed, or rented — from a simple dime-store hairbrush or coffee cup to a roomful of chairs and tables from a New York City Automat. Elaborate historical dress had played a large role in Rockwell's early work, but the loss of his extensive costume collection in the 1943 studio fire

GIRL AT MIRROR (detail), 1954
Saturday Evening Post cover, March 6, 1954

GIRL AT MIRROR (study), 1954
Norman Rockwell Museum, Norman Rockwell Art Collection Trust

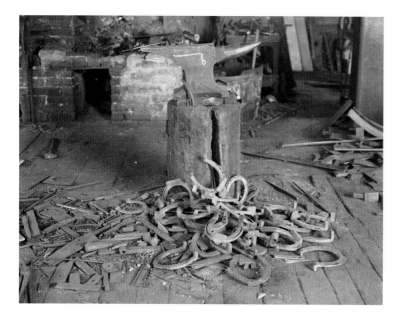

and his growing preference for contemporary themes simplified costuming beginning in the mid-1940s.

Norman Rockwell's settings had to tell their own story and be unimpeachably genuine. He located and took detailed photographs of a Vermont blacksmith shop for *Blacksmith's Boy — Heel and Toe* (left), an Arlington garage for *Homecoming Marine* (p. 78), and several different soda fountains for *Soda Jerk* (p. 116), *After the Prom* (p. 184), and *The Runaway* (p. 188). And twice — for *Little Girl Observing Lovers on a Train* and *Boy in a Dining Car* — he arranged for railroad cars to be sidetracked for his personal use (pp. 74 and 100).

Rockwell usually photographed his models in his studio, though in later years he often took them on location. On occasion he had elaborate sets built in the studio, but more typically he improvised stand-ins to pair with separately photographed settings, allowing him to combine characters and backgrounds convincingly. A table might substitute for a soda fountain counter, a chair for an auto seat, the artist's palette table for a school desk. Perhaps most useful and versatile were Rockwell's ubiquitous white, gray, and black folding screens, which isolated his subject in clear silhouette while hiding distracting backgrounds, and which could also be pressed into service as a makeshift hill or riverbank.

THE ARTIST AS DIRECTOR

But the key elements in each new work were his models. "Some artists feel they can create the type they want from anyone but I believe this is all wrong," Rockwell said. "When you have a good idea clearly in mind spare no effort to get the ideal character for it. All of the artist's creativeness cannot equal God's creativeness."[17] Rockwell was constantly on the lookout for promising amateur models. He could use an actual physician to pose as a doctor if he wished, or persuade a stranger off the street to assume any role the artist thought a good fit. But above all, Rockwell models had to be able to smile on cue, raise their eyebrows, and be ready to cut loose and perform for the camera.

Rockwell frequently tried out multiple models for a single role, often without telling them and then neglecting to inform the rejected models that they had not been used. Rockwell's Stockbridge assistant, Louie Lamone, remembered scouting models for the artist. "First he would describe what he was looking for and I would come back with Polaroid pictures. If he would okay them we would set up a photo session. But this created a lot of problems, because a lot of my friends who posed for Polaroid pictures...

BLACKSMITH'S BOY—HEEL AND TOE, 1940 (see p. 44)

went around telling people they were going to pose for Norman and it wasn't so. They were rejected and, of course, this didn't make me too popular."[18]

Rockwell never failed to pay his models — a fee of five dollars in Arlington (his sons got just one dollar, an inequity one of them resents to this day), and more in later years. "The very fact that you are paying them is likely to cause them to give their best," said Rockwell, "and if you pay them you are justified in demanding it."[19]

With his models in place, Rockwell would explain the idea of his illustration to convey what he wanted from them. Then Rockwell the artist would step aside and Rockwell the director would take charge. In a 1979 instructional book, *Rockwell on Rockwell,* he wrote that "directing models so you can get the right poses for your pictures is an art in itself and is somewhat akin to the motion picture director's job. First, you must discard all your own dignity and vanity and 'get into the act' yourself in order to induce your model to lay aside his own dignity so he will feel and express the emotion which you want to convey in your picture."[20]

Rockwell would first strike the pose himself and act out the part as many times as necessary, both to demonstrate what he wanted and to get his performers into the spirit. Then his subjects took their positions and, as photographer Bill Scovill explained, Rockwell would "pose the models according to the way he had pictured them in his mind and the way he had rough sketched them....He was copying his own ideas when he posed the models."[21]

From behind the camera, Rockwell continued to direct, altering the models' positions, angling their head or hands, and adjusting their expressions over and over again until at last they matched his imagination. He might gently cajole from the sidelines, but other times "he would jump up and down, he would roll on the floor, he'd laugh like hell — anything to get his model into that pose,"[22] recalled Lamone. Wisecracking, shouting, banging on the floor — he would stop at nothing. "Do anything and everything," Rockwell said, "but get your story on film even if it kills the model and you too."[23]

"Norman had a knack [for] putting models at ease," recalled Scovill. "He approached the model shooting sessions with a sense of fun."[24] Many photographs capture the artist himself in the frame, exuberantly performing alongside his neighbors and doing his utmost to coax the ultimate expression from his eager-to-please subjects (and sometimes, like film director Alfred Hitchcock, personally appearing in a cameo role). As his son Tom tells it, "he would imitate the faces that he wanted and urge them along. 'Lift your eyebrows higher — higher! You're really excited! More — more smiles! Brighter — brighter!' He would tell the photographer when to take the picture — 'Now! NOW!'"[25]

Photography sessions lasted from a few minutes to several hours, during which Rockwell continued to develop his ideas. Frame after frame he pursued his original concept but remained open to spontaneous possibilities as they arose, allowing variations in the photographs to suggest refinements.

Rockwell might stage complete compositions or photograph each element separately to be jigsawed together later. He made an abundance of photographs for each new work — sometimes a hundred or more — giving him a spectrum of poses from which to choose. "I take a whole pile of them," he said, knowing he could later extract a face from one image, a hand from another, or an expression from yet a third, facetiously moralizing that "if you're going to sin you might as well sin completely."[26]

Rockwell devised techniques to help his models hold difficult poses long enough for his photographer to get the picture. Books borrowed from nearby shelves could prop up the toe of a leading foot and the heel of the second to simulate a walking posture. Clothing might be pulled back to suggest motion. And the painter's angle of view could be adjusted during the photo session — lowered by posing the model on a pedestal or a table, or elevated by positioning the camera on a balcony overlooking the studio floor. Rockwell rarely used artificial lights, reserving them for images requiring the harsh shadows they cast. He preferred the flood of natural light from the large north windows he installed in each of his studios. This simple, traditional indirect light source offered diffused illumination and open, detailed areas of shadow. Sheets of white paper or matte board appear in many images, strategically positioned both to silhouette features and to reflect light where needed.

From CRESTWOOD COMMUTER STATION, 1946
Saturday Evening Post cover, November 16, 1946

Finally, Rockwell photographed important details individually. The arch of a wrist, a clenched fist, or a curved ankle might be isolated and shot against a plain white or gray board to delineate their outline. Isolated elements such as a serving tray set with glasses, patterned wallpaper, a tea service, coatrack, a folded newspaper, and a cigarette butt were all captured on film to eventually take their places in Rockwell paintings. Not one of the storytelling props in the 1954 *Post* cover *Girl at Mirror* (p. 134) — an upturned doll, a hairbrush, lipstick and comb, and a magazine opened to an image of Jane Russell — appears in the photographs of Mary Whalen taken during her modeling sessions: each was shot separately for later inclusion in the final work.

ROCKWELL'S CAMERAMEN

As one of America's most successful commercial artists, Norman Rockwell could afford to employ skilled photographers to operate the camera and make his work prints. As Rockwell likened himself to a film director in relation to his actor/models, so his relationship with his photographer was one of director to cinematographer. He determined where to position the camera, how to frame the scene, and when to shoot, but preferred not to look through the viewfinder. "I'd say 'Hey Norman, look in the camera. Do you like that?' recalled Louie Lamone. "He'd say 'No, that's your job.'"[27] And Rockwell seldom fired the shutter himself, writing in the 1940s that "I have never taken my own photographs…. I never worry about the lighting, focus, exposures, or anything but the feeling I want the model to convey. That's trouble enough."[28]

Rockwell worked with many photographers in the more than forty years he used the camera, but three are responsible for the majority of his photographs: Gene Pelham, Bill Scovill, and Louie Lamone.

Gene Pelham (1909–2004) was Rockwell's photographer for the fourteen years the artist lived in Vermont. Pelham was a young illustrator and had earlier posed for Rockwell in New Rochelle. Rockwell was delighted to find Pelham living in Arlington when he and his family arrived in 1939, and soon hired him as studio assistant. Pelham also built props, prepared canvases, wrangled models, and was himself a versatile and expressive model. The relationship was mutually beneficial: Pelham grew as an illustrator as he learned from his mentor, and Rockwell gained from Pelham's considerable range

From Babysitter with Screaming Infant, 1947
Saturday Evening Post cover, November 8, 1947

From April Fool: Girl with Shopkeeper, 1948
Saturday Evening Post cover, April 3, 1948

of talents. Pelham used a tripod-mounted five-by-seven-inch camera until it was destroyed in the 1943 studio fire, and subsequently worked with a smaller view camera, usually set to f:8, using 3¼ x 4¼-inch and 4 x 5-inch film formats. The exceptional quality of his many images attests to Pelham's skill as a photographer and darkroom technician.

Bill Scovill (1915–1996) was Rockwell's first photographer in Stockbridge. Technically proficient, Scovill taught amateur photography and handled most of Rockwell's local photography for the next ten years. (When the artist traveled he hired photographers on location.) Scovill's role was strictly that of cameraman; unlike Pelham he neither modeled nor assisted in the studio. In addition to creating the photographs for at least 160 illustrations, Scovill also visually documented Rockwell at work during this prolific period in the artist's career.

Rockwell had first hired Louie Lamone (1918–2007), a local General Electric worker, to help during the family's relocation to Stockbridge and soon asked him to become his general assistant. Lamone worked with Rockwell for twenty-three years, the longest term of any of Rockwell's assistants, continuing until 1977 when the artist could no longer work. Adding to his multiple duties as handyman, carpenter, prop maker, and model scout, Lamone began to photograph in 1961 and took over as chief photographer in 1963. Both Scovill and Lamone used 4 x 5, 2¼ x 2¼ rangefinder, and 35mm cameras for model sessions and location photography, plus an oversize copy camera to document the artist's charcoal drawings, studies, and finished paintings.

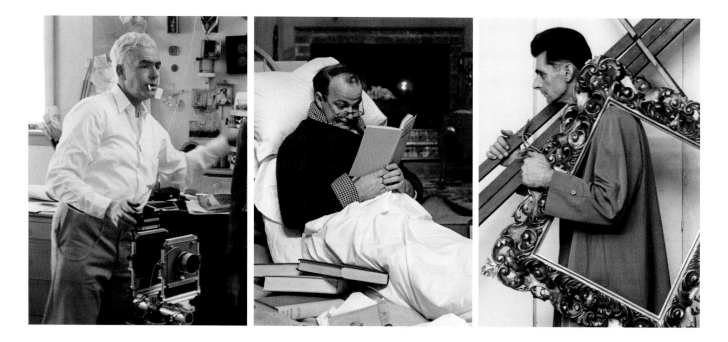

Bill Scovill, Gene Pelham, and Louie Lamone

Norman Rockwell preferred to train his photographers so their work would suit his particular needs as an illustrator. He wanted straightforward photographs and was careful not to allow the aesthetic effects of fine art or studio photography to skew his own vision. Photographers who brought too much personal artistry to the job were of no use to him. As Lamone observed, "A lot of photographers… figured they were artists in their own right. They liked deep, very contrasty, dark photographs that let the shadows go black…. [Rockwell] was looking for kind of a gray photograph…. He wanted to see into the shadows and, if he wanted to, could paint the shadows black. Most photographers were so used to making snappy, dark photographs they didn't understand this."[29]

Rockwell built well-equipped darkrooms in his Arlington and Stockbridge studios so that photographers could provide him with prints immediately after each session. When Rockwell dismantled the darkroom (constructed to Scovill's specifications) in his second Stockbridge studio, Lamone developed film and made prints in his own home. Lamone recalled the artist "would ask me to make three kinds of the photographs he'd picked out. He would want one light, one dark, and one in between…and then he'd want pieces of the photograph enlarged…. He wanted it right away, too."[30] With film quickly developed and eight-by-ten glossy prints (a gray master, and extras exposed for shadows and highlights) promptly made, the artist would have his photos waiting for him early the next morning.

FROM CAMERA TO CANVAS

After selecting the best photographs to tell his story, Rockwell began the process of translating his images into a finished painting. His first step was to create a charcoal drawing in which he developed his ideas and worked out the final details of composition. To Rockwell, the charcoal was "the most important step in making any story-telling picture…. Here is where you succeed or fail."[31]

Key to his working method was an optical device called the Balopticon, manufactured by Bausch & Lomb of Rochester, New York. A cross between an early-twentieth-century magic lantern and a modern opaque projector, Rockwell's Balopticon facilitated several steps in his intricate and labor-intensive process. But the machine caused Rockwell to wrestle with his conscience just as the camera had. "The Balopticon is an evil, inartistic, habit-forming, lazy and vicious machine! It also is a useful, time-saving, practical and helpful one," he noted. "I use one often — and am thoroughly ashamed of it. I hide it whenever I hear people coming."[32]

To make the charcoal drawing, Rockwell first mounted his rough sketch in the Balopticon and projected it on a vertical easel, positioning it closer or farther away to achieve the desired size. Drawing lightly with charcoal on a sheet of roughened architect's paper, he outlined his design.

Rockwell then introduced his photographs into the composition. Beginning with the most important subject, he placed them one by one in the Balopticon, fitting them to the outlined sketch. Maneuvering

each element — a face or a hand, a prop or an architectural detail — into position, he lightly traced the projected photographs and erased the first sketched figures. Rockwell sometimes cut out and used only the specific features that interested him, discarding the remainder of the image. This ability to mix and match disembodied details gave him flexibility and control as he fine-tuned his composition.

As he worked he could freely make adjustments, readily rearranging elements, changing the angle of a head or a torso, or even altering scale. "Often," he said, "I will enlarge an eye, reduce the size of the

mouth or do any number of things to make the character funnier or sadder or to portray any other expression needed to put over the story."[33] Making a man's head a bit smaller was "always a good stunt when drawing men," he revealed. "It makes them appear nobler."[34] And if the result didn't please him Rockwell erased or replaced the offending detail, rubber-cementing in a new section. Then, with the complete composition roughed in, he started again at the beginning, now tracing each photographic element in greater detail and making notations on lighting and tonality.

Finishing his monochrome charcoal (sometimes after a second or third attempt), Rockwell then produced a color study to the size of the intended reproduction in order to plan the palette of the final painting. Sometimes done earlier in his process, Rockwell's color studies often possessed a loose, painterly vitality quite unlike the finished illustration.

Making the final leap to finished painting, Rockwell transferred his charcoal drawing to the primed canvas using one of two methods. Usually he traced the charcoal onto translucent paper and then copied that outline to canvas by drawing over the lines with transfer (similar to carbon) paper, more a mechanical than an interpretive step that was often entrusted to assistants. Alternately, Rockwell had his charcoal drawing photographed, projected onto the canvas, and traced.

In his later years Rockwell cut procedural corners to save time and labor. To make his color studies, he sometimes painted directly on reproduction-size photographs of his charcoals. Occasionally he even dispensed with the charcoal drawing, projecting his photographs directly on the surface of his canvas.

After sealing the drawing on canvas with thinned shellac, Rockwell began what was for him the demanding process of laying down paint. His photographs played a final role as he tacked snippets cut from them to the easel for ready reference as he worked. Unlike the delightedly engaged artist glimpsed in his photographic sessions, Rockwell suffered through long, stressful days of personal doubt and anxiety as he struggled to complete his creative process.

Like many perfectionists, Norman Rockwell was often dogged by insecurity. Even at the height of his fame he never took for granted that *The Saturday Evening Post* would accept his latest cover or that the magazine wasn't about to replace him. Striving to get everything exactly right, Rockwell was known to repeatedly paint over entire sections of a composition, or scrape the paint down to the canvas and restart. He often convinced himself that he had irredeemably ruined his painting, reportedly calling this the "oh-my-God-it's-awful"[35] phase. Sometimes, even finished works could be discarded.

Rockwell routinely asked anyone who came into his studio to critique a work in progress, recalled Bill Scovill. "He would make you feel like you were the world's greatest art critic. He would say 'Oh yes, that's exactly where I'm stuck. Thank you for pointing it out.' He would start making the changes right then and there and...the next day he'd be back to where he was the day before. It finally occurred to me this was one of [his] ways of developing a sense of security about the way he was going about it."[36]

It was never easy for Norman Rockwell to refuse new commissions. *Post* covers competed for his attention with advertisements, calendars, and other commercial work, often with several differ-ent projects at various stages of completion in his studio at a time. Peter Rockwell acknowledged that his father's "folksy character was, after all, a pose. He was a workaholic. He worked seven days a week,

ABOVE AND OPPOSITE **Day in the Life of a Little Girl**, 1952 (see p. 122)
Saturday Evening Post cover, August 30, 1952

nine hours a day."[37] And, never satisfied, Rockwell found it difficult to let a finished painting go. Louie Lamone remembered Rockwell repainting details on a still wet canvas as it was about to be loaded into a station wagon for delivery to the *Post*. "As he was finishing," said Bill Scovill, "he'd find it hard to stop and say 'This is done.'"[38]

ROCKWELL AND PHOTOGRAPHY

Photography has had a symbiotic relationship with painting since its near-simultaneous invention in the 1830s by a French painter, Louis Daguerre, and an English gentleman-scientist and frustrated artist, William Henry Fox Talbot. While Daguerre and Talbot discovered completely different chemical means, their goal was the same: to improve the ability to capture and fix the images of reality and thereby render them fit for replication into art.

Long before the invention of photography, artists employed optical devices to aid drawing and control perspective. The benevolent relationship between optics and artists reaches back to the late Renaissance, as David Hockney, a contemporary artist who himself uses photography, has explored in his provocative 2001 study, *Secret Knowledge*. Norman Rockwell's use of the camera has a long line of precedents; in nineteenth-century Europe, Eugène Delacroix, Jean Auguste Dominique Ingres, Gustave Courbet, Henri de Toulouse-Lautrec, Paul Gauguin, Edgar Degas, and Édouard Manet all adopted photography. Indeed, a small industry soon arose of cameramen (the most celebrated being the Parisian Eugène Atget) who produced stock photographs as artists' studies. Later, the Dadaists and Surrealists of the 1920s and '30s virtually erased the conceptual line between photography and painting. In America, the nineteenth-century painters Winslow Homer, Thomas Eakins, Frederic Edwin Church, and Frederic Remington took up the camera, and in the twentieth century Charles Sheeler, Robert Rauschenberg, and particularly Andy Warhol explicitly intermingled the two mediums.

As staged scenarios created for the camera, Rockwell's photographs parallel the composite prints of nineteenth-century pictorialists Henry Peach Robinson and O. G. Reijlander, as well as the contemporary narratives of photographers Cindy Sherman, Gregory Crewdson, and Jeff Wall. Like Robinson's *tableaux vivants*, Rockwell's compositions were self-contained dramas staged for the benefit of the camera; echoing Reijlander, his finished works were often composed of elements snipped from separate photographs. And arguably Rockwell's working method was as fundamentally cinematic as that of Wall or Crewdson (the latter, like Rockwell, does not operate his own camera). Read as records or documents, Rockwell's photographs illuminate the secrets of his visualization method and complex working process. But beyond that, his empathetic characterizations invite comparison with the work of the best twentieth-century photographic portraitists, such as Arnold Newman, Philippe Halsman, or Irving Penn. Rockwell's meticulous attention to nuance in his photographs is the essence of art.

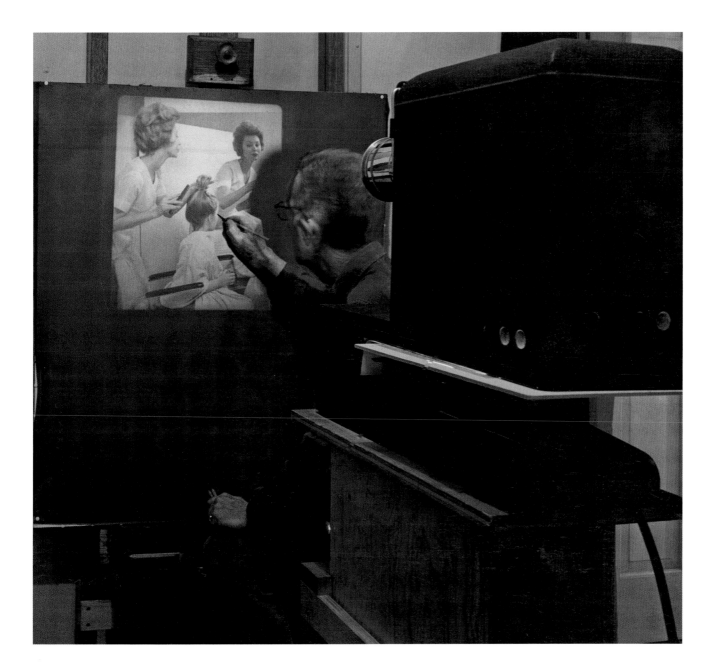

All three of Norman Rockwell's sons, Jarvis, Tom, and Peter, confirm that their father had little ostensible interest in the art of photography. But intriguing clues point tentatively in another direction. His studio library held both the 1958 and 1969 editions of Peter Pollack's *The Picture History of Photography*, the catalog of Edward Steichen's 1955 landmark exhibition *The Family of Man*, and a volume on Eakins's photographs. Editions of *U.S. Camera Annual* appear as props in numerous study photographs. Rockwell accepted at least one commission (from Eastman Kodak) whose end product was itself a photograph — a mammoth Colorama transparency sixty feet wide that dominated the main concourse of New York City's Grand Central Terminal in the autumn of 1957. In addition, Rockwell

Norman Rockwell using Balopticon while working on FIRST TRIP TO THE BEAUTY SHOP, 1972

had a working knowledge of photographic technique sufficient to train and direct his assistants; his third wife, Molly, and his son Tom both studied photography.

Two of Rockwell's own books, *The Norman Rockwell Album* (1961) and *Rockwell on Rockwell* (1979), reproduce examples of his photographs to illustrate the steps in his working method but are silent regarding their artistic value. Despite the lavish energies he invested in creating his photographs, to Rockwell they were simply workaday tools, a "means to an end,"[39] in Tom Rockwell's words. They were but one step — albeit a crucial one — on a multistage path toward the goal of a successful painting. That these images have survived is due largely to the fact that Rockwell was, in Jarvis Rockwell's words, "an orderly man"[40] who carefully archived them for reuse. It is fortunate that the unexpected treasure of the artist's photographic archive remains available today, thirty years after the artist's death. Its exploration has begun — and will continue — to open new windows on Norman Rockwell's achievements in twentieth-century American art. ❧

ILLUSTRATIONS AND FEATURES

NORMAN ROCKWELL IS BEST KNOWN
for his *Saturday Evening Post* covers, but
from the beginning his illustrations also
appeared inside the magazine. By 1934 the
Post's editors turned to Rockwell regularly
to illustrate stories and to contribute his
own features.

In addition to *The Saturday Evening Post*,
Norman Rockwell's work appeared in peri-
odicals such as *Boys' Life*, *McCall's*, *Ladies'
Home Journal*, *American Magazine*, and *Good
Housekeeping*. Though Rockwell claimed
illustrations were "relatively easy; one's
inspiration comes from the story or book,"
he spared no amount of energy researching
props and finding authentic locations. His
original features allowed him to expand his
narrative form and use multiple images to
tell his stories. The sometimes gritty and
dramatic subject matter of his illustration
assignments and the narrow focus of por-
traying an isolated literary moment offered
artistic opportunities to depict and explore
themes that would never have found a place
on the cover of a mass-market magazine.

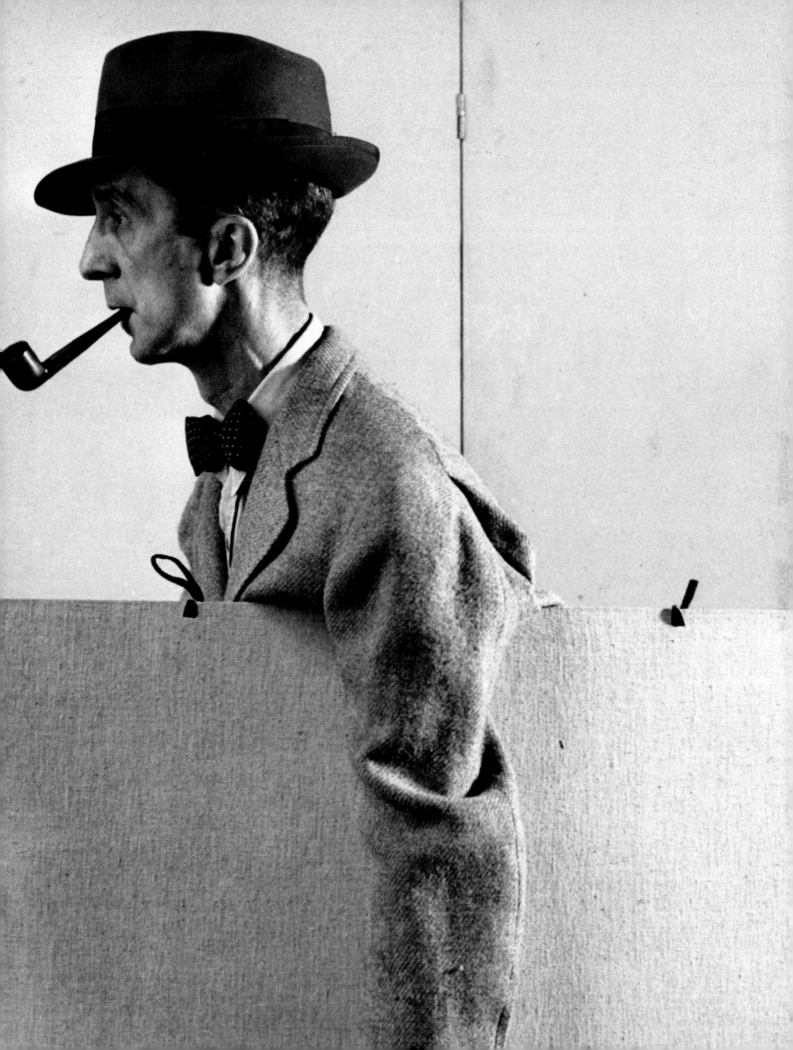

RIVER PILOT, 1940

"The two boats held their own, smoke billowing from each other, shearing the swift current of the gorge."
Saturday Evening Post story illustration for "River Pilot," by Carl D. Lane,
September 21, 1940. Private collection

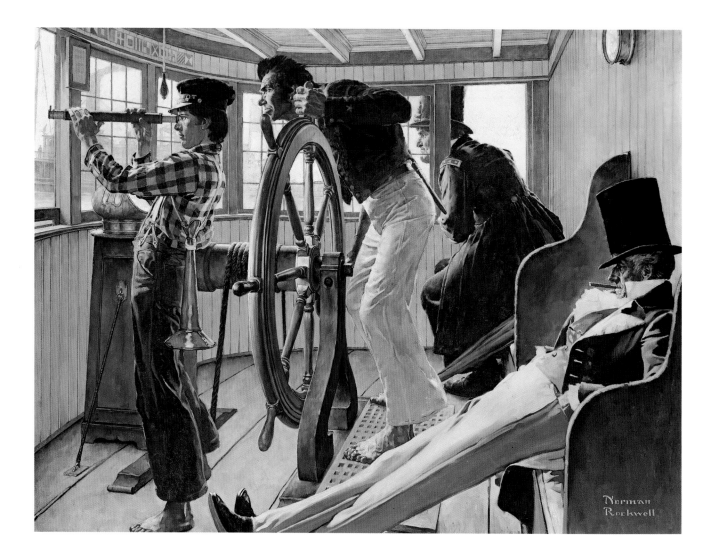

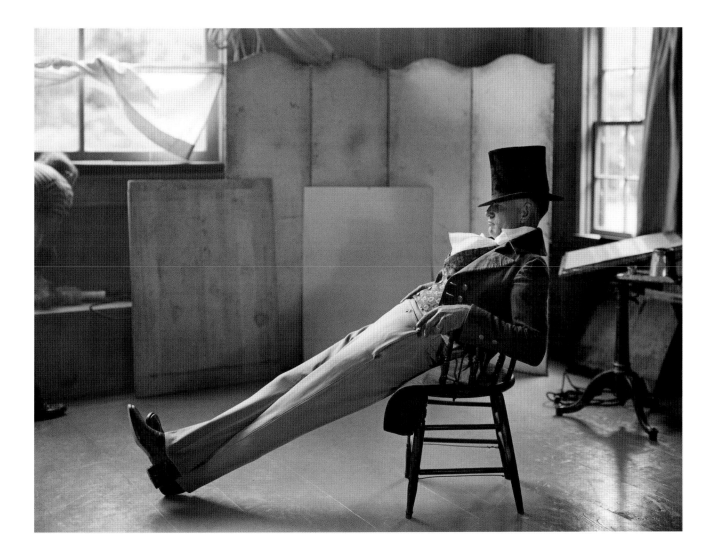

River Pilot, which Rockwell considered one of his "better illustrations," is one of three created for an adventure story of the same title about a steamboat race on the Connecticut River. For these photographs Rockwell transformed his Arlington studio into a riverboat wheelhouse. The artist's painting palette appears in the background of two images.

While photography had become a mainstay of Rockwell's studio practice by 1937, relatively few photographs from the first years of his camera work survive. In May 1943 a fire burned his Vermont studio to the ground, destroying canvases, files, props — and his photographs. The small number of negatives surviving from the years prior to 1943 offers a tantalizing hint of those lost images.

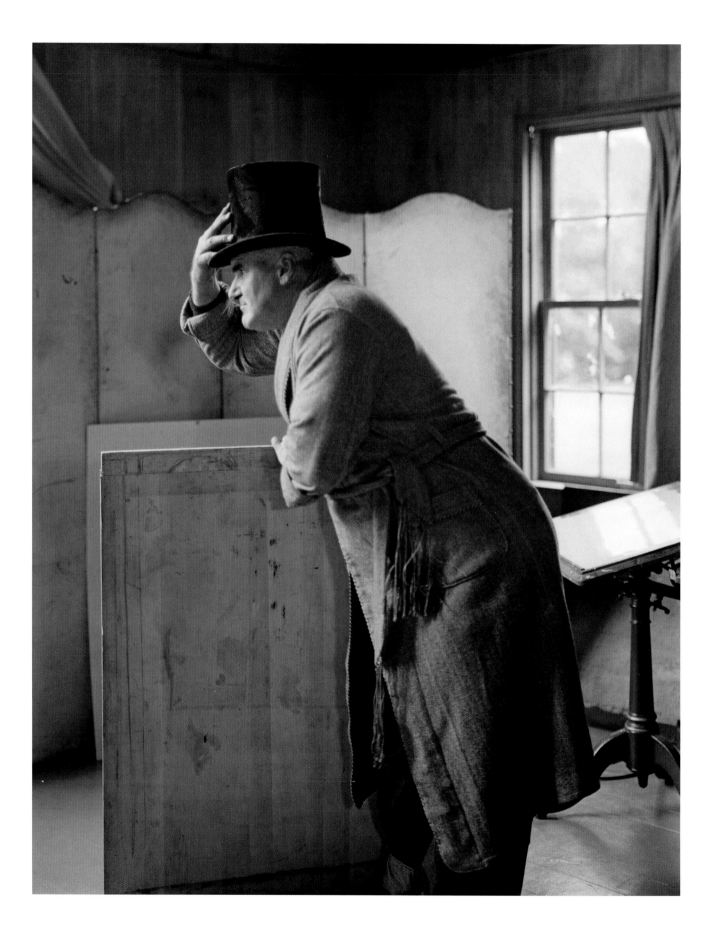

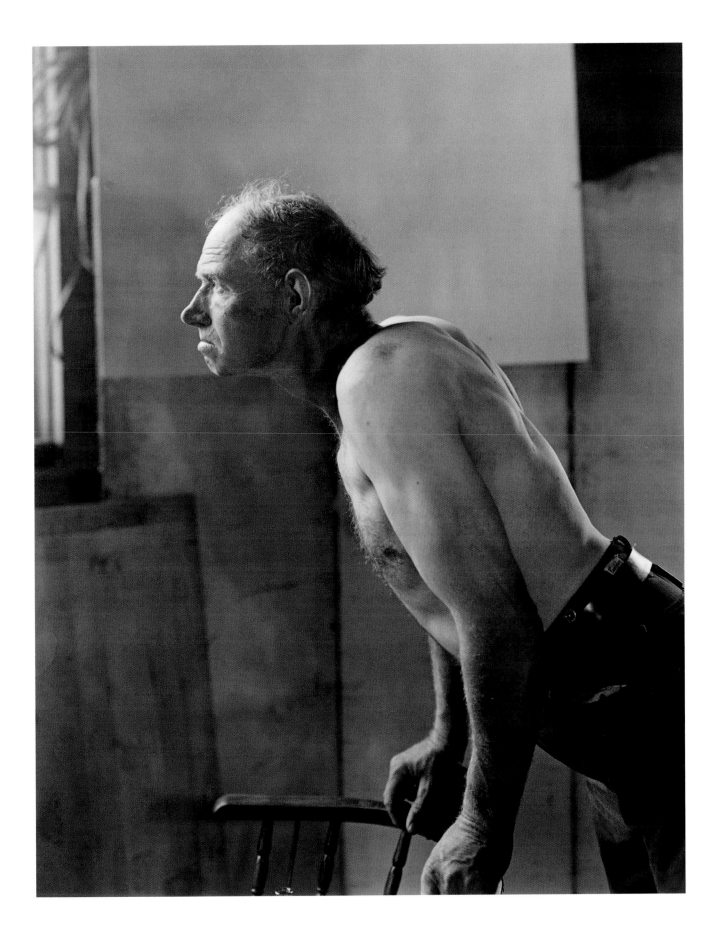

PROUD POSSESSOR, 1940

"Kiah loved the runty little hounds because they were his —
and because he didn't have much else to care for now that his mother was growing away from him."
American Magazine story illustration for "Proud Possessor," by James Street, May 1940.
Private collection

American Magazine was founded in 1906 as a muckraking successor to *Leslie's Monthly Magazine*. Rockwell illustrated thirty-one features for *American Magazine* between 1918 and 1947; he completed two paintings for Mississippian James Street's short story *Proud Possessor*. The charged moment Rockwell has chosen to illustrate resonates unexpectedly with his well-known civil rights paintings of the mid-1960s, in particular *New Kids in the Neighborhood* (p. 208).

The two young models were photographed separately in front of Rockwell's Arlington, Vermont, home. To achieve the illustration's upward perspective, he elevated his subjects by posing them on boxes painted white to silhouette their feet.

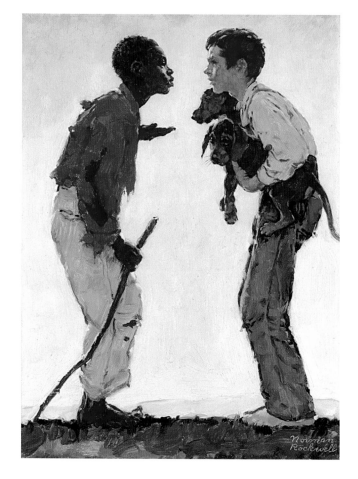

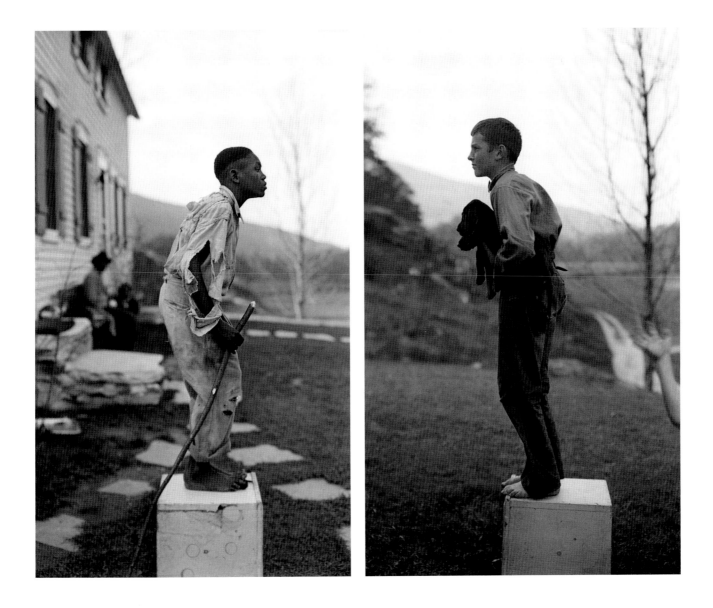

BLACKSMITH'S BOY — HEEL AND TOE, 1940

"I'll never forget that last hour. And never, I imagine, will any of those who watched. Both men were lost to everything now but the swing from the forge to the anvil, the heels to be turned and the toes to be welded." *Saturday Evening Post* story illustration for "Blacksmith's Boy — Heel and Toe," by Edward W. O'Brien, November 2, 1940. Berkshire Museum

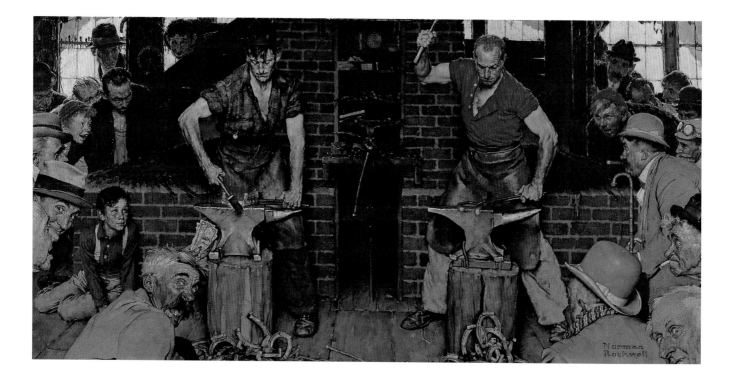

"When I do a picture with a lot of people, I often run out of models, or perhaps there is some space I wish to fill; then the easiest and cheapest thing to do is to pose myself; so there I am over on the left, wearing a dark-banded hat and looking straight at you." —NORMAN ROCKWELL

Rockwell photographed each of the twenty-three figures in *Blacksmith's Boy* individually in his Vermont studio. One of Rockwell's favorite models was Harvey McKee, undersheriff of Arlington. His expressive face — and magnificent mustache — won him featured roles in several Rockwell illustrations from this period. He appears twice in *Blacksmith's Boy*, once at lower left waving dollar bills, and again in profile on the right, cigarette dangling from his lips, but minus his mustache. Never one to waste a useful prop, Rockwell relocated a likeness of McKee's facial hair to the face of another neighbor, Nip Noyes, wearing a bowler and just above the McKee profile.

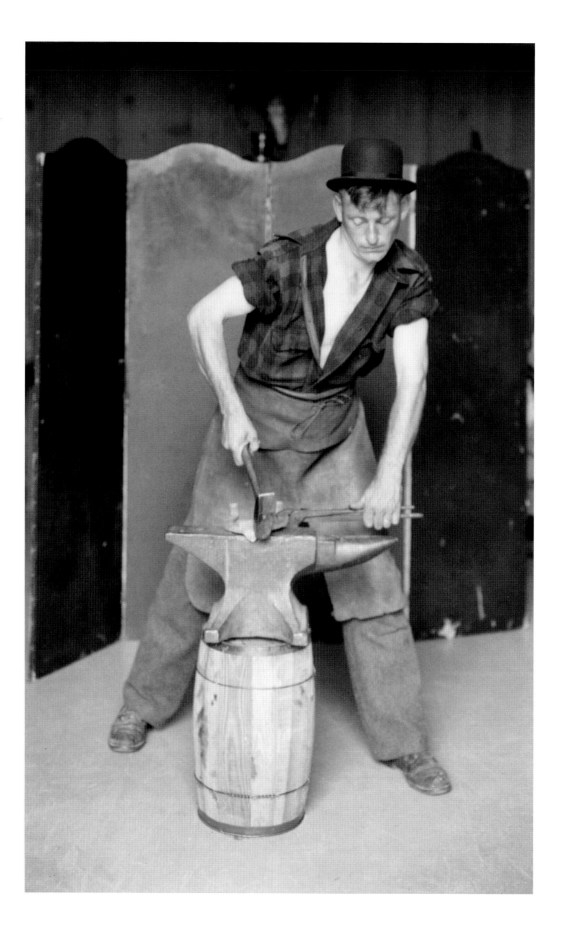

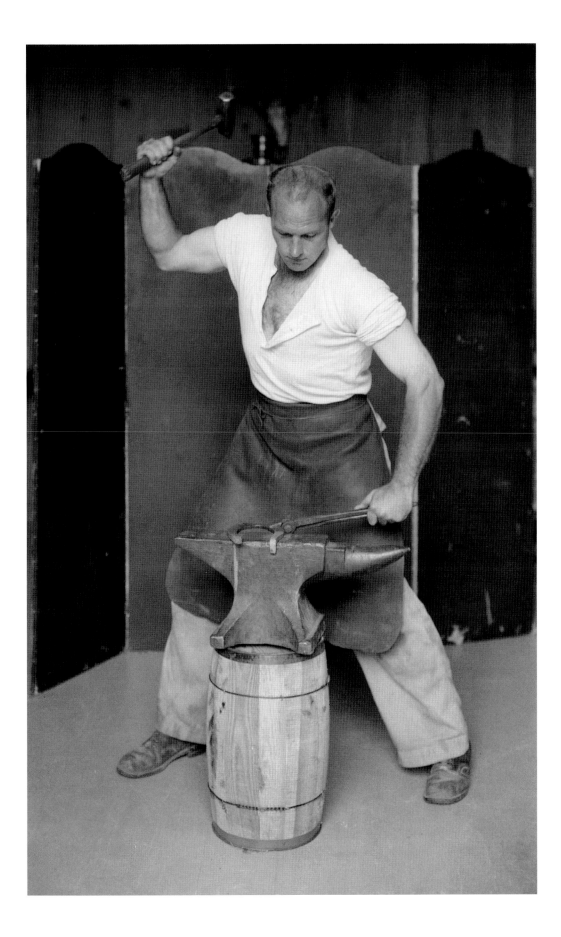

THE COMMON COLD, 1945

Saturday Evening Post feature illustration, January 27, 1945

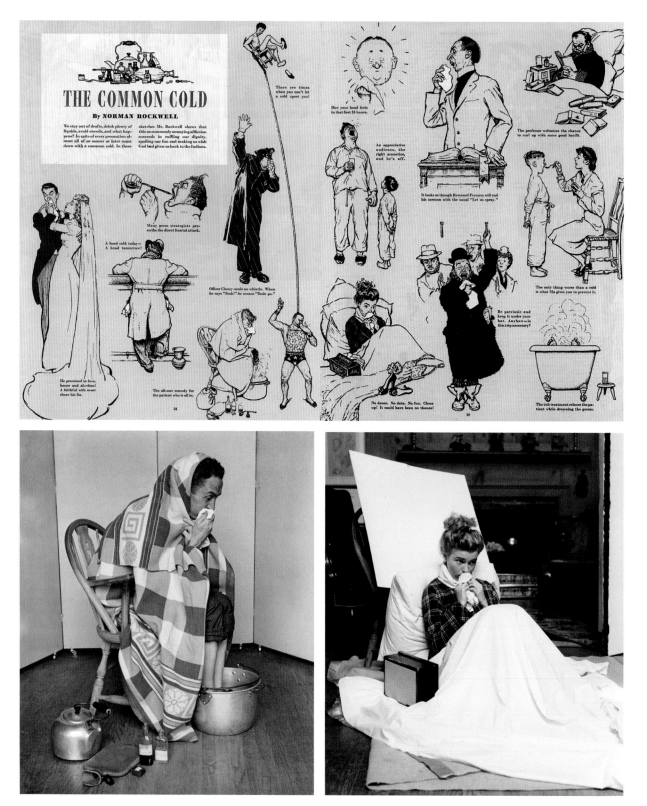

OPPOSITE "There are times when you can't let a cold upset you!"
LEFT "The all-out remedy for the patient who is all in."
RIGHT "No dance. No date. No fun. Cheer up! It could have been no tissues!"

Just as Rockwell had admonished illustrators to "discard all [their] own dignity and vanity" when directing their models, the artist himself would go to great lengths to achieve the perfect comedic effect.

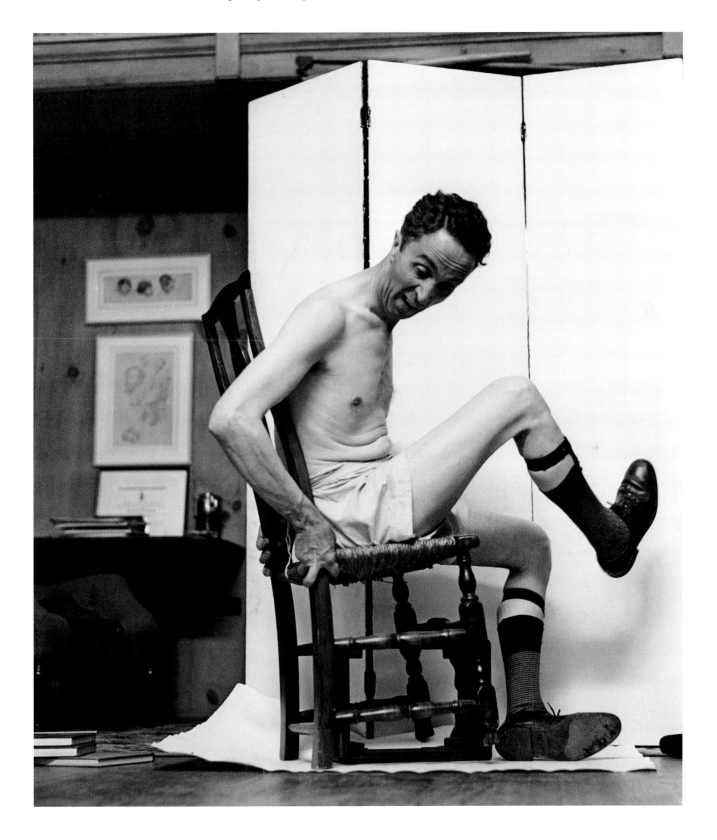

NORMAN ROCKWELL VISITS A COUNTRY EDITOR, 1946

Saturday Evening Post feature illustration, May 25, 1946. National Press Club.

Copyright © 1946 SEPS

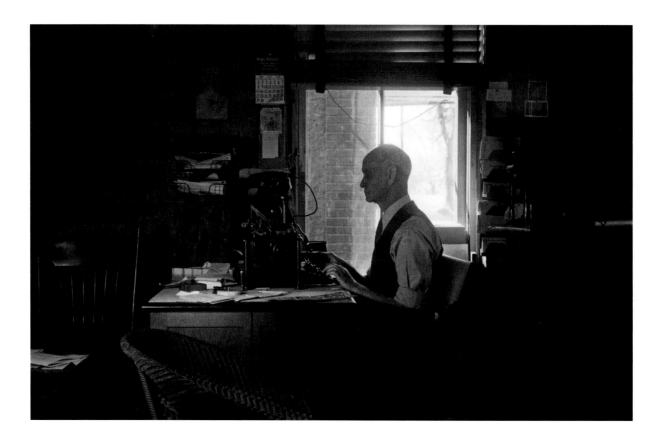

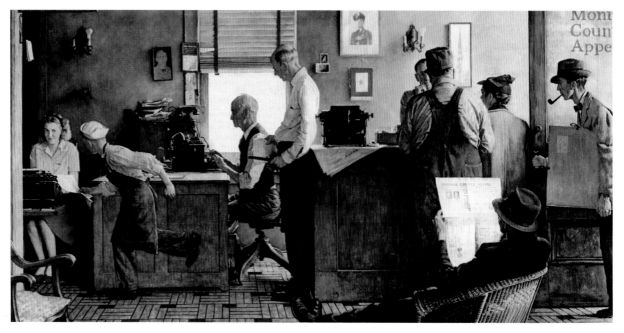

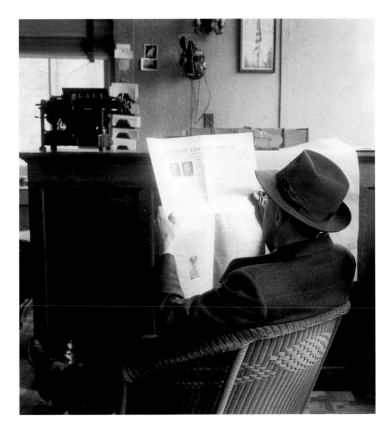

"During the 1940s I did a series of pictorial reports for the *Post*, variously entitled 'Norman Rockwell Visits a Country School,' 'Norman Rockwell Visits His Family Doctor,' and so on. Each report consisted of a full-color painting, printed as a double-page spread, and two pages of black and white sketches....I usually spent two days at the scene of the report. During the first day I tried to get the feel of the place and rough out in my mind the story I wanted to tell. The second day I made sketches, decided on the subject and setting of the painting, and had photographs taken. Back in my studio I did the painting and made the finished sketches. I enjoyed doing these reports. They were a pleasant and stimulating change from my regular work...and gave me a chance to travel about the country and meet a lot of people." — *NR*

Rockwell traveled to Paris, Missouri, for *Norman Rockwell Visits a Country Editor*, one of his eight *Saturday Evening Post* reports. He spent three days exhaustively documenting the daily operation of the *Monroe County Appeal,* founded in 1867 and still publishing today. The *Appeal*'s editor, Jack Blanton, is at his typewriter in a photograph exposed to capture detail outside the window beside him. And Rockwell himself is seen coming through the door, portfolio under his arm.

Rockwell's visit to the *Appeal* came shortly after the death of President Franklin D. Roosevelt on April 12, 1945. The lead story "End Comes to President" and photographs of FDR and his successor, Harry S. Truman, are visible on the front page.

MATERNITY WAITING ROOM, 1946

Saturday Evening Post feature illustration, July 13, 1946. Private collection

Perhaps to the great credit of Arlington, Vermont, Rockwell found no local models with sufficient inborn stress to illustrate this essay. He had to travel to New York City to photograph subjects able to display authentic anxiety. There was no shortage among his chosen model pool — the executives of the high-powered advertising agency Batten, Barton, Durstine and Osborn.

"Frightened Novice"

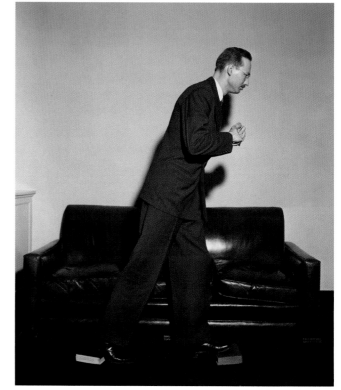

"Distraught Executive"

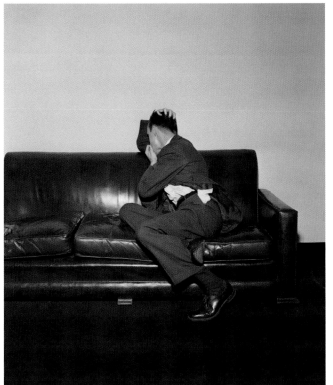

"Tragedian"

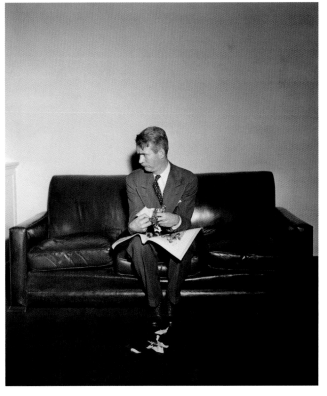

"Magazine Shredder"

NORMAN ROCKWELL VISITS A FAMILY DOCTOR, 1947

Saturday Evening Post feature illustration, April 12, 1947. Norman Rockwell Museum

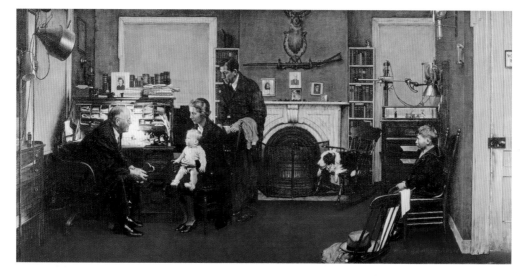

The subject of *Norman Rockwell Visits a Family Doctor* was Dr. George Russell, Arlington's town physician for over fifty years. After photographing the Marsh family in Dr. Russell's office, Rockwell discarded the composition. New photographs were taken in his studio with a different family who appears in the final painting.

WORLD WAR II

ALL BUT SIX OF NORMAN ROCKWELL'S twenty-eight *Saturday Evening Post* covers between October 1941 and August 1945 dealt with World War II. He went on to paint six more about homecoming G.I.s after the end of the war. While Rockwell focused primarily on the enlisted man, he also anecdotally examined life on the home front. Rockwell wrote that for the most part he "didn't attempt to do battle scenes — the troops in Italy or Saipan. I painted scenes and people I knew something about."

Too old to enlist, Rockwell contributed to the war effort with his art. Thematically, his homespun interpretations of core American values and ideals served as morale boosters, weekly reminders of why we fought. But more concretely, a national tour of his patriotic *Four Freedoms* canvases (see pp. 20–21), published by the *Post* in 1943 and reissued as posters by the Office of War Information, raised $133 million in war bonds.

LIBERTY GIRL, 1943

Saturday Evening Post cover, September 4, 1943.

Copyright © 1943 SEPS

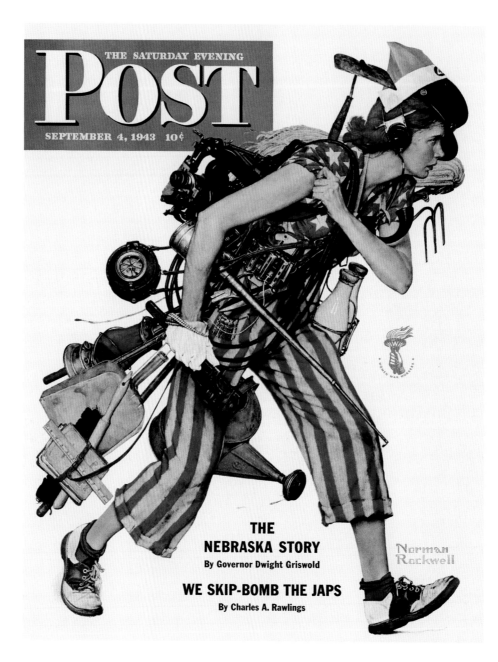

Rockwell hired a professional model to pose for *Liberty Girl*, one of two covers he painted celebrating contributions to the war effort made by women war workers. (No photographs survive for its well-known companion piece, *Rosie the Riveter*.)

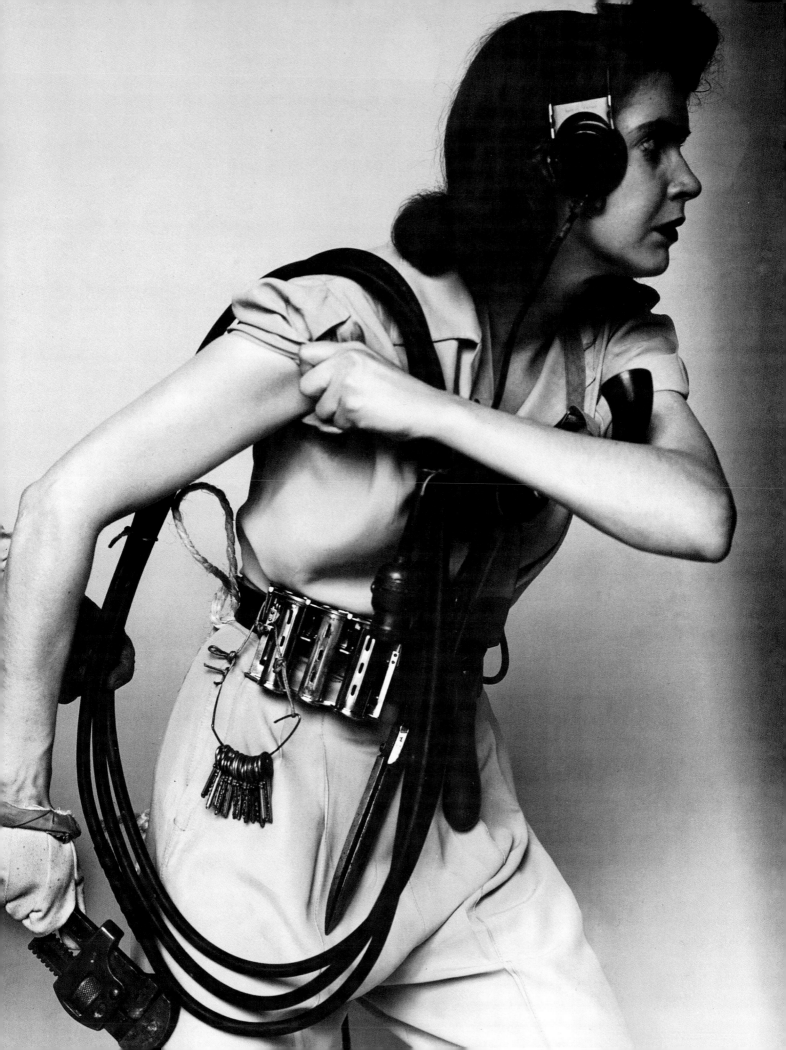

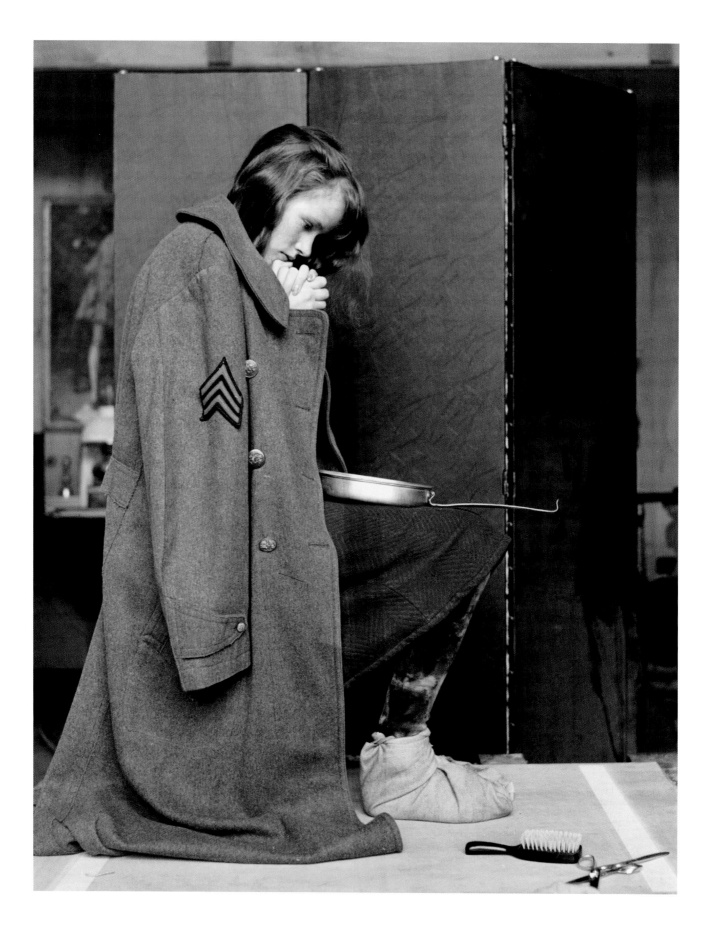

THANKSGIVING: GIRL PRAYING, 1943

Saturday Evening Post cover, November 27, 1943.

DISABLED VETERAN, 1944

Saturday Evening Post cover, July 1, 1944.

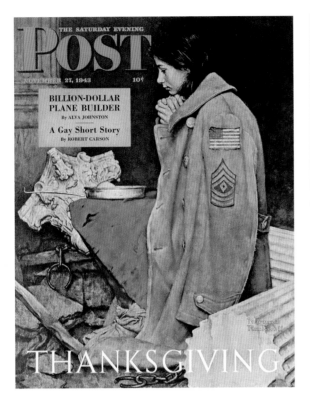

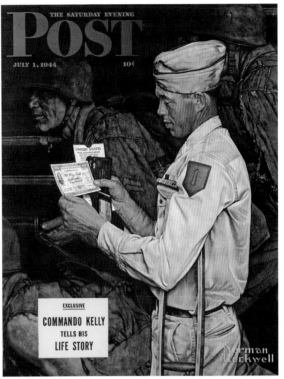

This image of a young refugee in war-ravaged Italy, giving thanks for the comfort of a G.I.'s coat and rations, is unusually somber. Rockwell often photographed multiple models for each subject, making his selection only when the photographic prints were in his hands. He photographed two teenage girls for this image; the model here would not be his final choice.

Rockwell's eerie photographs of a combat-ready soldier prowling his darkened studio are unlike anything else in his archive. Successive images capture a G.I. in battle-torn uniform — rifle at the ready with fixed bayonet — on patrol, alert for movement, under enemy fire, and finally, mortally wounded.

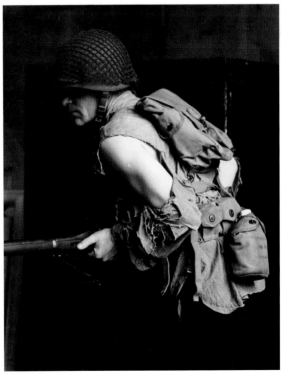

SO YOU WANT TO SEE THE PRESIDENT! 1943

Saturday Evening Post feature illustration, November 13, 1943. Private collection

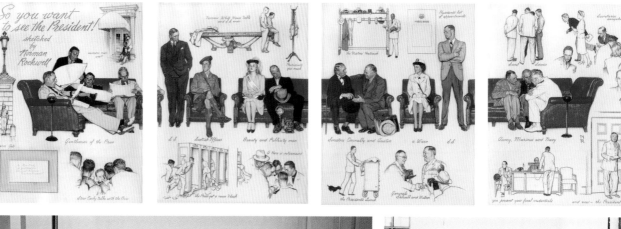

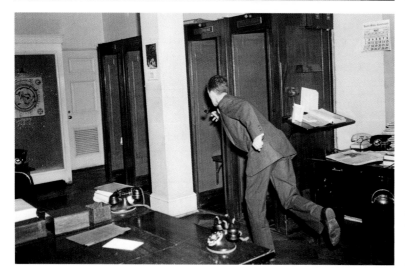

ABOVE LEFT "During a lull, White House reporters catch up on their newspaper reading and a Nelson Rockefeller man (left) waits to see the President."

LEFT "Correspondents sprint for telephones with an Early communiqué."

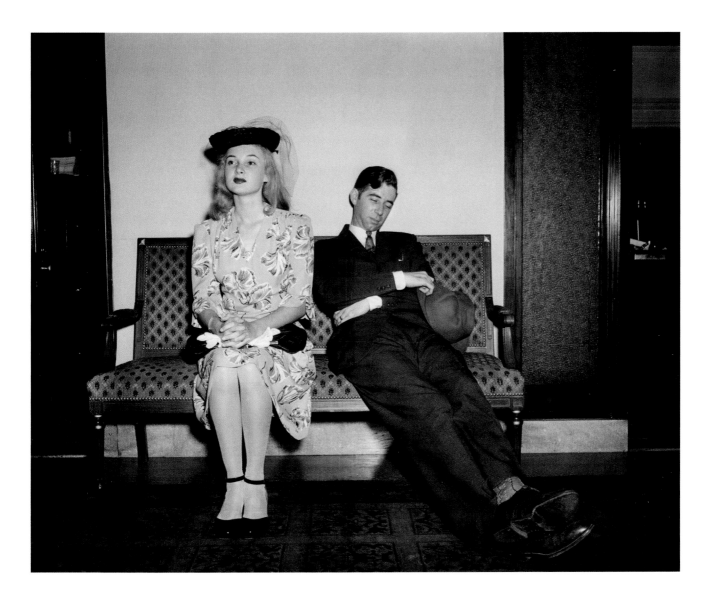

So You Want to See the President! was one of the first original features Norman Rockwell contributed to *The Saturday Evening Post*. Rockwell was welcomed to Franklin D. Roosevelt's White House by "the secret service men, the secretaries — they all went out of their way to see that I got what I was after and told me about life at the White House whenever they had a spare moment....And I met senators and politicians, generals, a beauty contest winner, a delegation of school children and a movie actress and talked with them all."

Three of these images were photographed on location in Washington. The fourth, of Rockwell's assistant Gene Pelham in the role of press photographer, may have been taken in a schoolhouse in West Arlington that Rockwell used as a studio after his own studio burned.

"The Boss sees all he can, but some get turned away, which is probably the fate of this hopeful beauty and her bored cameraman."

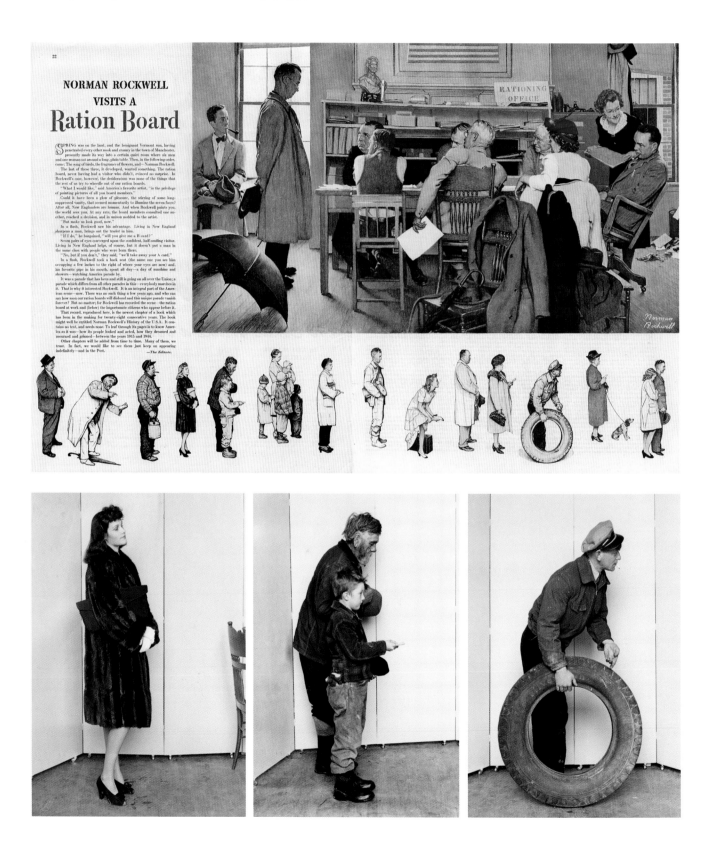

Rockwell owned three folding screens — black, white, and neutral gray — to use as photo backdrops. They served double duty, isolating the model in a space free of distracting background elements while silhouetting the subject's form.

WAR NEWS, 1944

Intended for *The Saturday Evening Post*, unpublished. Norman Rockwell Museum

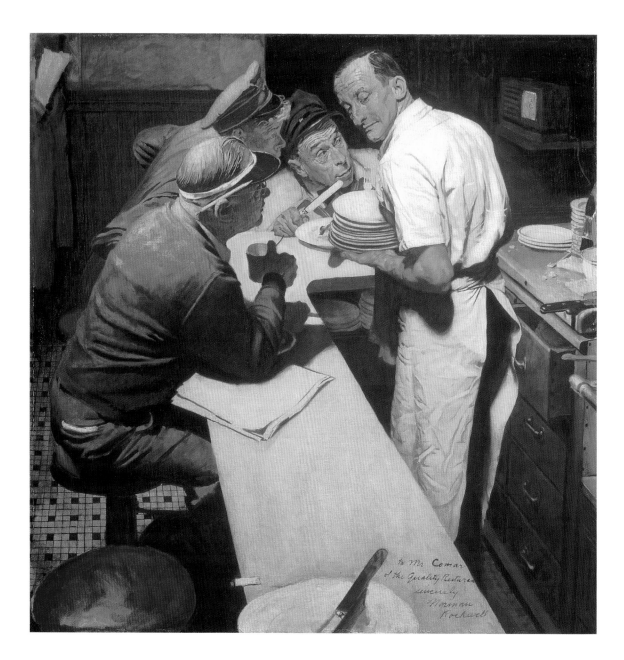

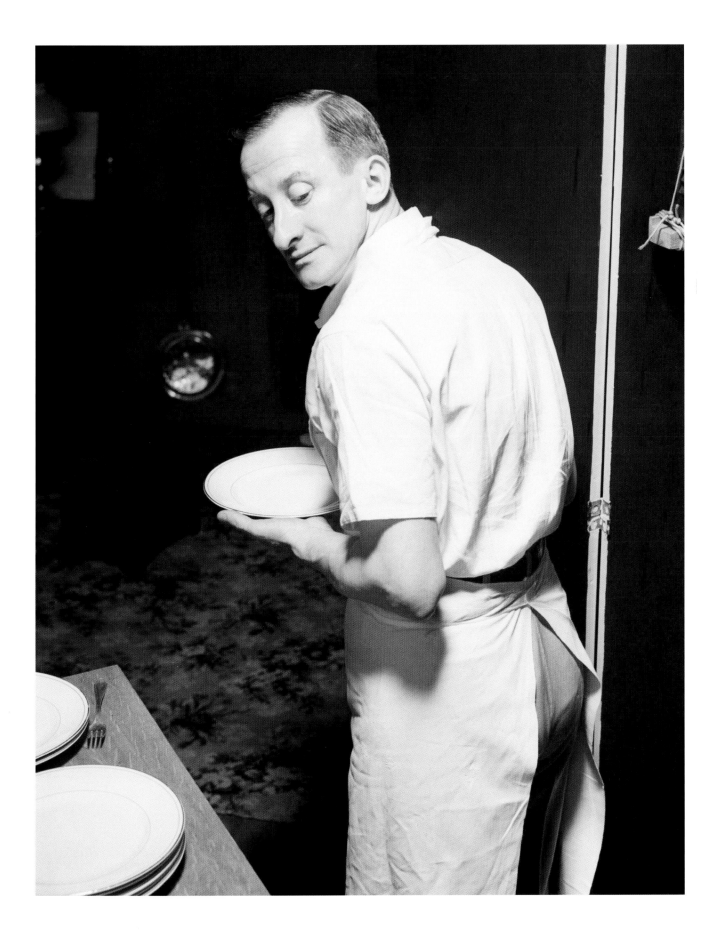

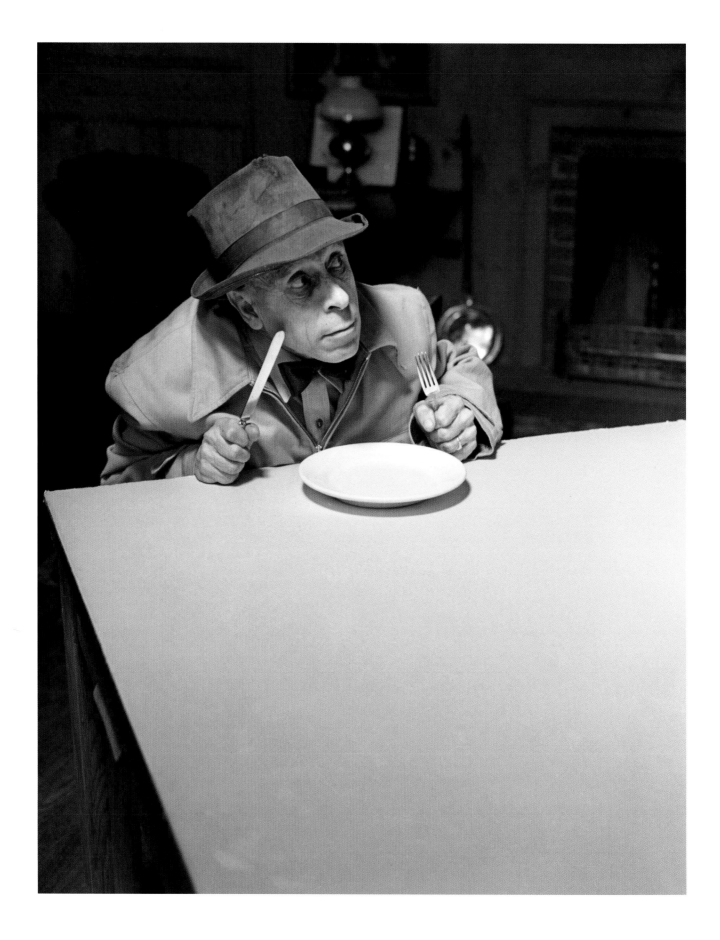

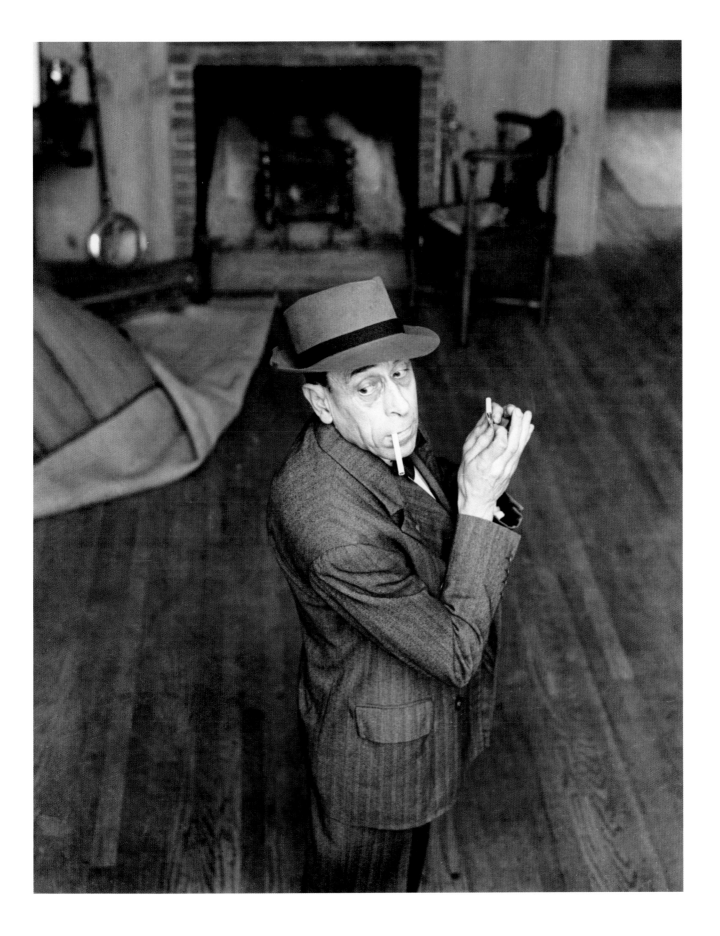

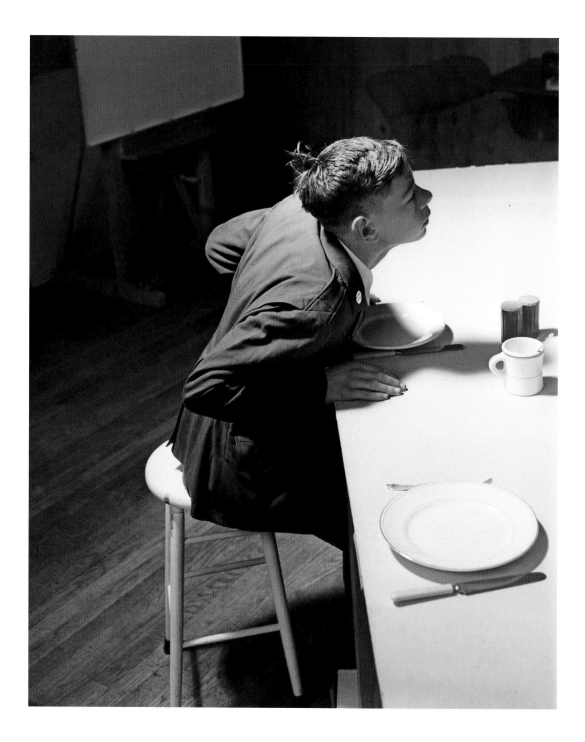

War News captures a dramatic moment of anticipation and quiet focus. The artist's models, looking as though they have stepped out of a film noir casting call, are frozen as they strain to hear a news flash from the diner's radio. Rockwell intended this image for the cover of *The Saturday Evening Post* but it was never used, nor was it finished (note the blank newspaper on the counter).

Among Rockwell's subjects — he photographed more than were used — was the owner of the Quality Restaurant, in which the scene is set, as the short-order cook (the painting is inscribed to him). Wearing a fedora in the photograph but a black-brimmed cap in the painting, Albert LaBombard lived in the Rockwell family's home as the husband of the family cook.

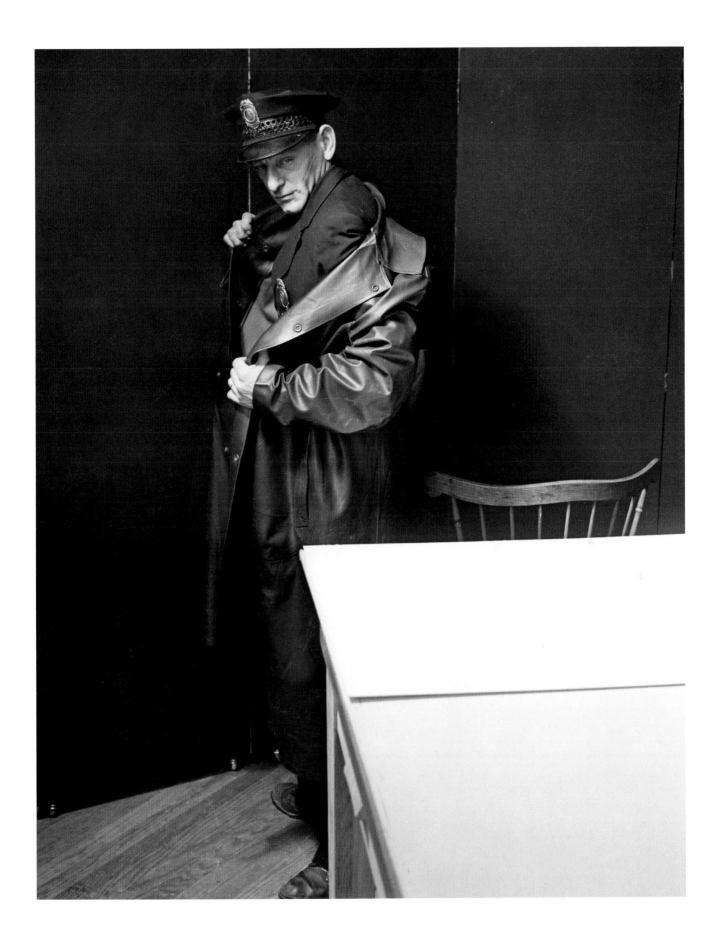

MAN CHARTING WAR MANEUVERS, 1944

Saturday Evening Post cover, April 29, 1944. Private collection

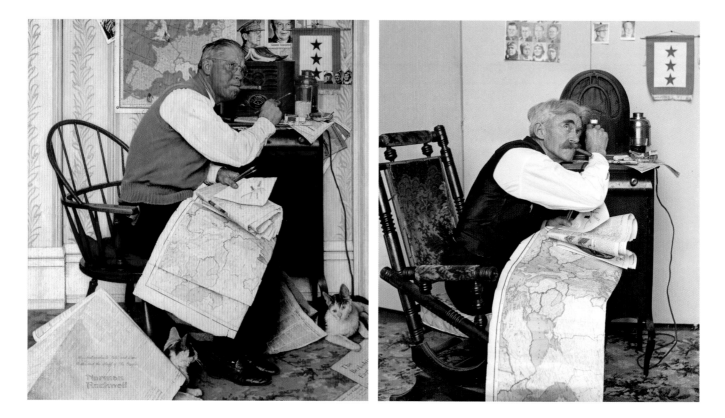

Having put aside the more complex composition of *War News*, Rockwell delivered this simpler version of his concept to the *Post*. The two models Rockwell photographed in his studio possess strikingly different qualities, demonstrating how he distilled and refined his ideas through his photography sessions.

TATTOO ARTIST, 1944

Saturday Evening Post cover, March 4, 1944. Brooklyn Museum

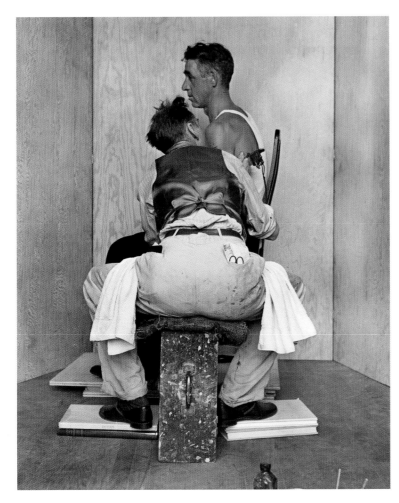

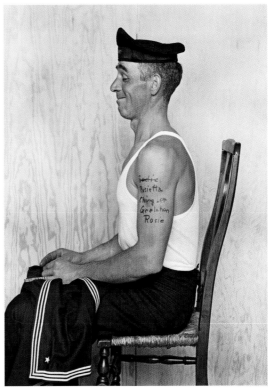

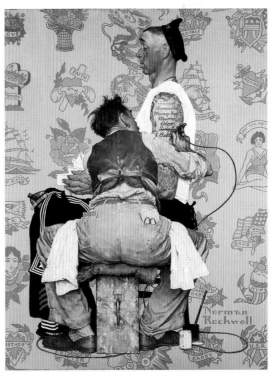

In Arlington, Vermont, Norman Rockwell belonged to a close-knit circle of fellow illustrators. All were drafted into service as models for Rockwell, as were their families, and Rockwell returned the favor. Among these colleagues was Mead Schaeffer, also an artist for *The Saturday Evening Post* and other magazines, who is seen from the rear as the tattoo artist in this image, one of Rockwell's most popular.

LITTLE GIRL OBSERVING LOVERS ON A TRAIN, 1944

Saturday Evening Post cover, August 12, 1944. Memorial Art Gallery of the University of Rochester

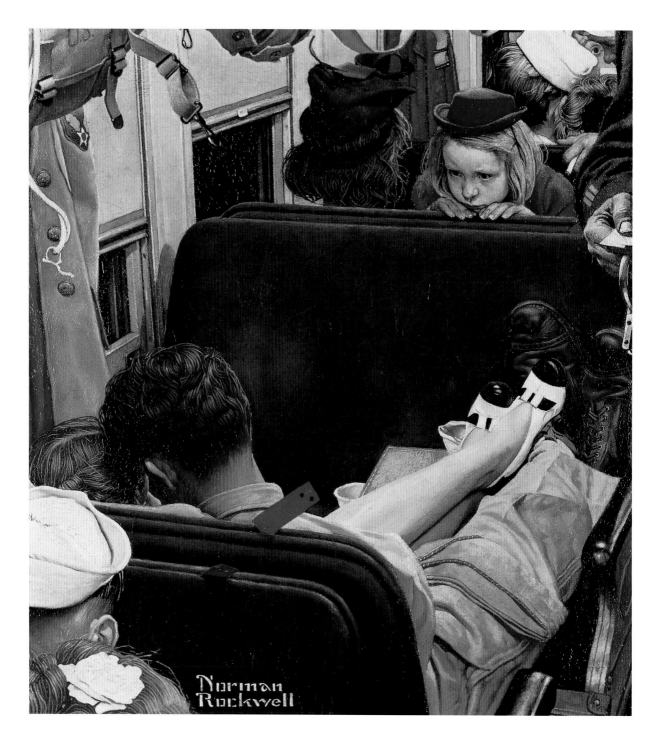

While it was Rockwell's usual practice to stage his photographs in his studio, this image was made in a railroad car left by the Rutland Railroad on an Arlington siding for the artist's use. The winsome Yvonne Cross (featured in the 1947 work *Going and Coming* [p. 86]) gazes at the artist, who stands in for the nuzzling couple who occupies his seat in the final painting.

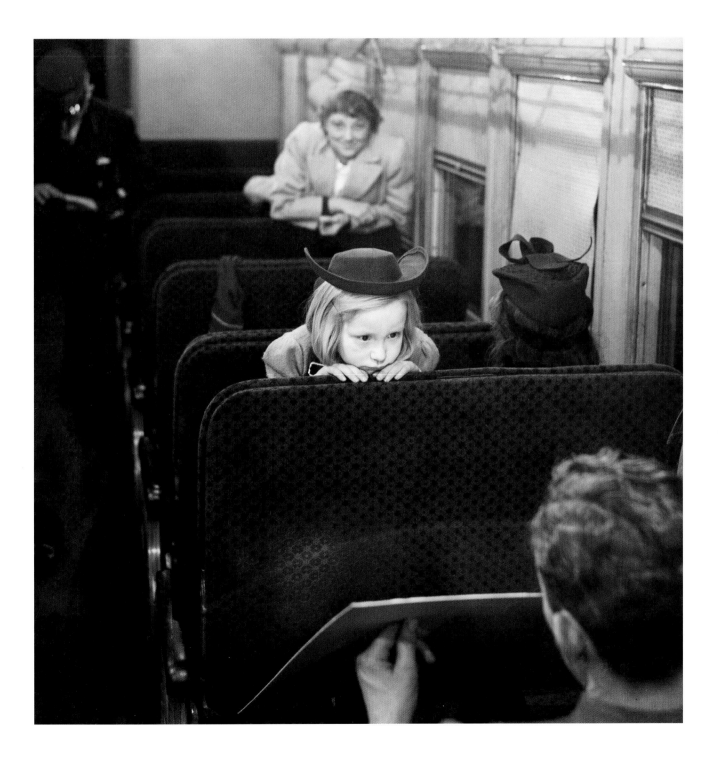

HOMECOMING MARINE, 1945

Saturday Evening Post cover, October 13, 1945. Private collection

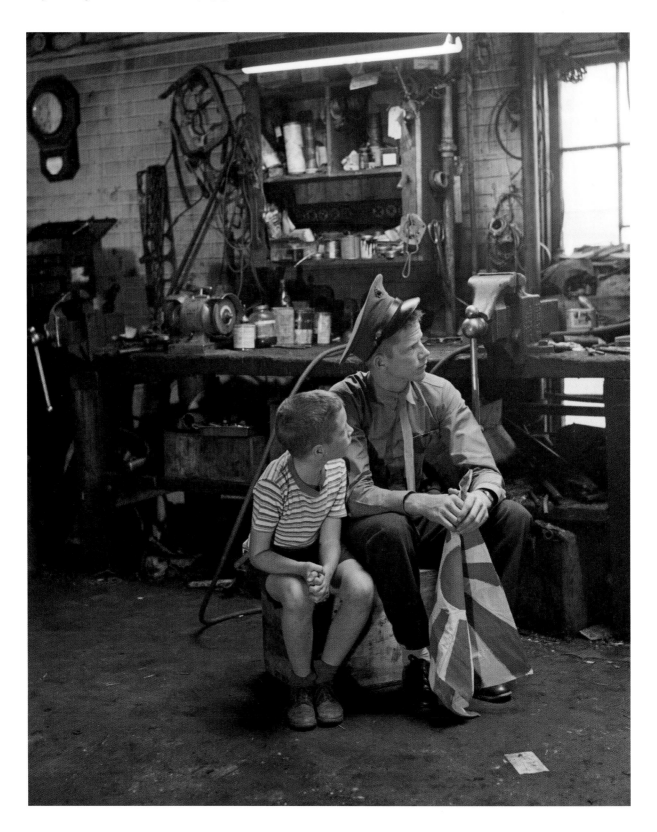

"The setting is Bob Benedict's garage in Arlington. The cop is Nip Noyes, our town clerk and editor of the paper. The marine is named Peters; he earned those ribbons the hard way. I discovered him at a square dance…. Two of my sons are included — Jerry, my oldest, and Peter, my youngest. Bob Benedict stands behind the marine." — NORMAN ROCKWELL

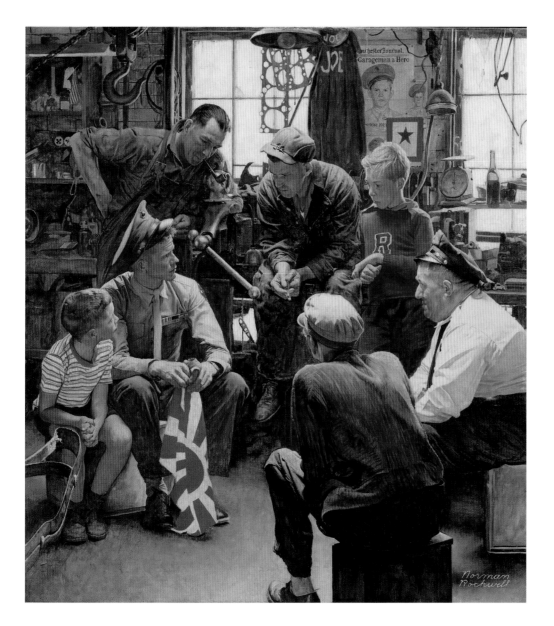

Rockwell photographed the models for *Homecoming Marine* on location. The props, detailed setting, and natural lighting of the garage were ideal for the important story he wanted to tell with this picture, of which the artist was justifiably proud.

One key prop was lacking, however, and was improvised for the sake of the photo session: the Marine's battle-trophy rising sun flag appears to have been hand-painted in order to complete the composition.

BACK TO CIVVIES, 1945
Saturday Evening Post cover, December 15, 1945. Private collection

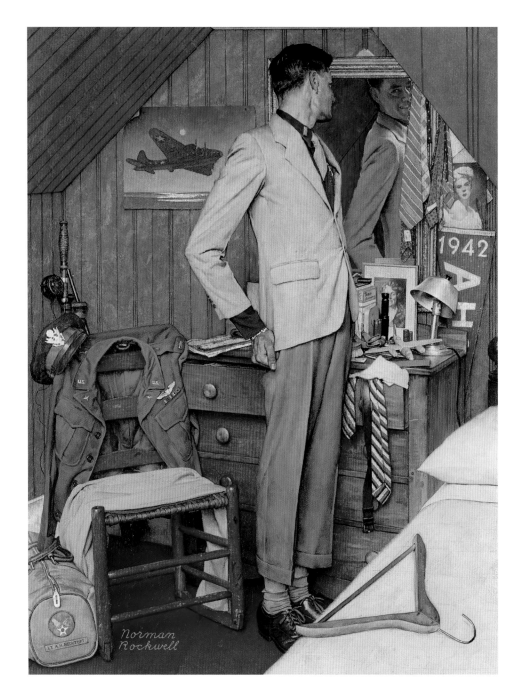

Rockwell photographed other prospective models in the wardrobe he assembled for this *Post* cover before settling on Arthur Becktoft. Air Force Lieutenant Becktoft had just returned home from the war after having been imprisoned in Germany when his Flying Fortress was shot down behind enemy lines. The pilot's actual uniform and name-tagged Air Force valise are among the many props, as is a child's model airplane, a poignant counterpoint to the framed image on the wall of a real Flying Fortress.

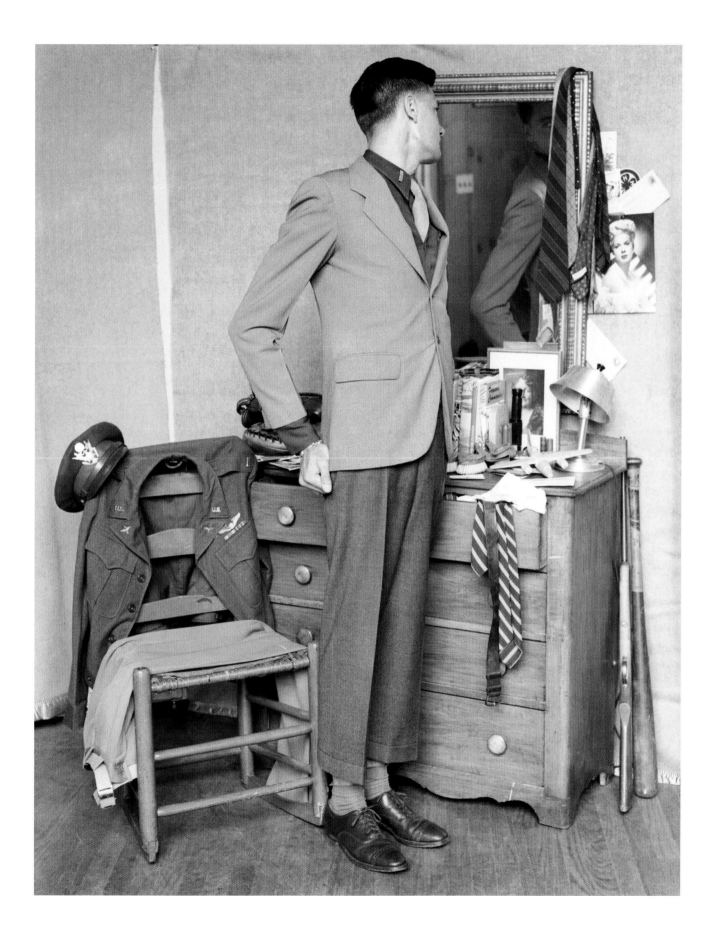

WORLD WAR II 81

WILLIE GILLIS IN COLLEGE, 1946

Saturday Evening Post cover, October 5, 1946

Willie Gillis was Norman Rockwell's G.I. everyman. There were eleven Willie Gillis *Post* covers in all, the first appearing in October 1941 following the first draft call. Rockwell's model, chosen as much for his innocent charm as for his availability due to a draft exemption, was Robert Buck. "I painted him in situations which I thought were typical of an average draftee's life in the Army: receiving a food package from home, sleeping late during a furlough, peeling potatoes," Rockwell wrote. "The series became quite popular and I figured I was set for the duration." But eight covers into the series, Buck enlisted in the Navy, and the resourceful artist based two more covers on earlier photographs of his model.

After World War II Rockwell photographed Buck one last time following his discharge from the Navy. Willie Gillis is attending college on the G.I. Bill, an artillery shell and hand grenade poised on his bookcase.

NORMAN ROCKWELL PREFERRED TO PAINT covers for *The Saturday Evening Post* because they were his own inventions, compositions that told complete stories in a single image. By 1948 he had become almost exclusively a cover artist, and by 1963, when Rockwell ended his long association with the magazine, the *Post* had published an astonishing 321 Rockwell covers.

Surrounded by a supportive community of friends and fellow illustrators, Rockwell's years in Arlington, Vermont (1939–1953), were prolific. During the tenure of Ben Hibbs, who became editor of the *Post* in 1942, and art editor Ken Stuart, Rockwell produced many of his most iconic images, among them *Homecoming Marine*, *Boy in a Dining Car*, *Going and Coming*, *The Gossips*, *Shuffleton's Barbershop*, and *Girl at Mirror*.

GOING AND COMING, 1947

Saturday Evening Post cover, August 30, 1947.
Norman Rockwell Museum, Norman Rockwell Art Collection Trust

"The cover artist, accustomed to filling vertical spaces is glad of a
chance to paint a horizontal picture now and then." — NORMAN ROCKWELL

Going and Coming was the first of a pair of two-panel covers Norman Rockwell painted for the *Post*. He enjoyed the creative possibilities of this before-and-after narrative and relished the rare opportunity to tackle a horizontal composition.

Rockwell photographed a variety of automobiles, but the one he wanted was driven by his postman on his rounds. One day he met the postman at the mailbox and told him to go up to the house where something was waiting for him. There the postman found a check for twenty-five dollars for the use of his car, and when he returned, the car was gone. Rockwell had taken it to be photographed.

Except for the automobile photographs, which could be flipped horizontally to point the cars in the right direction, the models for *Going and Coming* were photographed in Rockwell's studio. He did not deploy his familiar folding screens as backdrops, allowing us a view of his studio furnishings and decorations. Yvonne Cross, from *Little Girl Observing Lovers on a Train* (p. 74), is the young girl with bubble gum, which Rockwell noted brought letters in which "some objected to showing such a 'vulgar performance,'" adding that "a bubble gum firm sent me a whole crate of gum 'in appreciation.'" Cross's real-life father plays her dad. Rockwell was able to use a single photograph for the upper and lower portraits of the impassive grandmother — her expression is unchanged from one panel to the next.

NORMAN ROCKWELL: BEHIND THE CAMERA

NORMAN ROCKWELL: BEHIND THE CAMERA

APRIL FOOL: FISHING, 1945

Saturday Evening Post cover, March 31, 1945.

Copyright © 1945 SEPS

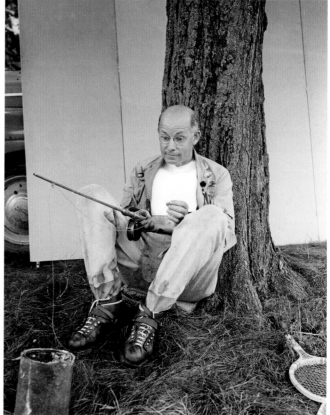

Rockwell was fastidious when it came to the historical authenticity of his props, researching each element to ensure accuracy. Nonetheless, his fan mail often included letters from *Post* readers delightedly pointing out mistakes — real or imagined — he had made in selecting his props. The three *April Fools' Day* covers he painted in 1943, 1945, and 1948 were his revenge. The artist claimed this piece, modeled by fellow Arlington illustrator John Atherton, contained more than fifty intentional mistakes, though he received mail from readers claiming to have identified many more.

SALESMAN IN SWIMMING HOLE, 1945

Saturday Evening Post cover, August 11, 1945.

Copyright © 1945 SEPS

"I like to do a picture which, instead of depicting a single incident or a single moment in time, traces the course of an action over a period of time. Here one can see that the salesman got out of his car, took off his clothes but not his shoes (his feet are tender), spread a newspaper on the grass and laid his glasses on it; then, at the water's edge, took off his shoes, waded in, and, just before submerging, carefully laid his lighted cigar on his shoe, ready to be puffed the minute he emerges from the stream." — *NR*

The photography for *Salesman in Swimming Hole* was done in March, a month too cold in Vermont for an outdoor dip. "George Zimmer, my model for the swimming picture, was an awful good sport. He stripped and I poured several buckets of water over his head to get the effect," explained Rockwell. "The mirror he is holding was intended to show his reflection but this didn't work." The image of the riverbank and automobile were reversed for the final *Post* cover.

EXTRA GOOD BOYS AND GIRLS, 1939

Saturday Evening Post cover, December 16, 1939.

Copyright © 1939 SEPS

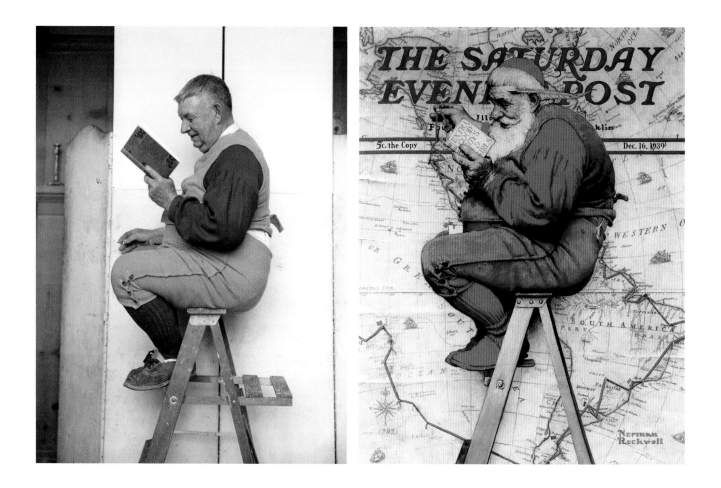

BAKER READING DIET BOOK, 1953

Saturday Evening Post cover, January 3, 1953

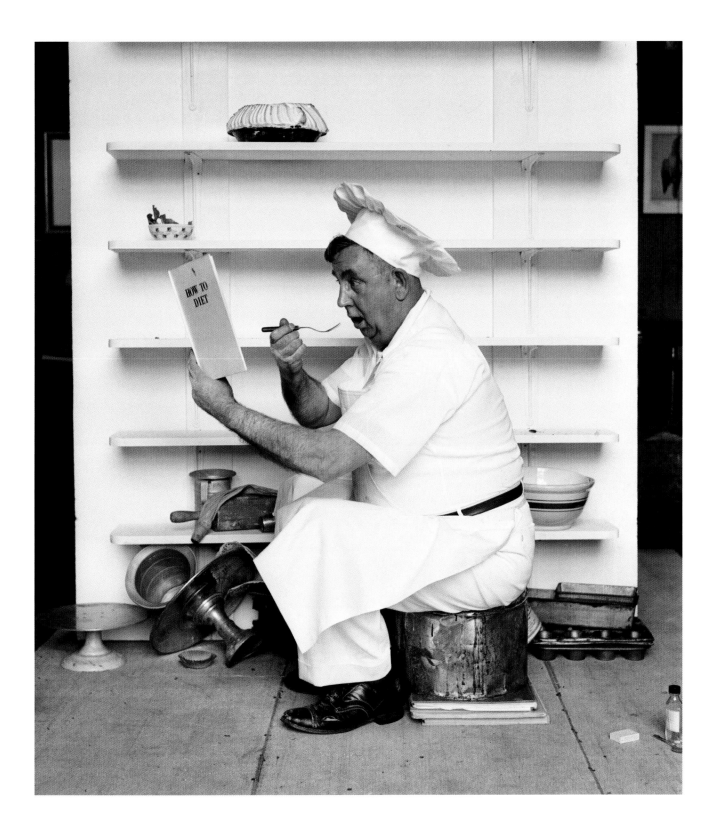

CREATING AUTHENTICITY

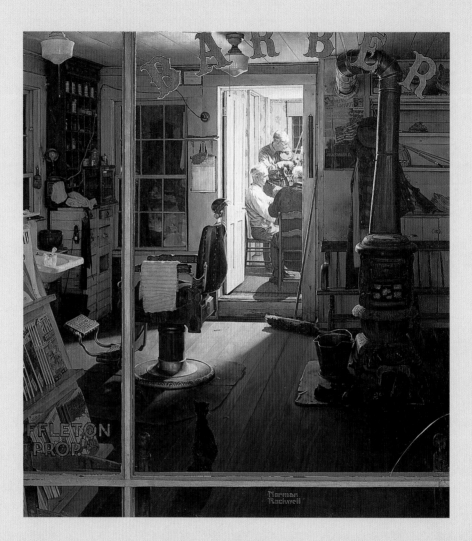

While Rockwell found the perfect settings for works such as *Homecoming Marine* (p. 78) and *Shuffleton's Barbershop* close to home, he was willing to travel any distance for his location photography. He went to New Mexico to photograph a train station for *Breaking Home Ties* (p. 176), the White House for *So You Want to See the President!* (p. 62), the offices of a Missouri newspaper for *Norman Rockwell Visits a Country Editor* (p. 50), and New York City to shoot a Times Square restaurant intended for *Saying Grace* (p. 114). In so doing, Rockwell gained more than photographs of a background that met his demand for genuineness. Experiencing the actual location often suggested ideas he could not have imagined in the studio and that he could later incorporate into his final painting.

SHUFFLETON'S BARBERSHOP, 1950
Saturday Evening Post cover, April 29, 1950. Berkshire Museum

"There were details, accidents of light, which I'd missed when I'd been able to make only quick sketches of a setting. For example in Rob Shuffleton's barbershop in East Arlington, Vermont: where Rob hung his combs, his rusty old clippers, the way the light fell across the magazine rack, his moth-eaten push broom leaning against the display cases of candy and ammunition, the cracked leather seat of the barber chair with the stuffing poking through along the edges over the nickel-plated frame. A photograph catches all that." — NORMAN ROCKWELL

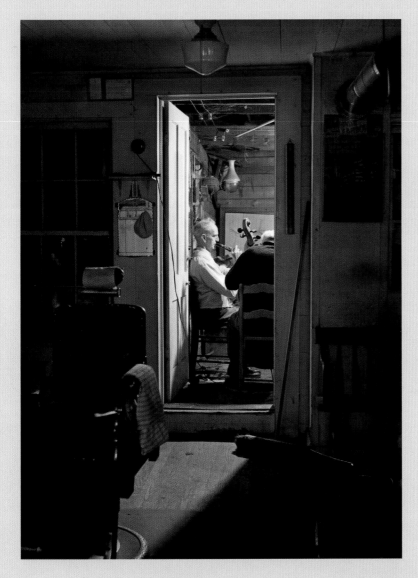

The camera enabled Rockwell to describe his New England barbershop in minute detail. Stacked comic books on the magazine rack, the wood-burning stove, the proprietor's tonsorial tools, and his shotgun, rod, and creel are all persuasive clues to the veracity of his setting. The darkened interior and the illuminated room beyond were painted with such painstaking detail that Rockwell considered adding raindrops to the panes to demonstrate that the view is through a window.

Analyzing *Shuffleton's Barbershop* in 2000, art historian Robert Rosenblum pointed to the "almost humorous marriage" of the art of the seventeenth-century Dutch realists with that of a much later Dutch painter, Piet Mondrian, renowned for his grids.

BOY IN A DINING CAR, 1946

Saturday Evening Post cover, December 7, 1946. Norman Rockwell Museum

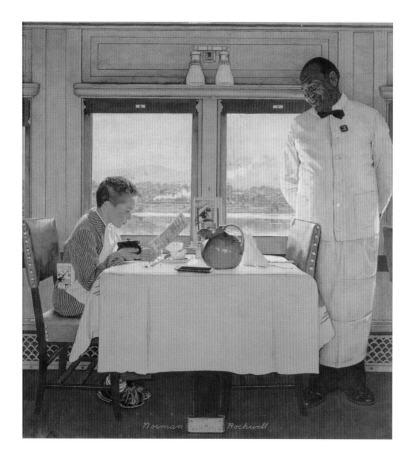

Seventy-three photographs survive from the series for *Boy in a Dining Car*. Four models were photographed in the role of the young boy. Rockwell's youngest son, Peter, who was chosen for the final work, was photographed both in the Arlington studio and in the dining car on "the hottest day of the year," he recalls. "My father finally got me to pose by promising to take me to FAO Schwarz and buy me anything I wanted if I would just calm down and pose and stop complaining about the heat—and he did it."

The model for Rockwell's waiter was a veteran New York Central dining car employee. The narrow confines of a sidetracked New York Central Railroad car prevented the photographer from positioning his camera far enough from the waiter to capture his full stature in a single shot.

"I do not work from any single photograph exclusively but select parts from several poses, so my picture which results from the photographs is a composite of many of them." — NORMAN ROCKWELL

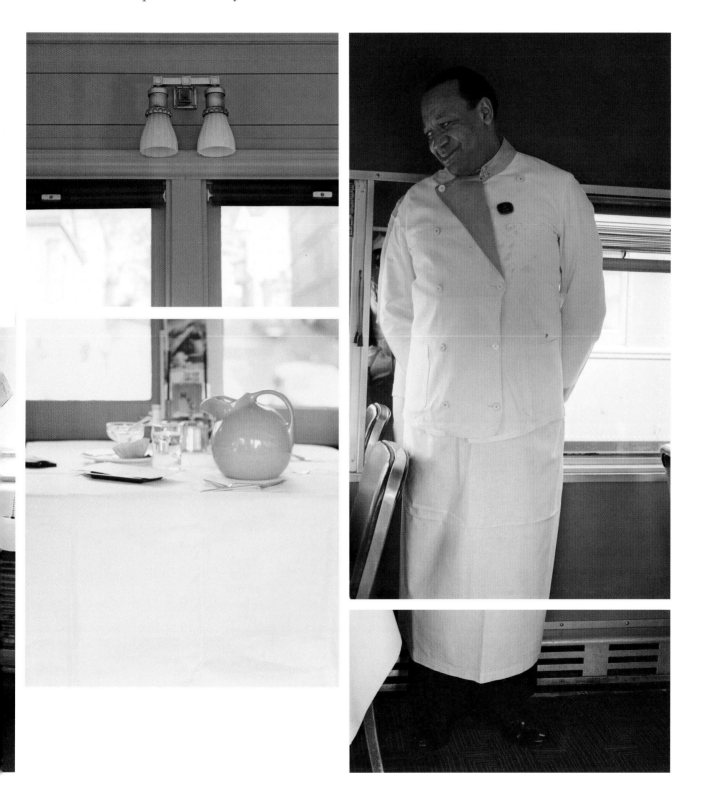

FIXING A FLAT, 1946
Saturday Evening Post cover, August 3, 1946. Private collection

Norman Rockwell took Gene Pelham on location to shoot dozens of photographs for the setting of *Fixing a Flat* but photographed the models in his studio. Patty Schaeffer, in this image, was the daughter of Rockwell's friend and fellow *Post* artist Mead Schaeffer (p. 73).

FRAMED, 1946

Saturday Evening Post cover, March 2, 1946.
Taubman Museum of Art

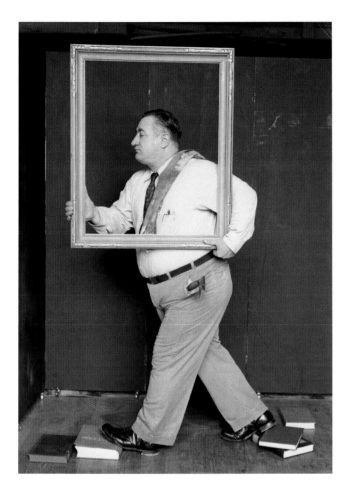

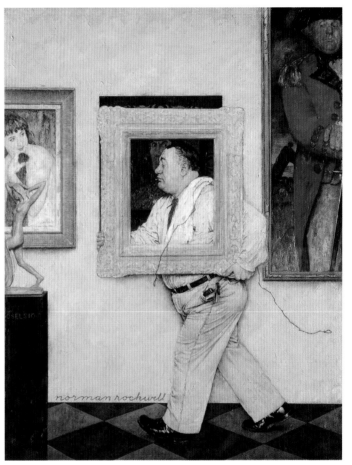

When Rockwell wanted to portray a walking or running figure, it was unreasonable to expect a model, particularly an amateur, to hold so awkward and unstable a pose, so he devised a repertoire of tricks to mimic the appearance of motion. He often used books pulled from studio shelves as blocks to obtain the precise angle of a walking foot while relieving stress on the model. Books scattered at the feet of the museum guard suggest Rockwell had experimented with varying thicknesses to produce the right effect.

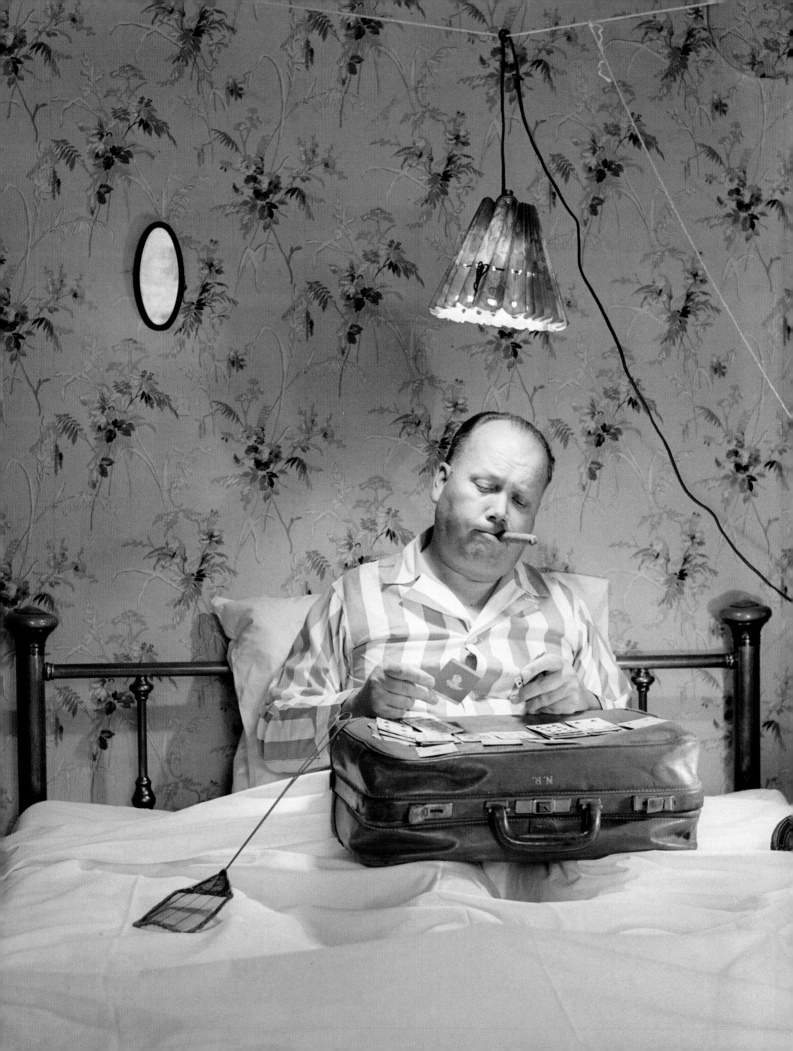

SOLITAIRE, 1950

Saturday Evening Post cover, August 19, 1950.

Copyright © 1950 SEPS

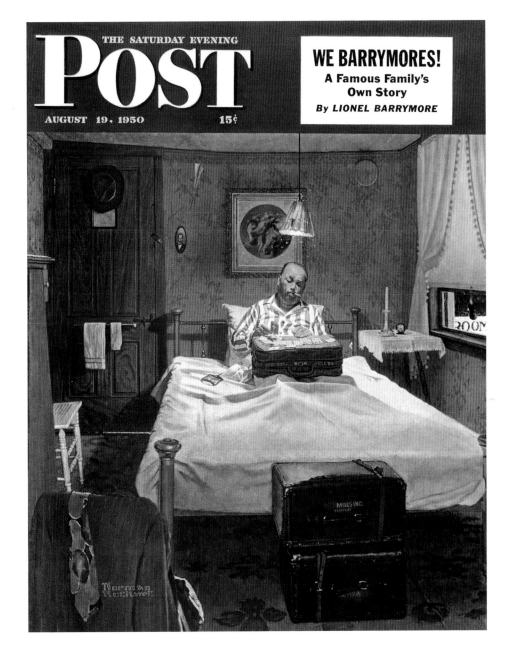

Rockwell and his photographer Gene Pelham traveled to Woodstock, New York, to photograph his model. The artist's valise, stamped *N.R.*, stands in as the traveling salesman's improvised card table.

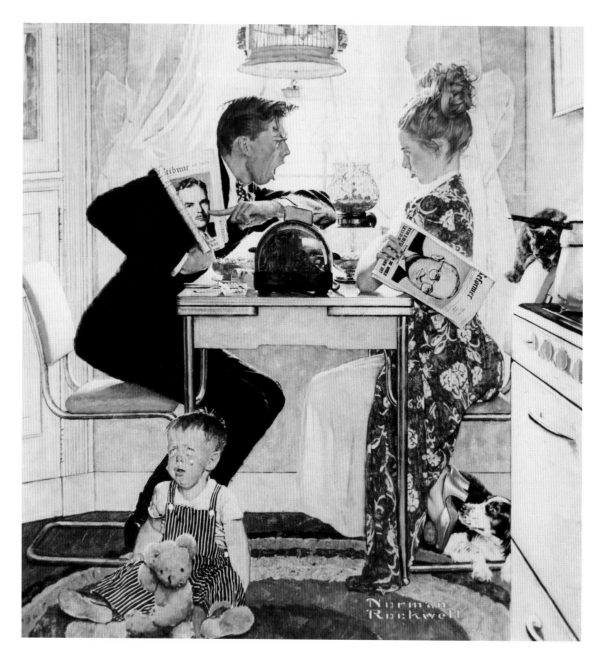

Domestic political discord is one of many themes Rockwell reprised over the years. He had interpreted it twice before, in 1920 and again in 1944. Over copies of the *New York Herald Tribune* and the *Brattleboro Reformer,* the couple argue about their preferences in the 1948 presidential election: he's filibustering for Dewey while she supports Truman. Rockwell later decided that the male subject in this photograph was the wrong type for the wife. When friends confided that a "girl as cute as she is would not have a husband like him," he found a new male model.

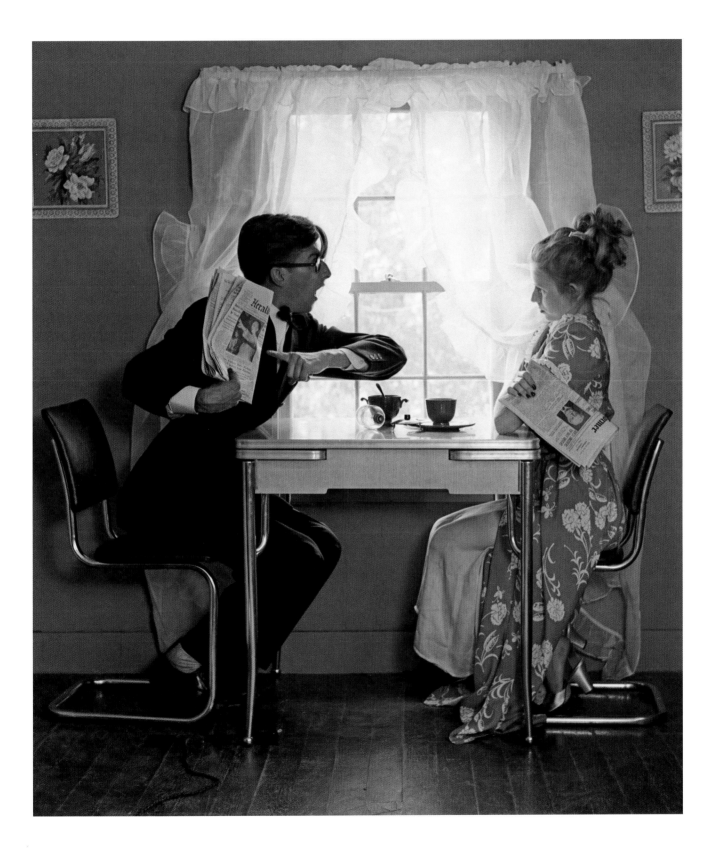

THE GOSSIPS, 1948

Saturday Evening Post cover, March 6, 1948. Private collection

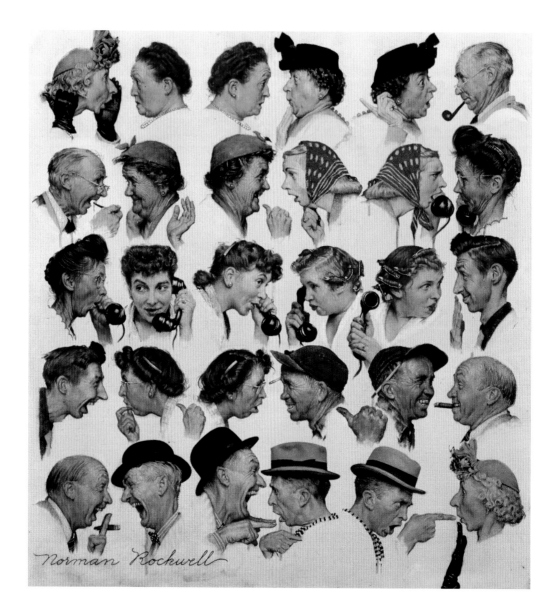

"I used my neighbors in Arlington as models for the gossips cover. 'Gee,' they said when I showed them the sketch, 'we're not gossips, are we?' So I put Mary and myself into the cover to avoid any suspicion that I was insulting my neighbors. Still, one woman was very angry when the cover came out. I dare say the proverbial shoe fit a bit too well." —NORMAN ROCKWELL

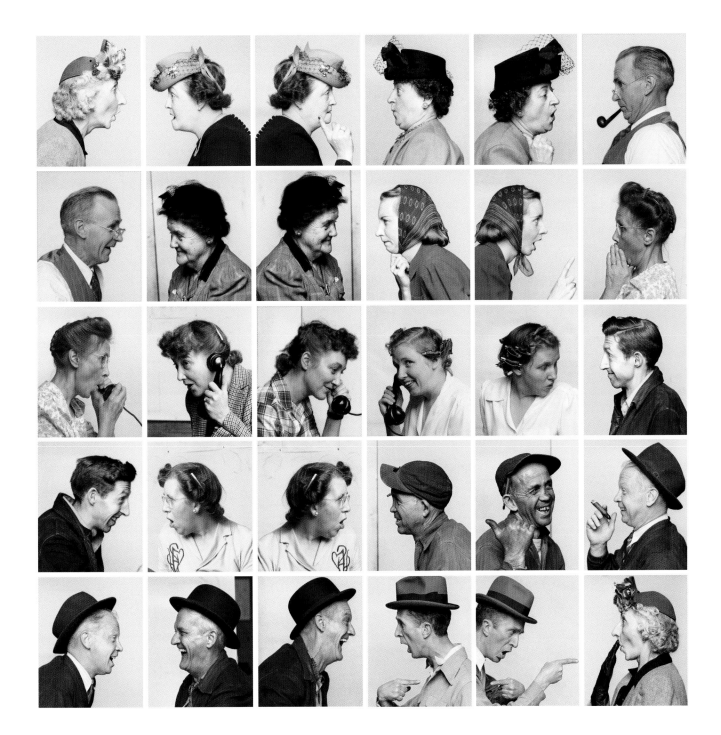

According to Norman Rockwell's *Post* art editor, Ken Stuart, the incubation period for *The Gossips* was thirteen years. Rockwell had painted the theme several times before, notably as a 1936 *Ladies' Home Journal* illustration and as covers for *LIFE* (1922) and *The Saturday Evening Post* (1929). The ambitious 1948 version began with just two gossips, then ten, and finally developed into an animated grid of fifteen different subjects; Rockwell himself poses in the second and third to last frames in the bottom row. He would use this innovative cinematic approach for three more *Post* covers, including *Day in the Life of a Little Boy* and *Little Girl* (pp. 126 and 122).

Presented with the finished painting of *The Gossips*, the *Post*'s editor, Ben Hibbs, reportedly questioned whether Rockwell's characters could possibly have been real. His doubts were allayed only when the artist produced his working photographs.

TWO PLUMBERS, 1951

Saturday Evening Post cover, June 2, 1951.

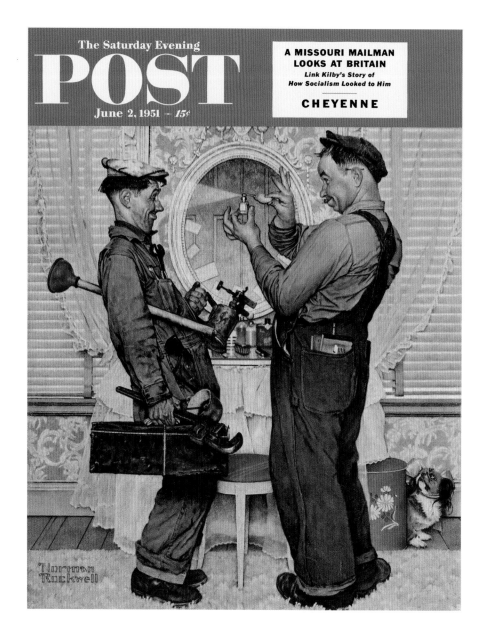

Norman Rockwell found the perfect stand-ins for Stan Laurel and Oliver Hardy in Gene Pelham and Don Winslow. Winslow was one of six students who were offered internships with the artist in the summer of 1950. At summer's end Winslow stayed on as Rockwell's apprentice, living in a one-room schoolhouse the artist had once used as a studio. He is seen in many photographs from this period and as a model in *Saying Grace* (p. 114).

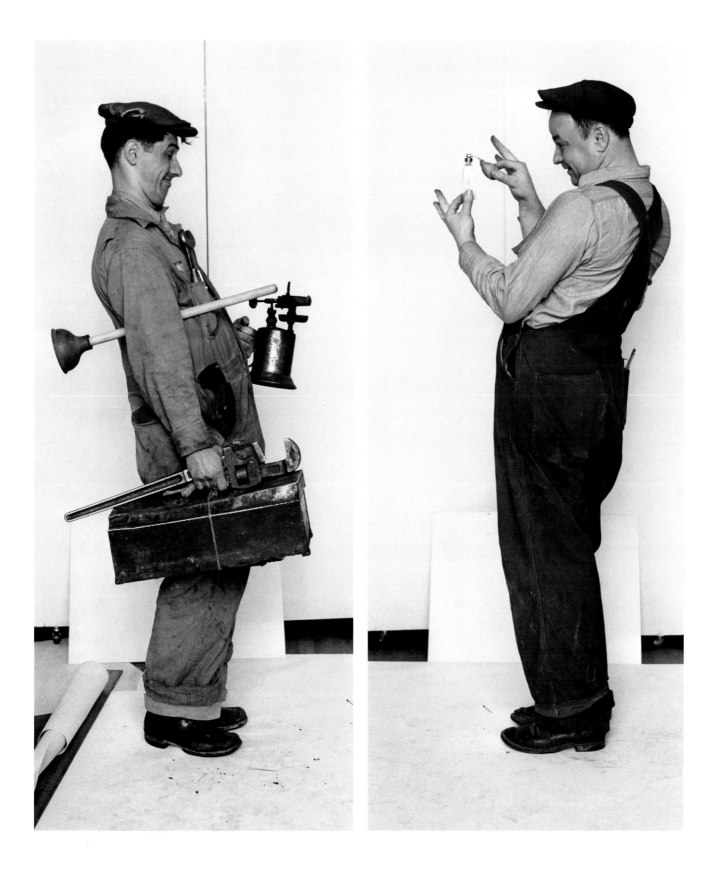

THE DUGOUT, 1948

Saturday Evening Post cover, September 4, 1948. Brooklyn Museum

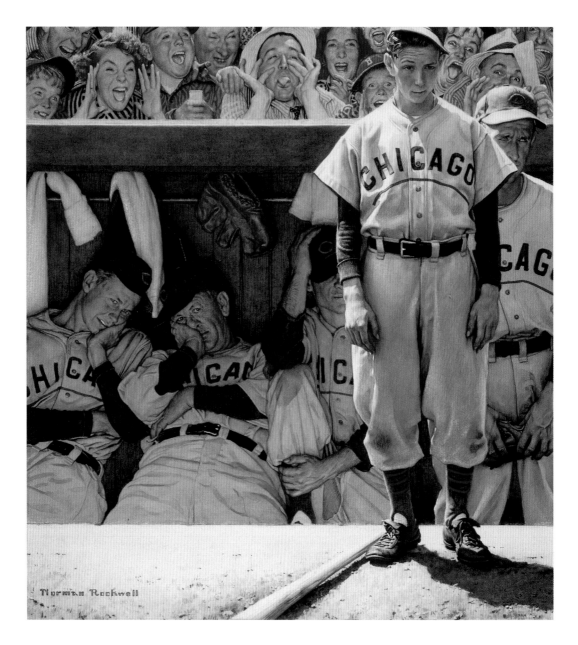

Rockwell traveled to Braves Field in Boston to photograph fans in the stands during a doubleheader between the Boston Braves and the Chicago Cubs. Additional images taken in the Arlington studio were used to fill out the jeering crowd. Ardis Edgerton, the daughter of Rockwell's next-door neighbors Jim and Clara Edgerton, razzes the camera as she trades grimaces with the artist, who can be found in the upper left corner of the finished watercolor. "I inherited a lot of his dress-up shirts when his collars wore. Bobby socks, saddle shoes, and long tails" were the style of the day, Ardis remembers, "so I wore his shirts all through high school," A frequent Rockwell model, she believes today that "he used me as a model more than he needed me. I think he did it when he saw I needed school clothes or new shoes."

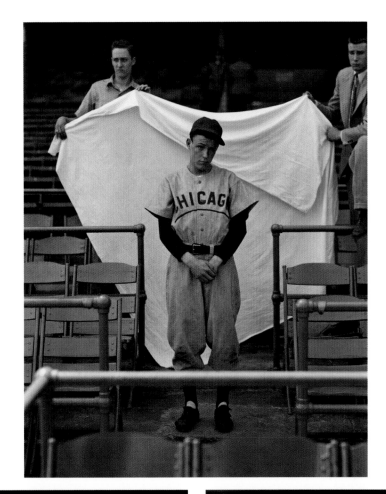

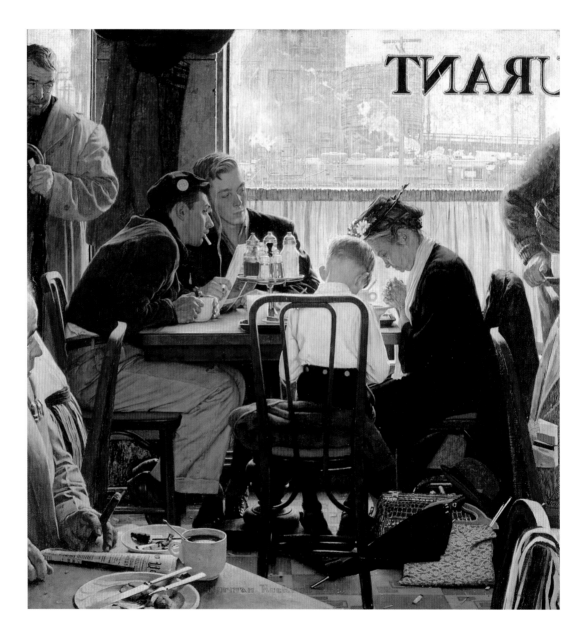

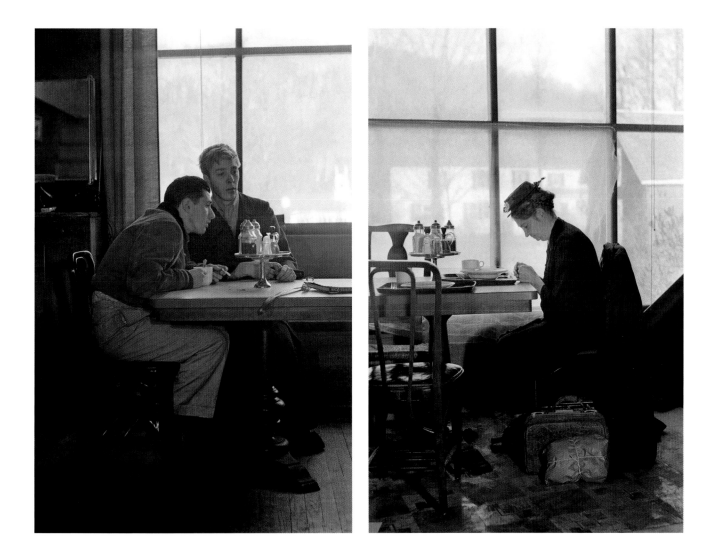

Like many quintessential Rockwellian moments, *Saying Grace* isolates an instant of quiet contemplation. The artist originally intended to set this work, one of his most popular, in New York City. He went so far as to travel to Manhattan to photograph models as passersby to be glimpsed through the window of a Times Square restaurant in which this incongruously spiritual moment was to be set.

Abandoning the concept, Rockwell relocated the scenario to a train station diner. He directed extensive photography of a railroad yard in order to accurately render the setting. For the interior, photographed in the Arlington studio, Rockwell had a set of tables and chairs trucked to Vermont from a New York City Automat. Jarvis Rockwell is seated at the center table along with Don Winslow. The elderly model opposite, hands folded in prayer, did not live to see the *Post* cover for which she had posed.

SODA JERK, 1953

Saturday Evening Post cover, August 22, 1953. Columbus Museum of Art, Ohio

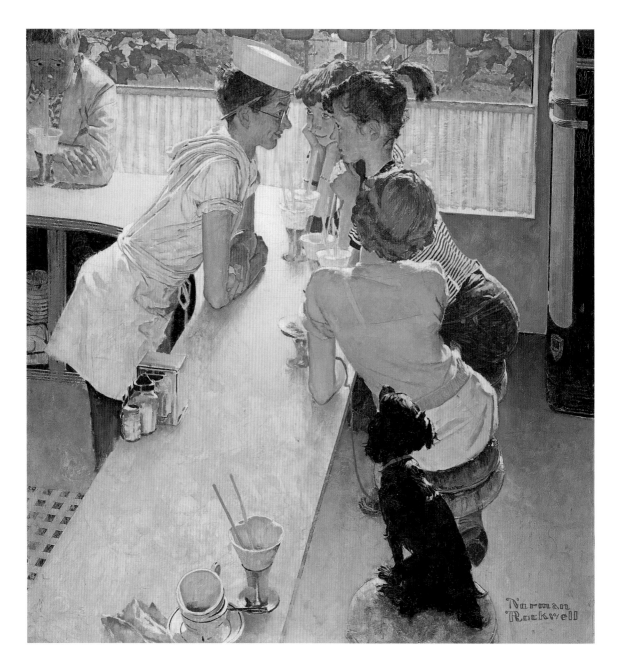

Rockwell brought his son Peter and a group of classmates home from school in Putney, Vermont, for the weekend to be photographed for *Soda Jerk*. The idea is based on Peter's own summer job experience working in a soda fountain, which made him the fitting choice for the role of counterman. Rockwell photographed each of his subjects individually and combined them for the final composition, placing them in a setting assembled from photographs taken in a nearby soda fountain.

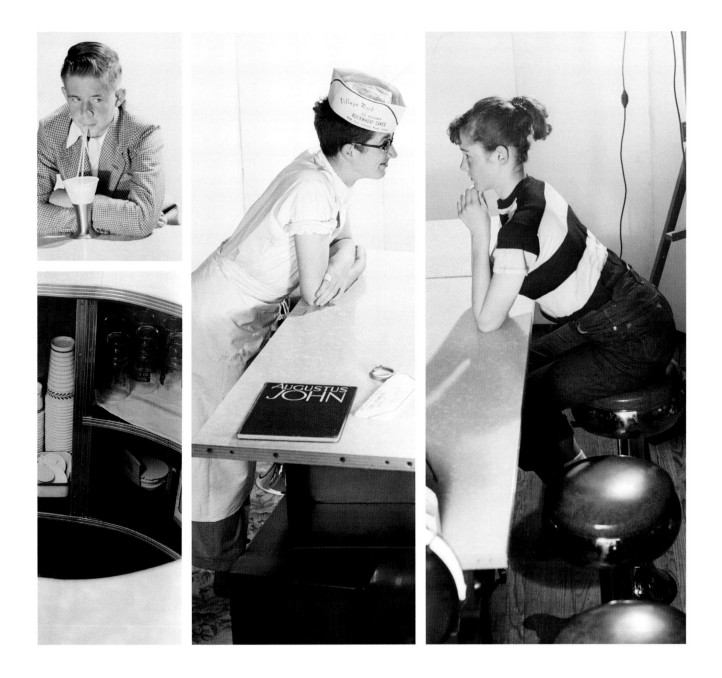

BOY PRACTICING TRUMPET, 1950

Saturday Evening Post cover, November 18, 1950

In the 1940s Norman Rockwell befriended the American folk artist Grandma Moses. Then in her eighties, Grandma Moses lived in Eagle Bridge, New York, just over the Vermont border from Arlington. Rockwell admired the honesty of her work and in tribute created the slipcovers for the chair in this image, basing the design on one of her paintings.

THE FACTS OF LIFE, 1951

Saturday Evening Post cover, July 14, 1951

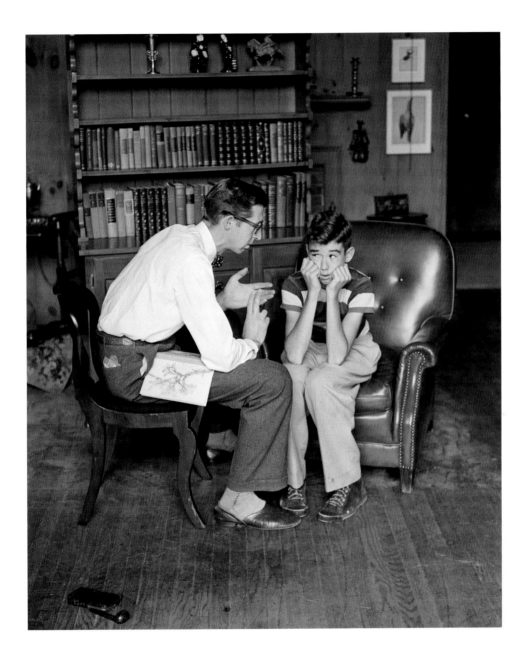

Norman Rockwell spent eleven months struggling with *The Facts of Life*. An uncomplicated composition, the birds and bees saga proved a difficult one for the artist for whom the subject may have struck a nerve. Rockwell photographed multiple fathers and sons in various poses and settings, and his son Peter recalls that "he did it four times before he got a version that he found satisfactory."

THE ARTIST AS DIRECTOR

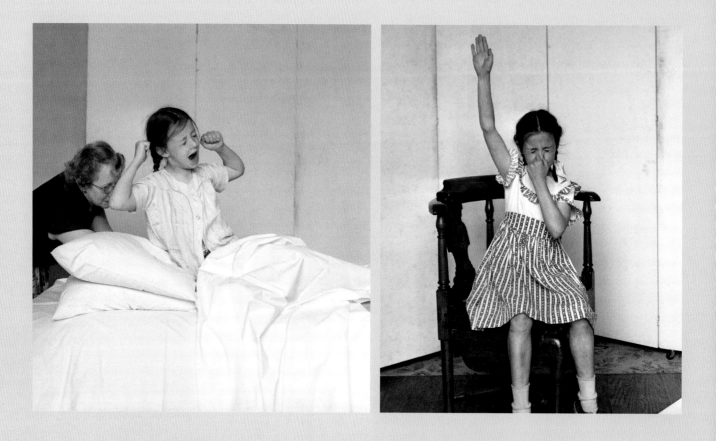

Norman Rockwell assumed the role of director to get the gestures and expressions he needed for his pictures. The first step was to impart his idea to his models. Mary Whalen, who posed for *Day in the Life of a Little Girl*, recalled that Rockwell would explain by showing her his sketch, saying, "This is the story. This is what we're going to do today." After acting out the part himself, he would guide his models until, under his direction, they matched the pictures in his imagination.

The extensive photography (170 negatives exist) for *Day in the Life of a Little Girl* provides a window on Norman Rockwell's directorial method and captures many of his techniques. Mary Whalen's mother lifts her braids while a second pair of hands extends her bathing suit and cap to achieve the

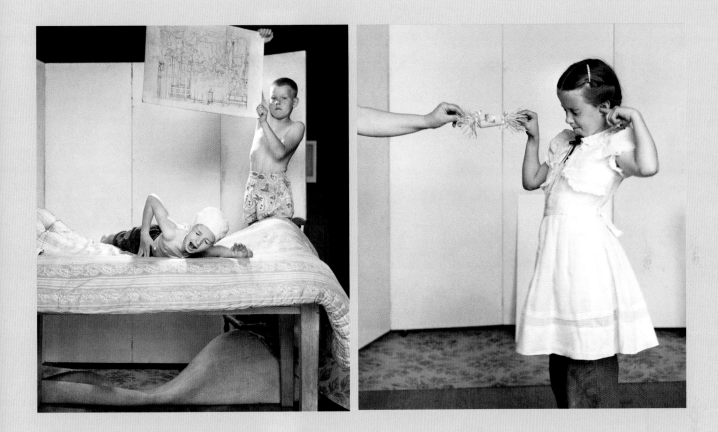

effect of motion as the young girl rushes off to school. Her eyebrows are raised as high as they can go — an essential talent for any Rockwell model. In the image of Whalen swimming (not used in the final composition), Rockwell has positioned her on a table to allow the camera to view her at water level.

Successive photographs reveal a gamut of emotions as she skillfully followed the artist's instructions given "offstage." Mary strikes emotions of excitement, disdain, concentration, and joy with the flair of a trained actress coached by a talented director. Mary Whalen was "the best little-girl model I ever had," Rockwell said. "I am sorry to say that she has since grown up."

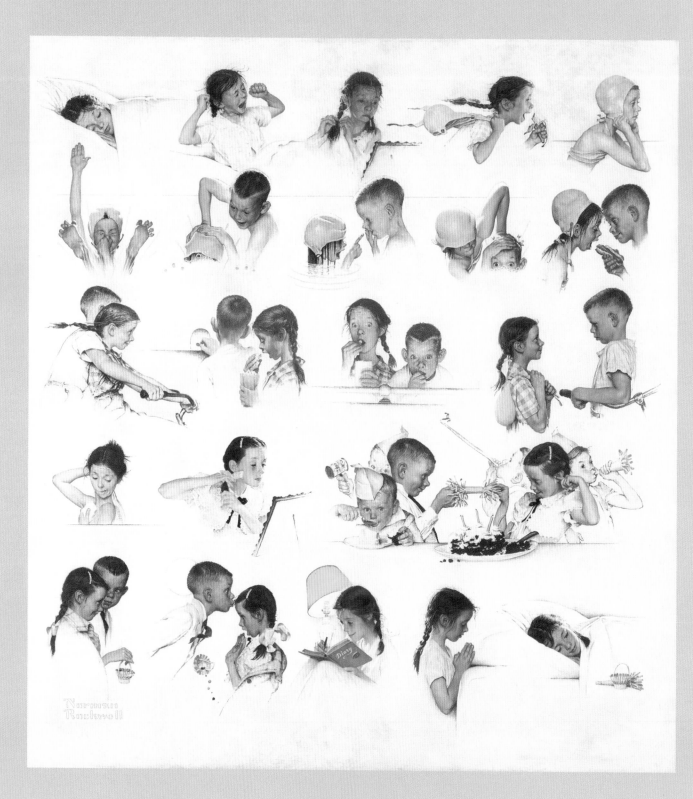

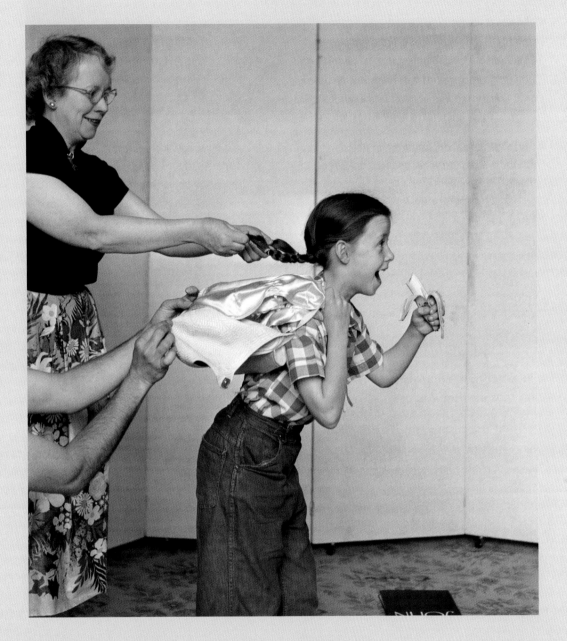

Mary Whalen first met Norman Rockwell at an Arlington high school basketball game in which Norman's son Tom was playing. She had asked her father for a soda "and with that here comes a Coke over my shoulder," remembers Mary. "I hesitated, and my parents said, 'Thank you very much' for me, and I took it." (Whalen's father was Rockwell's lawyer and they knew each other well.) "After the game my parents…introduced me to him and he asked, 'How would you like to pose for me?'"

Today, Whalen remembers the "absolute focus" of her studio sessions. "When we were in the studio there were no interruptions….He made it very clear that this was work and that you were important."

Mary's first modeling session was for a Plymouth advertisement (p. 144). Soon after, Rockwell asked her to pose for a weeklong project and requested that her mother also attend. "I was the kind of a youngster who loved new adventures, so I saw this as something potentially fun." Rockwell had purchased a party dress for his

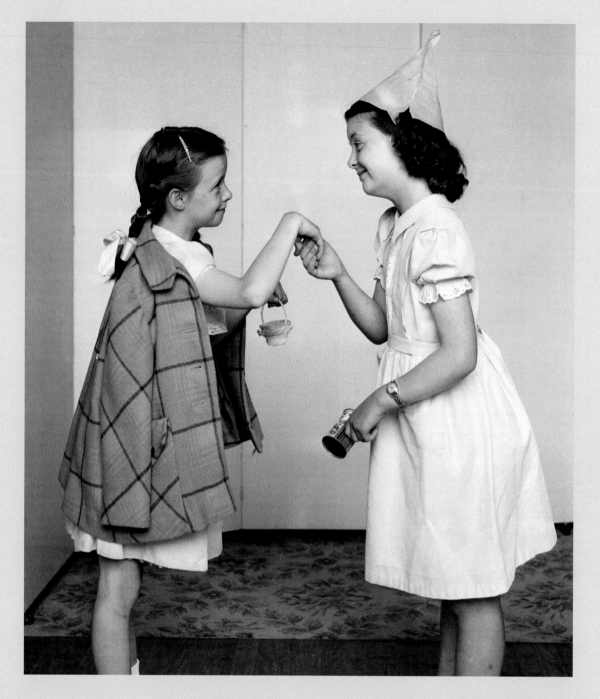

model to wear as well as a two-piece bathing suit with which she was less than comfortable (but still owns), recalling that "I was shocked — it was just a little bit beyond me."

The photographs for *Day in the Life of a Little Girl* were shot in sequence. Arriving the first morning, Rockwell messed up Mary's neatly done hair for the frame in which she is waking up. "He would sit me up and…

pose me and have my mother hold me. He'd put my arms exactly the way he wanted them. He would stand a few feet away and say, 'Do this…no, no, no. Try this. No,' and then finally…he'd say 'Get it. Get it!' and Gene Pelham would snap the picture." The first six pictures in which Mary appears alone were shot the first morning. The next day she was joined by Chuck Marsh, her partner for the rest of the series. For the party image they were joined by Mary's twin brother and by Chuck's

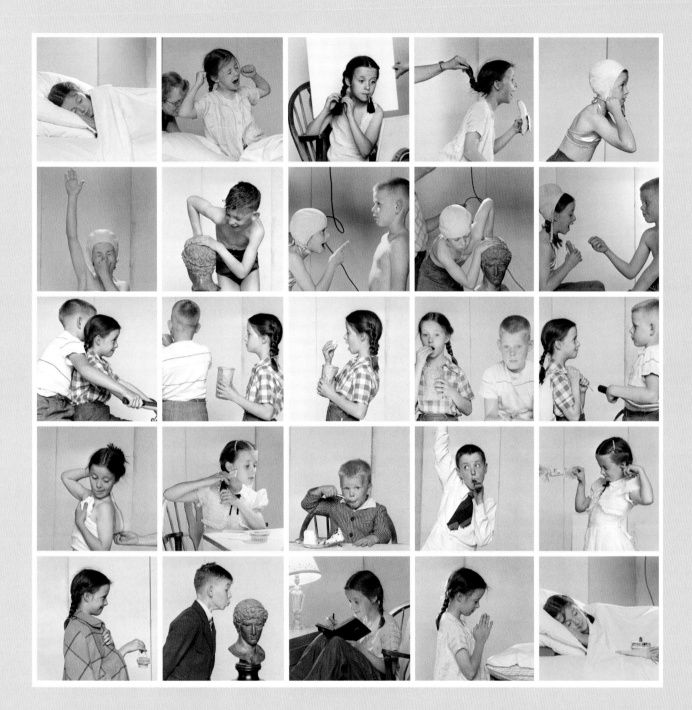

younger brother, who, Mary recalls, was "practically uncontrollable. He was ready to eat the cake and the ice cream immediately. As I recall, there was a little shortness of temper that day."

Mary Whalen sheds light on an image omitted from the final work in which she says good-bye to the party's hostess. "That is in the original charcoal. Later that summer, almost to the deadline that he had to get this picture sent out, he remembered that in the *Day in the Life of a Little Boy* he got criticism that the little boy did not stop to pray. So he called up and said, 'You've got to get Mary down here.' So we went right down, and he said to me, 'Mary, kneel like you were saying your night prayers.'...The only time he ever told me to do something all by myself."

DAY IN THE LIFE OF A LITTLE BOY, 1952

Saturday Evening Post cover, May 24, 1952.

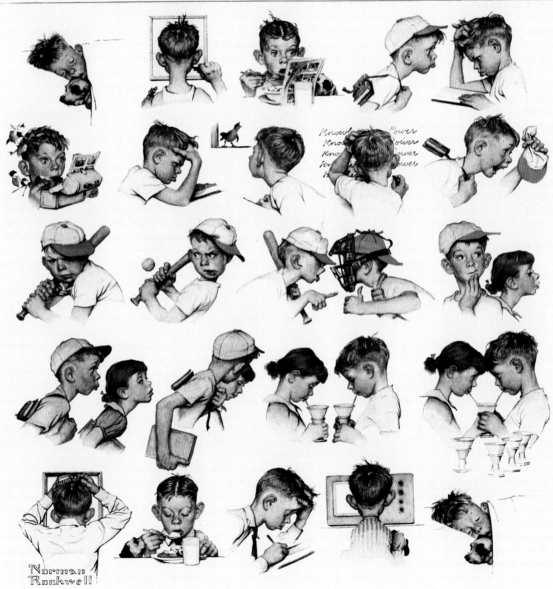

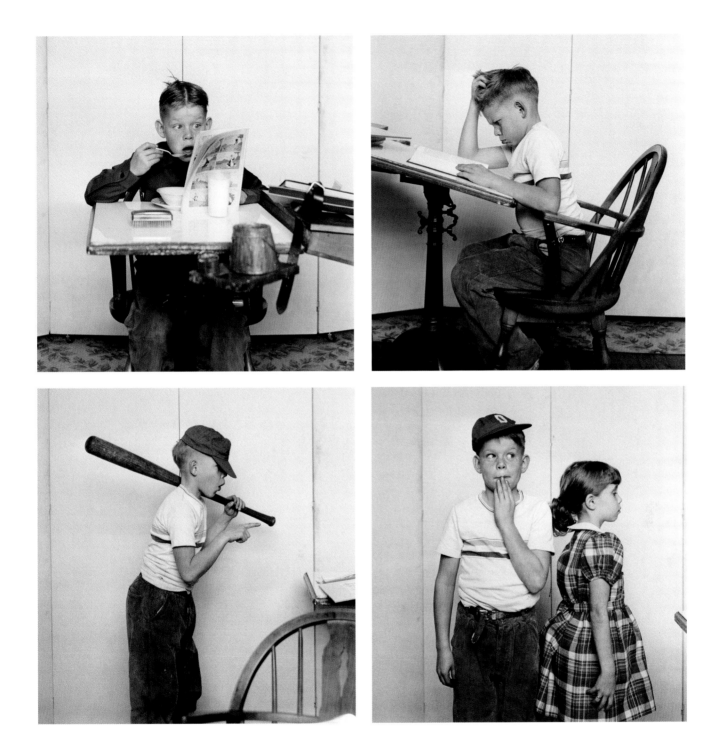

Rockwell felt that this was the more successful of the pair of covers that followed a young boy and girl through the events of a day "because a little boy leads a more active and varied life than a little girl." The original canvas of *Day in the Life of a Little Boy* was donated to a community group raffle where it sold for fifty cents. Its whereabouts are unknown today.

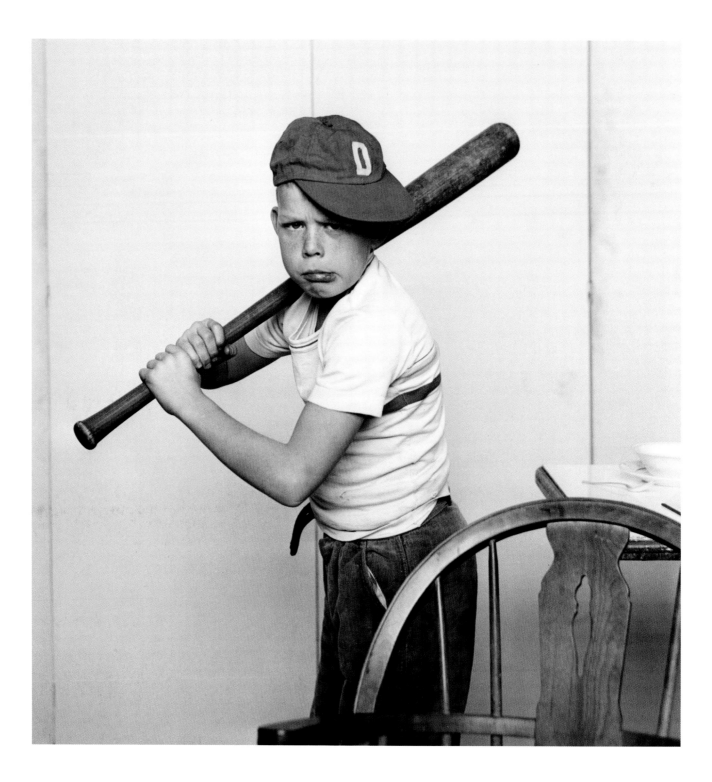

128 **NORMAN ROCKWELL:** BEHIND THE CAMERA

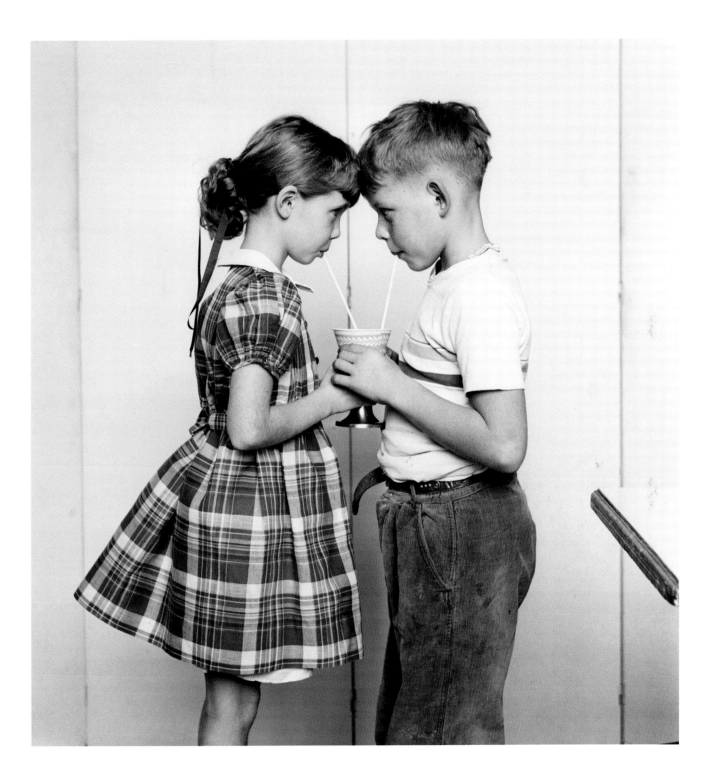

GIRL WITH BLACK EYE, 1953

Saturday Evening Post cover, May 23, 1953. Wadsworth Atheneum Museum of Art

"Ironically," the model recalls, "I had had an encounter with the principal that day!" After a school field trip, "there was a note on the desk that said, 'Please send Mary Whalen to the principal's office'…and I started to cry. My brother, Peter, said to me, 'I'll go with you,' so we walked hand in hand to the principal's office, and I'm trying to control myself. The principal said, 'Mrs. Rockwell is going to pick you up after school tonight and your mother has given you permission.' When I get down to the studio, Norman tells me I'm sitting outside of a principal's office! Of course, I'm just shaking inside. Norman thought this was the funniest thing—he was just howling."

It took three or four sessions to get the photographs for *Girl with Black Eye* just right, and Whalen recalls being allowed to go to Rockwell's studio by herself. "He started right in. I sat there, and he started getting me to make that grin. Being a New Englander I tend to be a little reticent, so he had to really work hard to get that laugh out of me. Eventually he was down on the floor banging his hands trying to get me to laugh."

"The first two times I posed we didn't worry about a black eye. I think he thought he would just be able to stick that on. He [put] charcoal on my eye and that didn't work. Then we did make-up—that didn't work. The black eye was the hardest thing [in] that picture. It had to be just perfect." The solution for Rockwell was to copy a genuine black eye, but he was unable to find one locally. The *Berkshire Eagle* ran a story about his search, and when the national wire services picked it up he soon had more offers than he could handle.

Arriving for a modeling session for *Girl at Mirror* (p. 134), her last before Norman Rockwell left Arlington, Mary remembers that "the Black Eye picture was on the easel, and Norman said, 'Oh, Mary, go look at the picture of you… and tell me what you think.' I didn't know what to say. I think for the first time I realized that was a picture of me."

WALKING TO CHURCH, 1953
Saturday Evening Post cover, April 4, 1953

Small-town life is popularly thought to be the focus of Rockwell's work, but many of his *Saturday Evening Post* covers are set in America's cities. The artist later criticized his choice to caricature the earnest family walking to church through their urban neighborhood. While many of his works from this period are rendered with a clear-eyed naturalism, on occasion he couldn't resist the temptation to exaggerate his characters' features for comic effect, possibly to leaven the sentimentality of his theme.

CHEERLEADERS, 1952

Saturday Evening Post cover, February 16, 1952

The center cheerleader, on whose face the devastation of her team's loss is eloquently written, is an alternate who does not appear in the final work. Photographs of the many models Rockwell passed over are fascinating. They often strike radically different emotional chords than the figures in the final work, reaching for expressions that make for wonderful photographs in their own right (see pp. 135–136 for more examples).

GIRL AT MIRROR, 1954

Saturday Evening Post cover, March 6, 1954. Norman Rockwell Museum,
Norman Rockwell Art Collection Trust

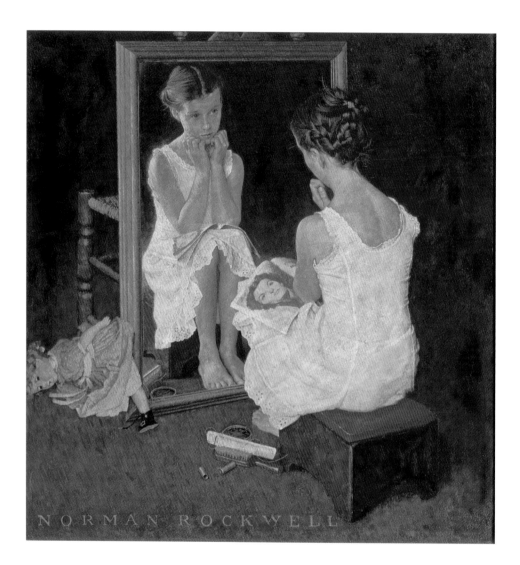

One of his most evocative images, *Girl at Mirror* was among the last projects Rockwell photographed before leaving Vermont. The images approach the painting for their poignancy, and in one way perhaps surpass it. Rockwell would later comment that he regretted adding the magazine opened to a picture of Jane Russell in the young girl's lap; it is absent from the touching photographs of Mary Whalen.

Rockwell auditioned at least three other models for *Girl at Mirror* before selecting Mary. "I did not understand what this picture was about," she remembers. "Norman told me, 'So,

Mary, you've outgrown your doll.' Inside I'm saying to myself I never had a doll — I was a real tomboy. And he said, 'You're dreaming about putting on lipstick and becoming a beautiful woman,' and I hadn't thought about a tube of lipstick in my whole life....I wasn't connecting. He said, 'I can remember looking at myself. You want to be something beautiful in your life — dream about the wonderful person you're going to become.' That's how I was able to get into that picture.

"When [I] walked in the studio there was a mirror and a little stool that I sat on, and he told me what to do. He might

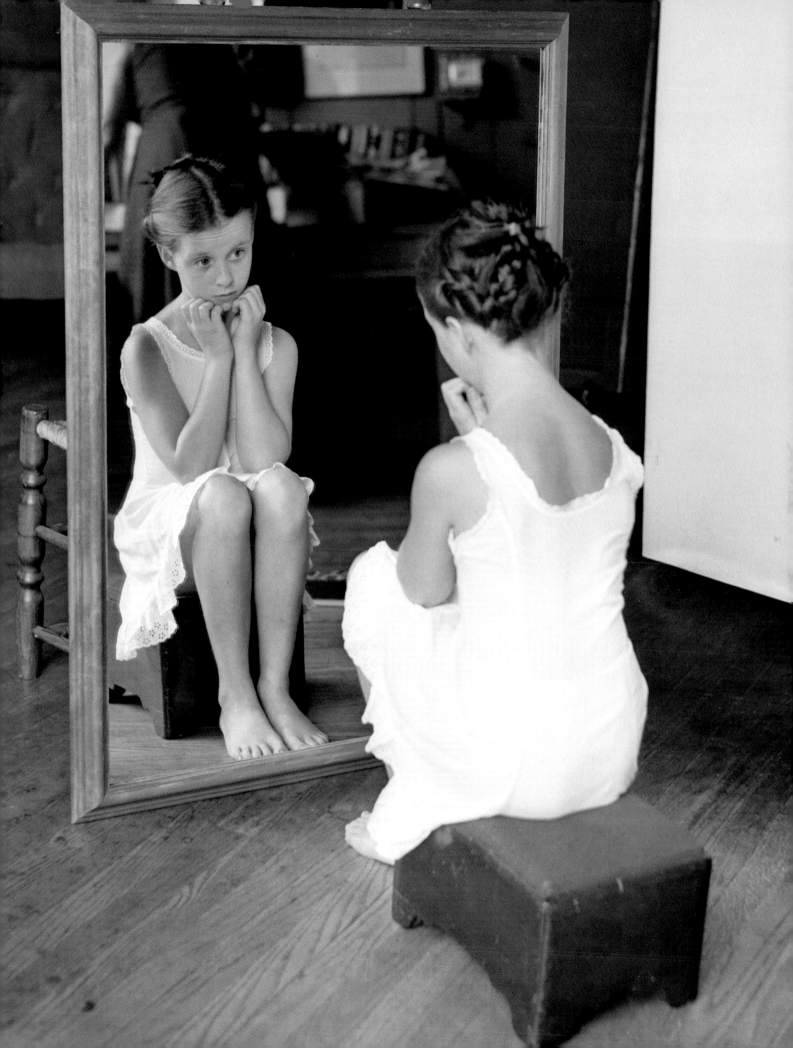

have made a few adjustments physically, but...he was removed — he was behind me somewhere, and he would speak to me. 'Just move your head...just a little...yeah... that's good, that's good,' very, very quietly. He just gave a few directions, and it seems to me we moved very slowly. There was seriousness in that room."

Like all of Rockwell's models, Mary Whalen was paid for each of her sessions. She bought a blue Columbia bicycle with her earnings.

Mary Whalen recalls seeing the painting of *Girl at Mirror* for the first time. "I was in my early twenties. I had never seen that painting because he left Arlington before [it] came out. I went to the Bennington Museum...and here was the original in front of me and I was just knocked over by it. I was speechless. And this woman said, 'Think of how proud the parents must be of that beautiful little child.' I just completely fell apart — I started to cry." Whalen's experiences with Rockwell continued to touch her life. "I'd be in somebody's house, and there would be a Rockwell print, and... I wouldn't know what to say. Should I say, 'You know, there's a picture of me on the wall'? I wouldn't tell just anybody that I had posed for him until I knew how they felt about him. I wanted to defend him."

ADVERTISEMENTS AND
COMMERCIAL COMMISSIONS

DESPITE NORMAN ROCKWELL'S CAREER-LONG success, he always found it difficult to turn down a new commission. He worked for more than 150 commercial clients; his earliest advertising work dates from 1915.

The volume of commercial assignments Rockwell accepted increased beginning in the 1950s and rose steadily to the end of his active career. He did significant work for such leading American companies as Ford, Pan American, Kellogg, Upjohn, Hallmark, and Franklin Mint.

While the designs for most commercial commissions were supplied by the companies or their ad agencies, some clients offered more creative latitude. For fifty years Rockwell contributed cover illustrations for the Boy Scouts of America annual calendar, published by Brown & Bigelow, who also published his own popular *Four Seasons* calendar series from 1948 to 1964. Rockwell's most extensive advertising commission came from Massachusetts Mutual Life Insurance Company, for whom he did a series of eighty-one freely drawn pencil illustrations examining American family life.

"MERRY CHRISTMAS, GRANDMA...WE CAME IN OUR NEW PLYMOUTH!" 1951
Advertisement

CAROLERS, 1948
Christmas card illustration

JOLLY POSTMAN, 1949
Christmas card illustration

Gene Pelham tenderly lifts the wings of a tiny bird to simulate the attitude of flight, enabling the artist to include its likeness in the finished work. The photograph was probably taken by Rockwell himself, in spite of his preference that his assistants handle all photographic responsibilities.

OFF TO SCHOOL, 1952
Advertisement

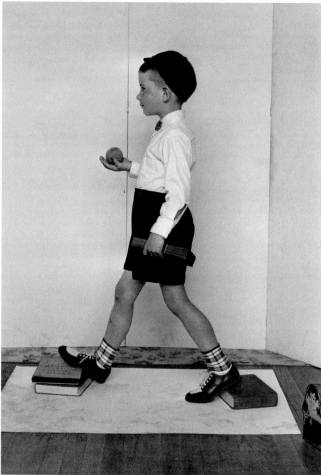

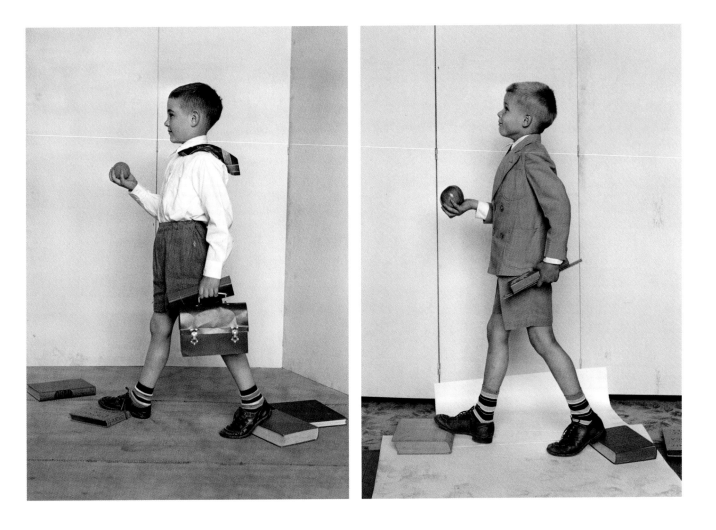

DANCE ON A MUSIC BOX, 1950s
Christmas card illustration

"Obtaining good photographs of animals for use in pictures is quite a test of your photography or, in my case, my photographer. ...The person taking the photographs must be extremely quick and ingenious because an animal may assume the pose you want for only a split second and you must be ready to snap the photograph at that unpredictable moment. I hold the animal where I hope he will assume the desired pose and my photographer focuses on him. Then I try to induce the model to take the desired pose. When he does I yell at the photographer to shoot. Sometimes the result is a blurred picture but other times I am lucky."

— NORMAN ROCKWELL

Unidentified, 1940s

Rockwell needed a cat for his composition and borrowed one from Arlington's piano teacher. Peter Rockwell recalls that when the restless cat wouldn't sit still, "Gene Pelham said, 'I know what to do.' He got a little bit of chloroform and quieted the cat down with that and they were able to take the photographs. But then they couldn't wake the cat up. They kept trying and finally...it could sort of stand in a rather rocky way. They drove back up to town and put the cat over her garden gate — it went weaving up and they drove away. When he got home the piano teacher called and said, 'I didn't know that posing was so exhausting! That cat is so tired, he can hardly stand up.'"

CLOSING UP A SUMMER COTTAGE, 1957
Advertisement

Closing Up a Summer Cottage is unique in Norman Rockwell's career as his only credited photograph. (Though he is thought to have directed some print advertisements for Kodak, definitive documentation is lacking.) In 1957, Rockwell was approached by Eastman Kodak to design and direct a photograph for the company's immense Colorama display in New York's Grand Central Terminal. Claimed to be the world's largest photographs, the Coloramas were eighteen-by-sixty-foot rear-lighted color transparencies that occupied Grand Central's east balcony from 1950 to 1990. It was an imposing advertising vehicle for Kodak seen daily by every commuter entering the terminal's Grand Concourse.

Rockwell based his concept sketches on photographs taken for him by a Kodak staffer in Shinnecock Bay, Long Island; a rental cottage in Quogue was chosen as the photograph's setting. On location, the artist and Kodak Colorama photographers Ralph Amdursky and Charlie Baker recruited models in the village. With Rockwell's subjects in position and photofloods deployed as fill lights, the final images were taken from a platform mounted atop the photographers' company station wagon. The sweeping horizontal space captured by the Colorama camera allowed Rockwell to position his models in distinct groupings, each telling its own story. The central scenario seems to wittily echo his 1947 *Post* cover, *Going and Coming* (p. 86).

Perfectly timed for its subject, Rockwell's Colorama was on display September 9–30, 1957. The first credited to an artist, the Colorama was autographed by the artist himself during a visit to Kodak's Information Center in Grand Central.

MAN ASKING DIRECTIONS, c. 1950
Advertisement

Norman Rockwell traced the evolution of this picture through six very different permutations in his 1979 book *Rockwell on Rockwell*. Never published by the *Post*, the image of a tourist asking for driving directions appeared in an advertisement for the Famous Artists School, a correspondence art school for which Rockwell was an instructor.

LINCOLN THE RAILSPLITTER, 1965
Advertisement. Butler Institute of American Art

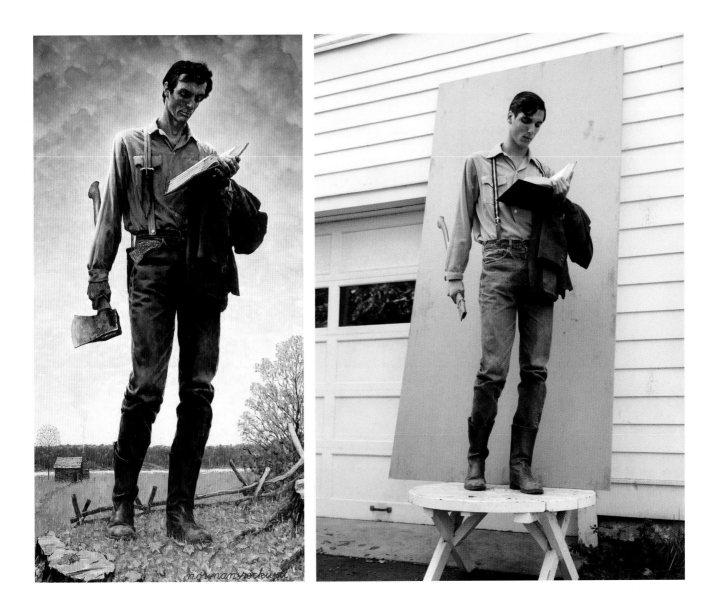

FAMILY IN AUTO, 1950s
Advertisement. Norman Rockwell Museum

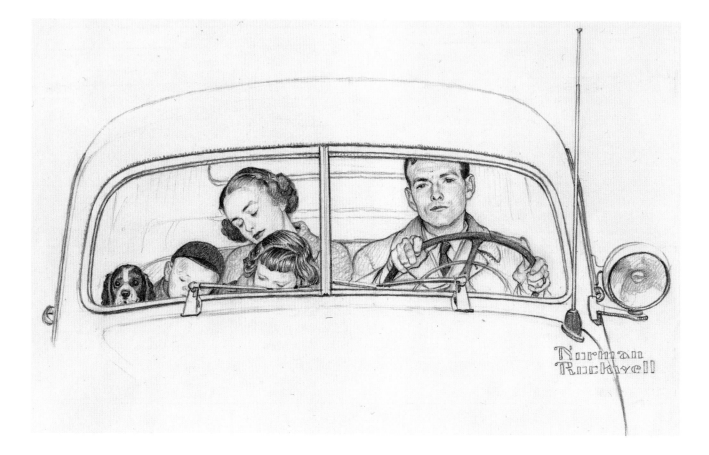

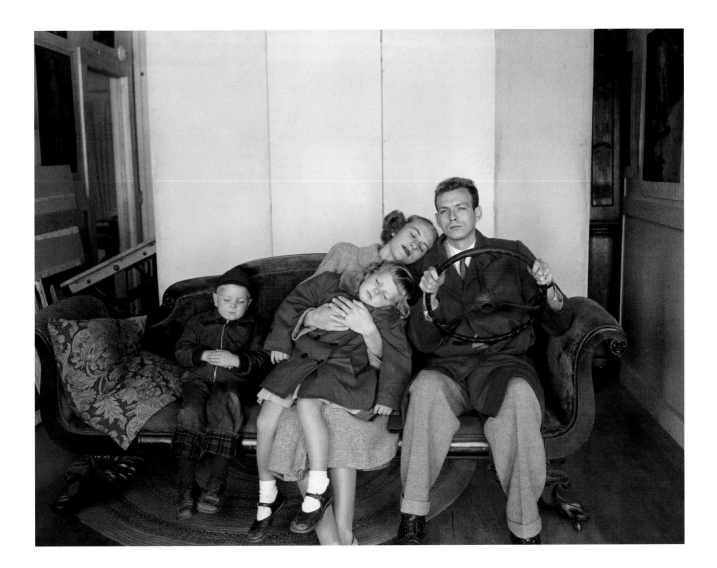

CIRCUS, 1955
Advertisement

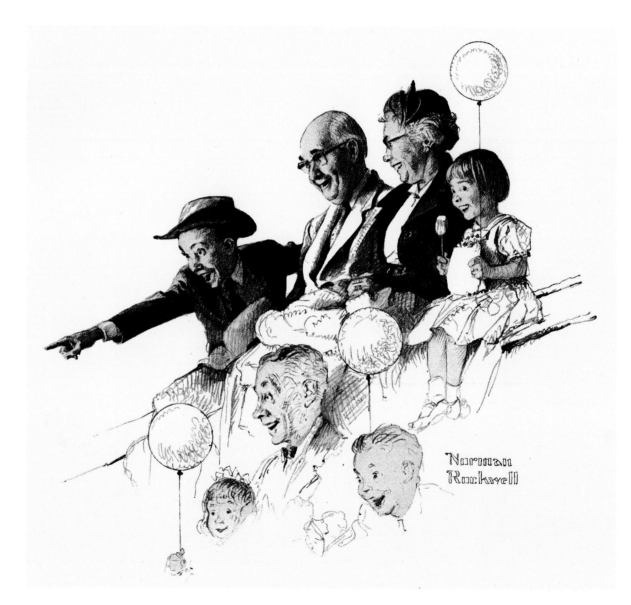

Circus was one of eighty-one drawings Rockwell did as part of a ten-year advertising campaign for the Massachusetts Mutual Life Insurance Company. The photographs were taken in the artist's first Stockbridge studio, a rented space above a Main Street market. Betsy Campbell, the daughter of the town's physician (who also modeled for Rockwell), remembers the occasion well. Whether it was her precarious perch in a chair atop a table, or because she was "a prim and proper little girl at five years old," Rockwell wasn't able to get the expression of surprise he wanted from his young model until he "threw popcorn all over us, and...there it was!" To her disappointment, the popcorn (visible in the photograph) was stale.

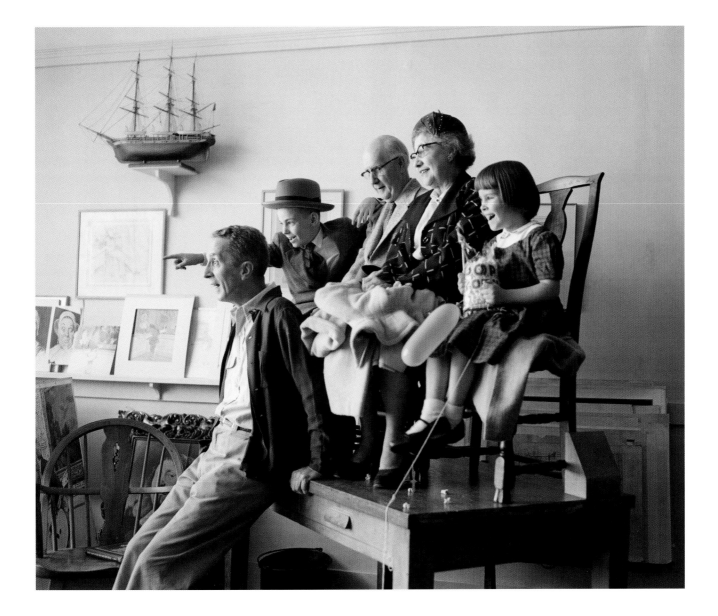

DINOSAUR, 1963
Advertisement

STOCKBRIDGE LIBRARY LIBRARIAN, 1962
Poster design. Stockbridge Library Association

Norman Rockwell married Stockbridge native Molly Punderson in 1961, two years after the death of Mary Barstow Rockwell, Rockwell's second wife and the mother of his three sons. A retired schoolteacher, Molly held deep liberal convictions, and she encouraged a shift in Rockwell's work toward social concerns following his departure from the *Post*. Molly posed for this poster design created for the Stockbridge Library's Centennial Celebration of 1962; the head and face of Stockbridge's town librarian replaced Molly's in the finished work.

THE STREET WAS NEVER THE SAME AGAIN, 1953
Advertisement

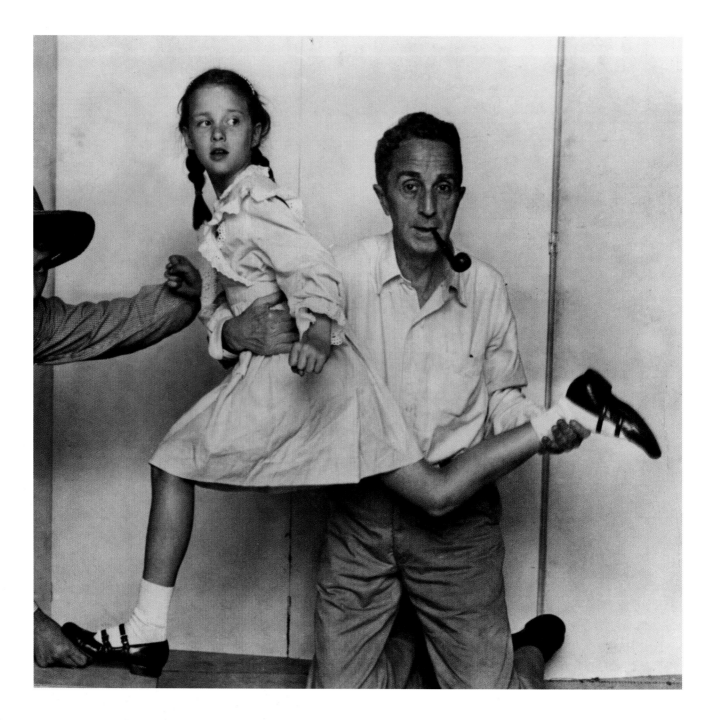

LEAVING THE HOSPITAL, 1954
Advertisement

TWO OLD MEN AND DOG: MUSICIANS, 1953
Calendar illustration

TWO OLD MEN AND DOG: SQUARE DANCE, 1953

Calendar illustration

This pair of models, always accompanied by their dog (photographed separately), were featured in Rockwell's *Four Seasons* calendars in 1950, 1953, and again in 1956. "He had a couple of elderly people — he called them 'the Old Codgers,'" Rockwell model Edward Schreiber remembers. "He drove over to Schenectady to get them every year to put on his calendars."

TWO OLD MEN AND DOG: NO SWIMMING, 1956
Calendar illustration

TWO OLD MEN AND DOG: SUMMER (STUDY), 1956
Calendar illustration, unpublished

For his 1956 *Four Seasons* calendar, Rockwell completed photography and preliminary sketches of domestic vignettes featuring a middle-aged couple. The series was to include a reprise of the pre-election discord theme that he had interpreted before (p. 106) as well as this romantic moment, for which Rockwell managed to haul a rowboat into his studio. Instead, he abandoned the series and turned once again to his reliable "Old Codgers" (pp. 162 and 163).

YOUNG LOVE: BUTTERCUP, 1949
Calendar illustration

Norman Rockwell's *Four Seasons* calendars contained four images tied to a unifying theme and were annual bestsellers. Yvonne Cross, who had appeared in the *Post* covers *Little Girl Observing Lovers on a Train* (p. 74) and *Going and Coming* (p. 86), is seen in this image for the 1949 *Young Love* calendar.

FIRST DATE — HOME LATE, 1970
Commercial illustration

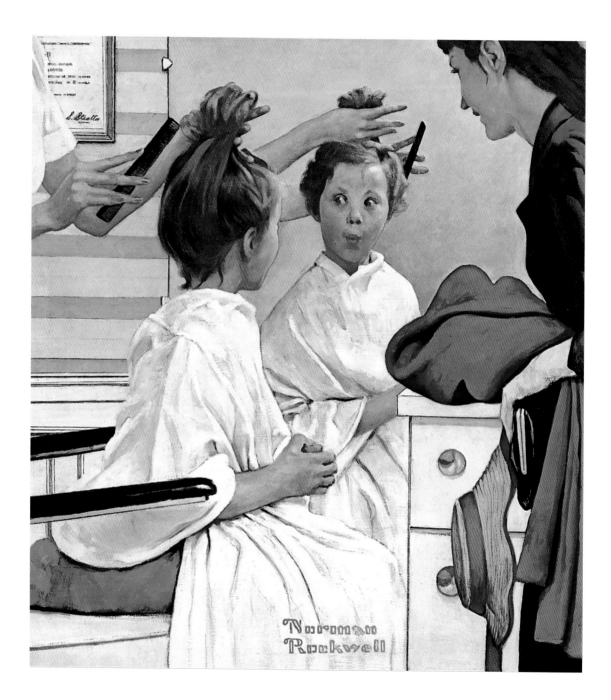

Reflected in the beauty shop mirror is a glimpse
of Norman Rockwell appearing in a favorite role,
that of director.

LIBERTY BELL, 1976

American Artist cover, July 1976. Norman Rockwell Museum

Liberty Bell was Norman Rockwell's last completed work and his final self-portrait. It was commissioned by *American Artist* magazine to mark the U.S. bicentennial and graced the magazine's cover. Though the name of Norman Rockwell is today closely associated with his covers for *The Saturday Evening Post*, his artwork appeared on the covers of seventy-nine other magazines over a career spanning sixty-five years.

SATURDAY EVENING POST COVERS:
THE STOCKBRIDGE YEARS

IN 1953, NORMAN ROCKWELL MOVED TO Stockbridge, Massachusetts, where his wife, Mary, was undergoing treatment at the Austen Riggs Center. Neither the relocation nor mounting advertising work interrupted his output for the *Post*. Rockwell produced some of his most popular covers in Stockbridge, among them *Breaking Home Ties*, the wryly complex *Triple Self-Portrait*, and three memorable childhood images, *The Discovery*, *Before the Shot*, and *The Runaway*. Five covers followed the stages of romance, from flirtation in *University Club* and *Window Washer*, to young love in *After the Prom*, and the pre- and post-wedding vignettes of *The Marriage License* and *Just Married*.

The *Post* underwent a modernizing redesign in 1961. The following year, editor Ben Hibbs resigned, photography began to compete with illustration for cover space, and just two Rockwell covers—the last of his *Post* storytelling images—were published. The artist's final four assignments were portraits, a signal to Rockwell of his diminished role at the magazine. Norman Rockwell left *The Saturday Evening Post* in 1963 at age sixty-nine.

ART CRITIC, 1955

Saturday Evening Post cover, April 16, 1955. Norman Rockwell Museum

Art Critic is one of the artist's most popular and extensively analyzed works. Bill Scovill, Rockwell's first photographer in Stockbridge, believed "it was the cover that gave him the most trouble and…agony of any. He had a terrible time finishing it." *Norman Rockwell: A Definitive Catalogue*, the catalogue raisonné of the artist's work, includes twelve different studies, plus a full-color study and the finished painting. The modestly risqué nature of the composition itself might account for his struggles, or it may have been the delicacy of the fact that Rockwell's final models were his wife, Mary, and their eldest son, Jarvis. Mary was photographed in at least two sessions for the work; the identity of the art critic in the photograph is unknown.

BREAKING HOME TIES, 1954
Saturday Evening Post cover, September 25, 1954. Private collection

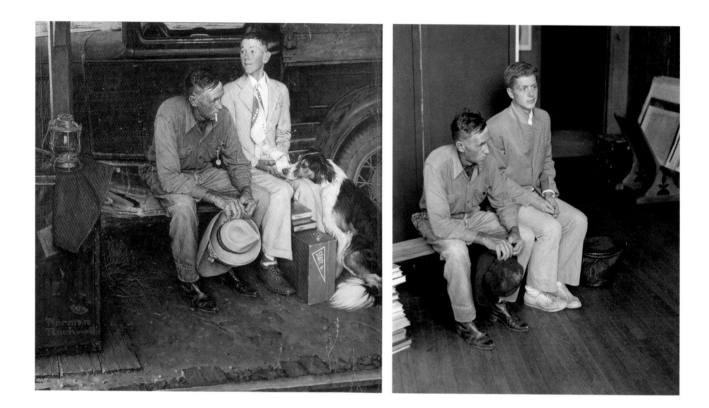

Breaking Home Ties was begun in Arlington and completed after Rockwell's move to Stockbridge in 1953. Rockwell wrote that "in theme at least, this cover is autobiographical. I was trying to express what a father feels when his son leaves home. Jerry, my oldest son, had enlisted in the Air Force; my younger sons, Tom and Peter, had gone away to school. Whenever I feel an idea strongly, I have trouble painting it." Indeed, he completed two versions in oil, and executed at least four different charcoal studies for the work, each taking his compositional refinements a step further.

Rockwell photographed many combinations of models in Arlington and in New Mexico, where he also documented the railroad station and automobile that became his setting. *Breaking Home Ties* was the subject of national attention in 2006 when the original oil was discovered behind a false wall in the home of cartoonist Don Trachte, a friend of Rockwell's from Arlington. Trachte had apparently hidden the original during divorce proceedings; a replica he had painted, thought to be authentic, had hung in the Norman Rockwell Museum in Stockbridge.

THE DISCOVERY, 1956

Saturday Evening Post cover, December 29, 1956. Norman Rockwell Museum, Norman Rockwell Art Collection Trust

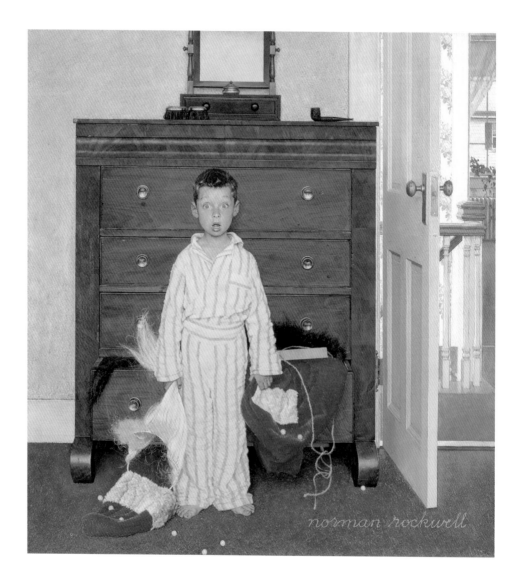

"A Norman Rockwell Christmas" evokes an instantly familiar tradition within the American mythology, so closely is the artist associated with the holiday. Much of the iconography of the American Christmas was invented by the popular media, and Rockwell's jovial Santas and lighthearted Dickensian scenes from the 1920s and '30s played important roles in its shaping.

The Saturday Evening Post published a Rockwell Christmas cover every year from 1919 through 1942, and its appearance on America's newsstands was an annual tradition. Rockwell's twenty-nine Christmas covers comprise a major chapter in the artist's career. But when he contributed this design in 1956, he had not proposed a Christmas cover in eight years. Rockwell had actually intended this scene of disillusionment (another theme the artist had previously interpreted) for a fall publication date, but the *Post*'s editors held it for the December holiday. It would be his final Christmas cover.

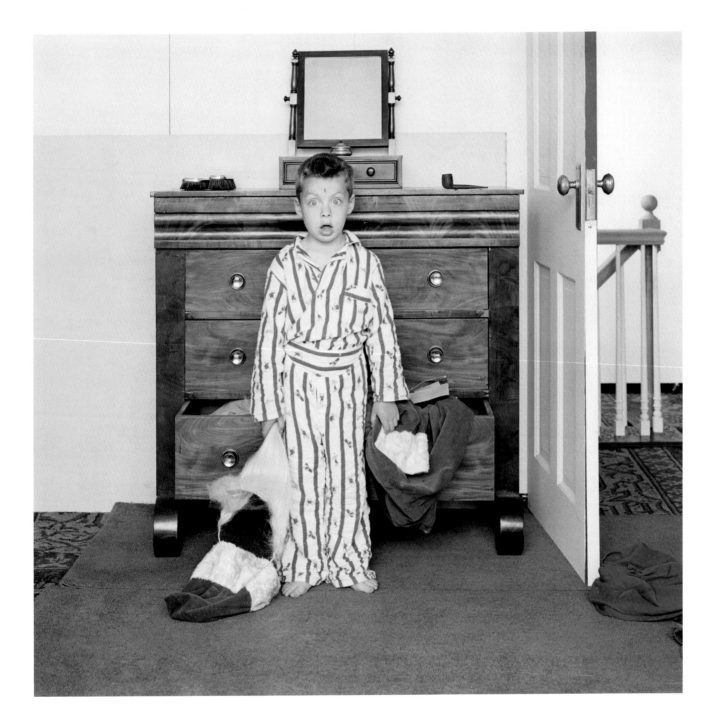

THE EXPENSE ACCOUNT, 1957

Saturday Evening Post cover, November 30, 1957. Norman Rockwell Museum, Norman Rockwell Art Collection Trust

The traveling businessman is a character with whom Rockwell sympathized. Two earlier *Post* covers (pp. 95 and 105) had portrayed business travelers coping with life on the road in very different ways. Here, unable to construct a properly authentic Pullman chair in his studio, Rockwell cadged a real one from the Santa Fe Railway.

MERMAID, 1955

Saturday Evening Post cover, August 20, 1955.

In 1955 Rockwell traveled to New York City to hire a professional model to pose in the nude for *Mermaid*. In Rockwell's Stockbridge studio the model was posed in a makeshift lobster trap built by his assistant, Louie Lamone. Photographer Bill Scovill was so embarrassed that he never came out from under his black focusing cloth.

AFTER THE PROM, 1957

Saturday Evening Post cover, May 25, 1957. Private collection

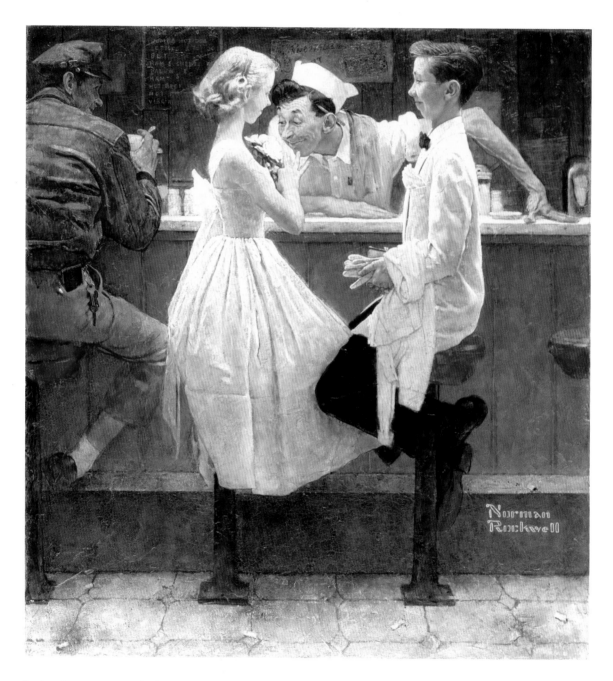

Rockwell again succumbed to the urge to caricature with *After the Prom;* "I call this my chinless picture," he said. This approach, which he later regretted, was part of the artist's intention from its earliest stages. He achieved much of the effect of caricature by recruiting models with fitting profiles, who were photographed in a set built in Rockwell's Main Street studio. Two authentic diner stools were borrowed to complete the scene.

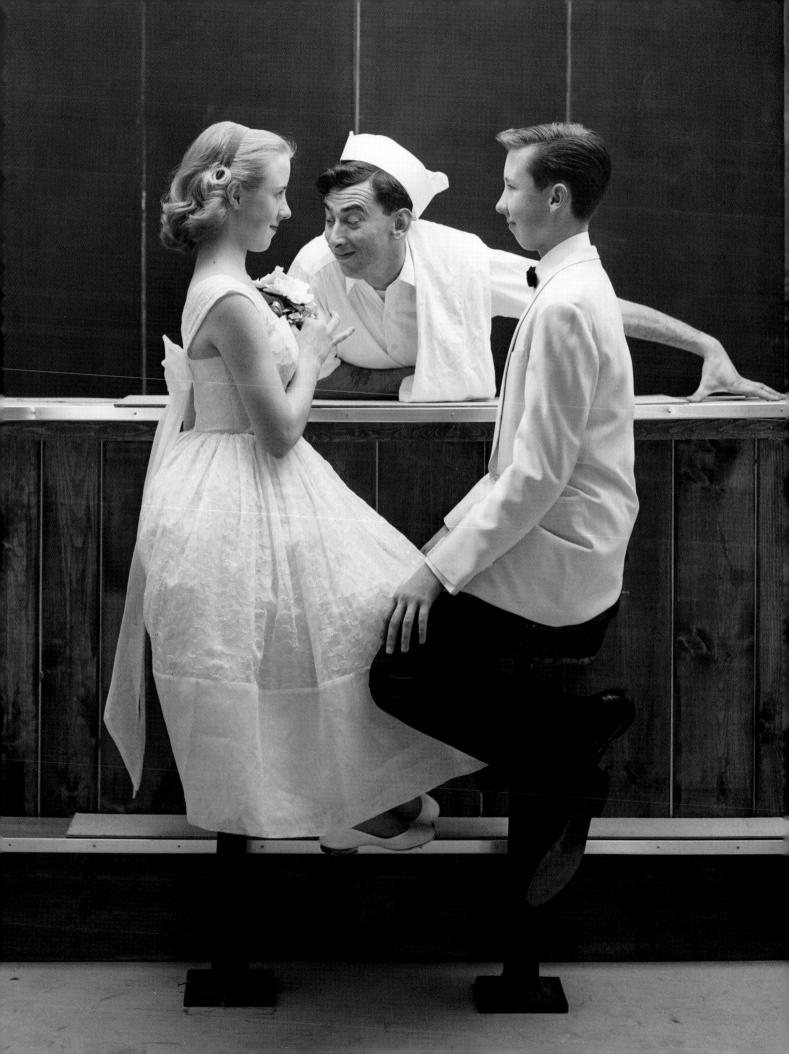

BEFORE THE SHOT, 1958

Saturday Evening Post cover, March 15, 1958.

Copyright © 1958 SEPS

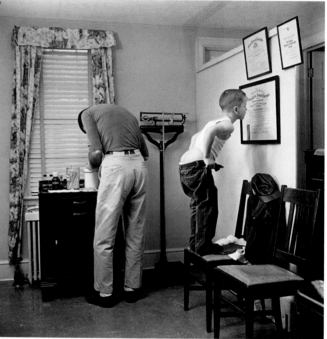

Ed Locke remembers the school lunch hour Norman Rockwell chose him to pose for *Before the Shot*. "He would select kids out of the cafeteria. Our principal, who was a very imposing man, would come and get you out of your seat and bring you over to Mr. Rockwell. You thought, 'Boy, you are in some big trouble now.' Mr. Rockwell would then interview you and call your parents....I don't think any of the kids were aware of how important a figure he was until Edward R. Murrow came to town and interviewed him.

"From my point of view it pretty much was reality. He was, in fact, my doctor — Dr. Campbell, kind of a legendary figure here in town — and it wouldn't be the first time that I had stood on that chair. He was not there when I posed. Mr. Rockwell was there with his photographer, Louie Lamone...posing as Dr. Campbell. As you can imagine, I was hoping that particular picture wouldn't take quite as long as it did, but I was there for probably two hours. I kind of got teased when the cover came out."

CONSTRUCTION CREW, 1954

Saturday Evening Post cover, August 21, 1954

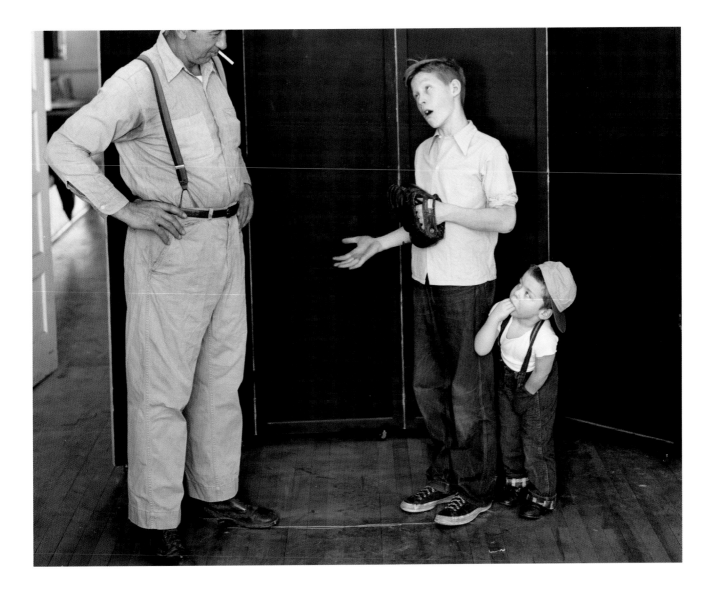

THE RUNAWAY, 1958

Saturday Evening Post cover, September 20, 1958. Norman Rockwell Museum,
Norman Rockwell Art Collection Trust

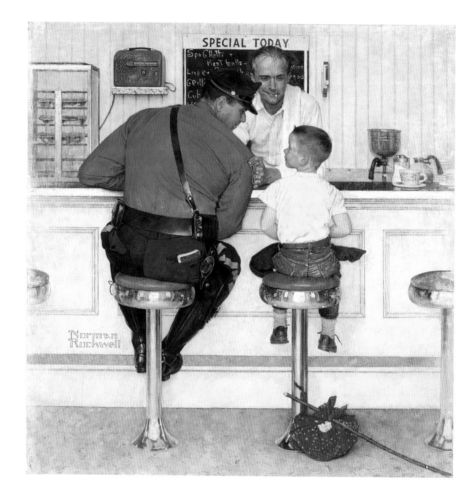

Norman Rockwell brought Ed Locke and Massachusetts state trooper Dick Clemens to the Howard Johnson's restaurant in Pittsfield, Massachusetts, to be photographed for *The Runaway*. Clemens remembers that Rockwell had them "sit at the counter facing away, facing straight, arms up on the counter, arms down. I don't think we were there two hours." The counterman's wristwatch visible in the photographs reveals that less than a half hour elapsed between the first and last shots taken that day. Locke, who enjoyed being allowed to "sit in the cruiser and fire off the siren," believes Rockwell worked speedily to accommodate "the attention span of an eight-year-old."

Completing a preliminary canvas that faithfully captured the diner's modern decor, Rockwell rejected it for a second version with a sparer setting. Asked by Clemens why he made the change, the artist explained that he wanted "a more rural background to give the impression that the little boy had gotten further out of town." This subtle revision heightened the poignancy of a moment shared by the would-be runaway and the trooper who, says Locke, ensures "no harm [will] come to that kid."

In the five decades since *The Runaway*'s publication, Clemens has seen it "become synonymous with law enforcement," conveying the mission to protect and serve. "Wherever you go, in state police agencies or law enforcement agencies, you'll find a picture of *The Runaway* hanging somewhere."

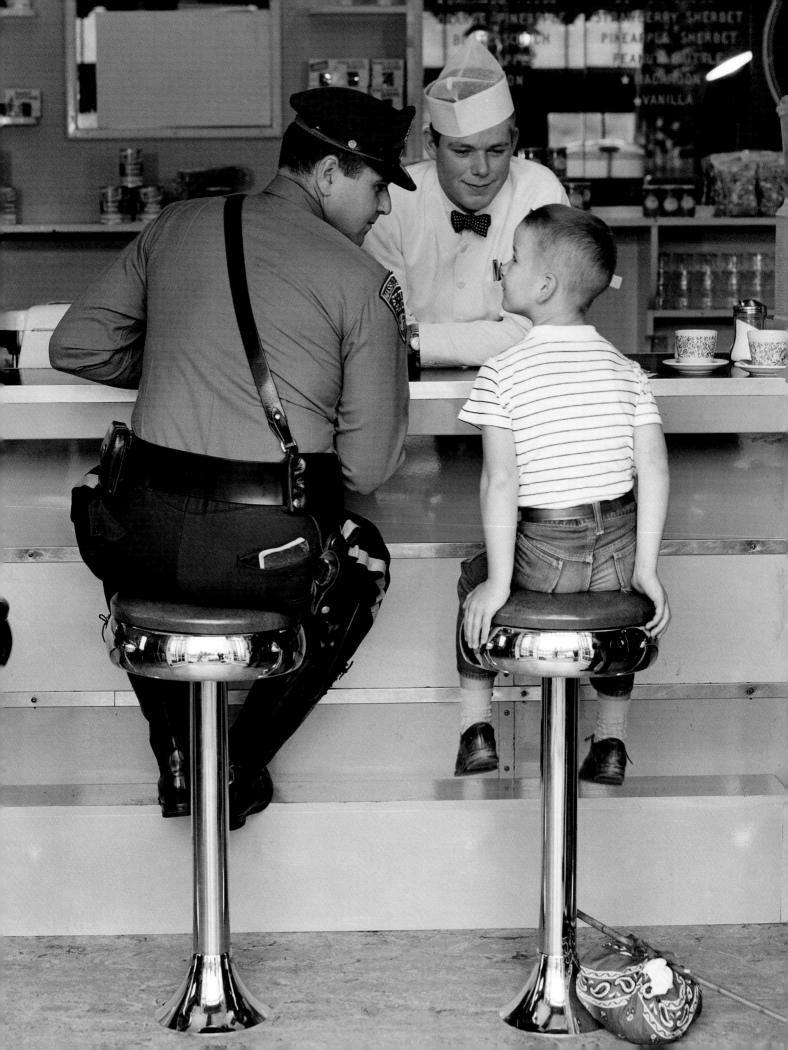

ROCKWELL THE LITERALIST

In the first two decades after Rockwell began to use a camera, he seldom photographed a completely composed scene in a single image. Every element of a new composition had to be photographed for Rockwell to incorporate it into his painting. He directed his photographers to frame each component separately and combined the images as he transferred them to canvas. By assembling the building blocks of his compositions, it is possible to reconstruct his working process (p. 100).

By the mid-1950s his working method had evolved and simplified. Rockwell often photographed his compositions as complete tableaux, posing his models together on location in his chosen setting. As a result, many of his photographs from this period are virtual mirrors of the finished works.

THE MARRIAGE LICENSE, 1955

Saturday Evening Post cover, June 11, 1955.
Norman Rockwell Museum, Norman Rockwell Art Collection Trust

The Marriage License was set in the Stockbridge town clerk's office only yards from Rockwell's studio. The sketch he had prepared as a guide for his three models differs significantly from the finished work; his intention was that the clerk should be looking up at the applicants. While the young couple (actually engaged in real life) were being posed, Jason Braman, the model for the town clerk, stared distractedly into space, and photographer Bill Scovill snapped the picture. Seeing the print, Rockwell knew instantly that this unplanned pose was superior to the one he had sketched, and faithfully captured it in his finished painting.

UNIVERSITY CLUB, 1960

Saturday Evening Post cover, August 27, 1960

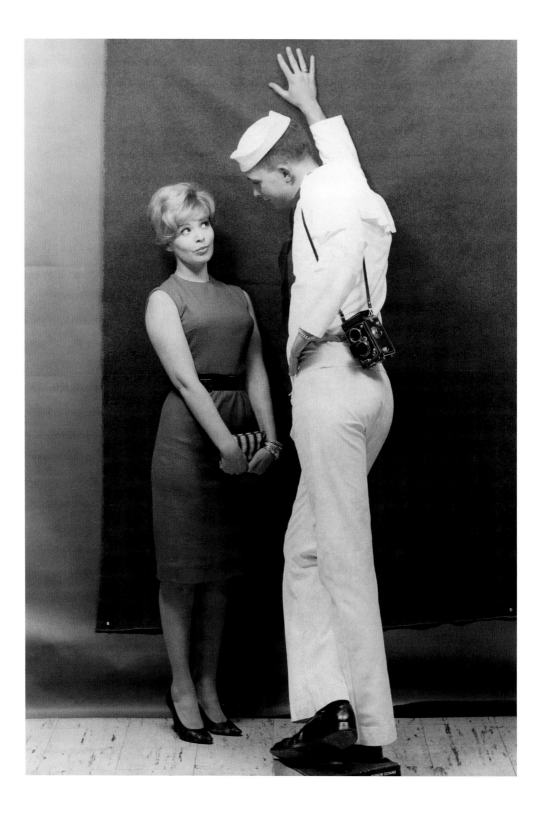

WINDOW WASHER, 1960

Saturday Evening Post cover, September 17, 1960.

Copyright © 1960 SEPS

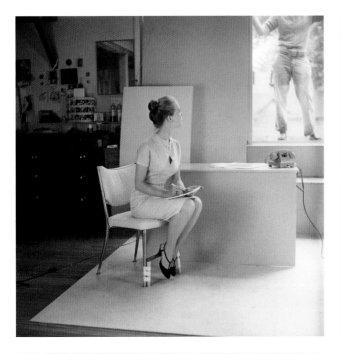

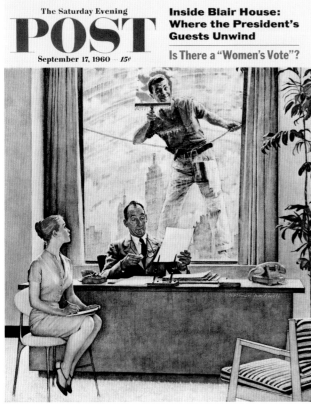

In 1960 a budding artist from Washington State was a young soldier stationed in western Massachusetts. With a furlough coming up, he wrote to his idol, Norman Rockwell, asking if he might be allowed to visit. Receiving an unexpected invitation by return mail, he traveled to Stockbridge and was introduced to the artist. "You'll do," said Rockwell on seeing his visitor, and he was cast on the spot as a leering window washer.

JUST MARRIED, 1957

Saturday Evening Post cover, June 29, 1957

"Before a model even attempts to pose for me, I tell him the story I want my picture to tell because I want him to understand what I am trying to do, what I am trying to convey. Then I get into the pose myself and show him how I think it should be done." — NORMAN ROCKWELL

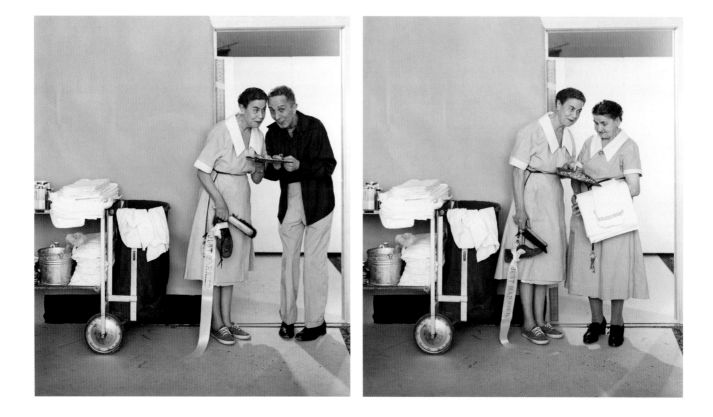

TRIPLE SELF-PORTRAIT, 1960

Saturday Evening Post cover, February 13, 1960.
Norman Rockwell Museum, Norman Rockwell Art Collection Trust

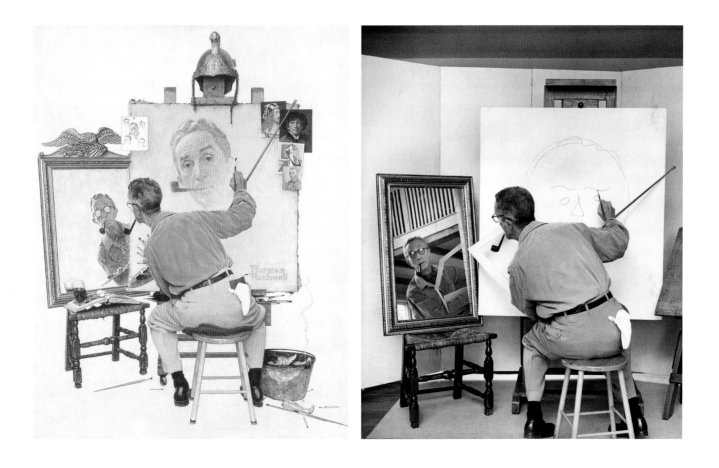

MARRIAGE COUNSELOR, 1963
Intended for *The Saturday Evening Post*, unpublished.
Norman Rockwell Museum, Norman Rockwell Art Collection Trust

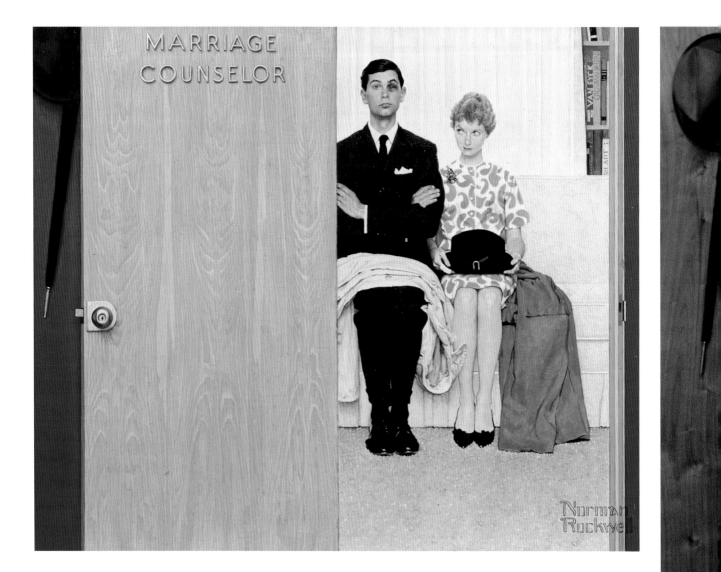

The inscription below a study for *Marriage Counselor*
confirms that it was intended to be a *Post* cover, but it was
never published. Rockwell's image of a damaged relationship
is a fitting metaphor for the artist's own struggles with
The Saturday Evening Post as he weighed the end of their
forty-seven-year association.

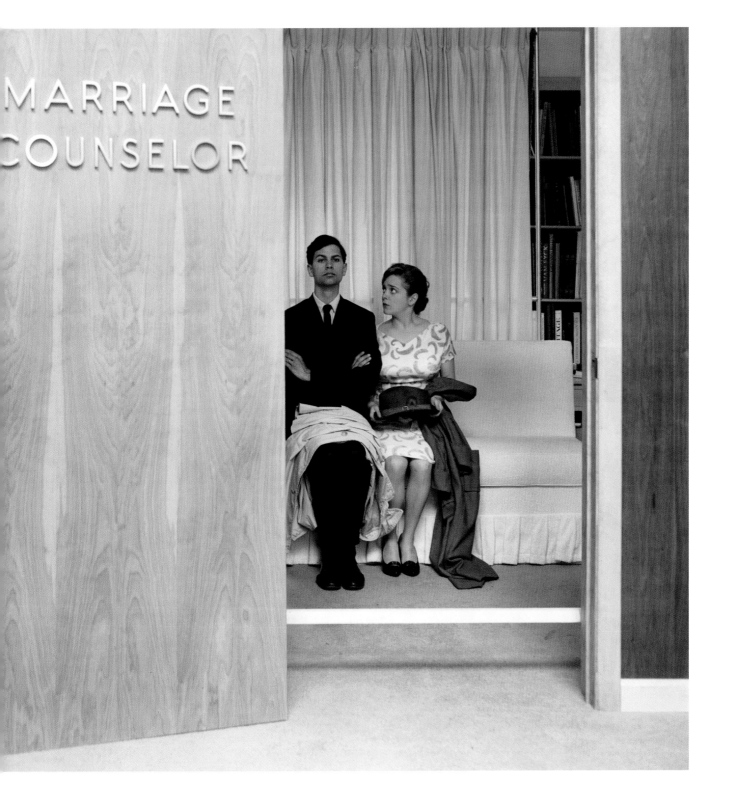

PORTRAIT OF RICHARD M. NIXON, 1960

Saturday Evening Post cover, November 5, 1960

Although Norman Rockwell didn't consider himself a portraitist, beginning in the mid-1950s the *Post* began to give him portrait assignments with increasing frequency. In 1963, at the end of Rockwell's relationship with the *Post*, all of his covers were portraits.

In 1956, 1960, and again in 1964, Rockwell painted paired images of the competing presidential candidates. His subjects could usually spare Rockwell only a few moments from their hectic schedules, and the camera proved the right tool for the job. Telling his cameraman when to shoot, he could try his subject in a variety of poses in a time too brief to allow sketches from life. Rockwell portrayed Richard Nixon five times, projects one of the artist's biographers says he did reluctantly.

IN THE MONTHS PRIOR TO HIS DEPARTURE from *The Saturday Evening Post*, Norman Rockwell was courted by its rivals, among them *LOOK* and *McCall's*. In 1964 he agreed to become a regular *LOOK* contributor.

Rockwell had never been politically conservative, and *LOOK*'s editorial focus offered him the freedom to explore challenging subjects that were off-limits at the *Post*. The fresh showcase also provided an opportunity to shift his focus from the narrative fictions with which he was so well known to a range of contemporary journalistic issues. His lifelong concern for human rights coincided with *LOOK*'s commitment to civil rights reportage. Embracing his transformation, Rockwell longed to satisfy his desire to "paint the BIG picture, something serious and colossal which will change the world."

THE PROBLEM WE ALL LIVE WITH, 1964

LOOK feature illustration, January 14, 1964. Norman Rockwell Museum

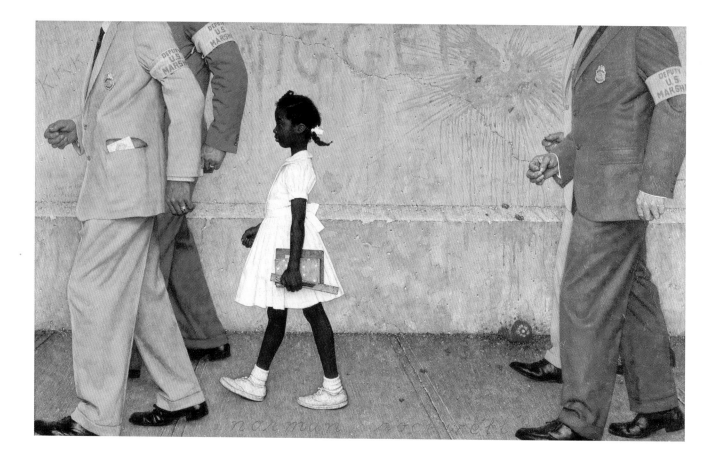

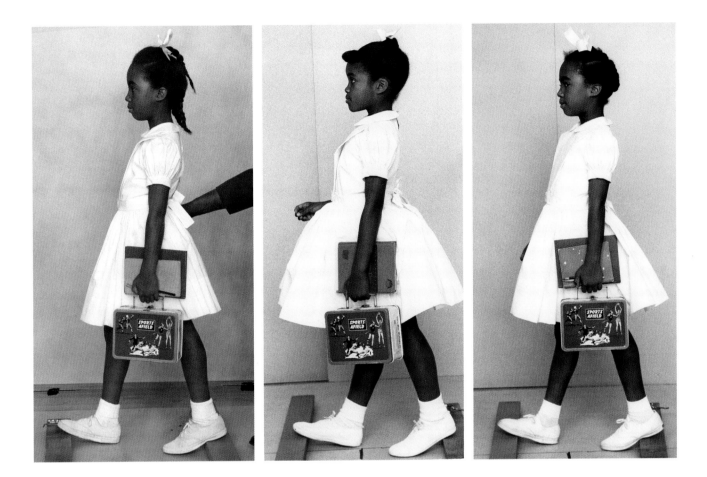

Rockwell's first commission for *LOOK* sharply defines the new direction his work took after leaving *The Saturday Evening Post*. One of Rockwell's landmark illustrations, *The Problem We All Live With* tells the story of a young girl as she bravely walks to her desegregated school under the protection of four imposing U.S. marshals. It was published as a two-page spread with no accompanying text.

Though the painting is inspired by the story of Ruby Bridges, one of the first African American children to attend previously all-white schools in New Orleans, Rockwell's painting is not a factual portrait of Bridges. Rockwell photographed three young girls from the Stockbridge area; the final figure is a composite of all three. His preparatory photographs include images of the marshals' feet and clenched hands, scrawled epithets, and a smashed tomato on the ground along with its violent splatter.

MURDER IN MISSISSIPPI (STUDY), 1965

LOOK article illustration for "Southern Justice," by Charles Morgan Jr., June 29, 1965.
Norman Rockwell Museum, Norman Rockwell Art Collection Trust

LOOK's publication of Norman Rockwell's first civil rights subject, *The Problem We All Live With*, drew letters of both praise and criticism from the magazine's readership. But Rockwell had reached a turning point in his career and welcomed assignments that explored subjects *The Saturday Evening Post* would never have considered.

Rockwell painted *Murder in Mississippi* for an article by Alabama attorney Charles Morgan Jr., which examined the 1964 murders of civil rights workers Michael Schwerner, James Chaney, and Andrew Goodman. The artist devoted his full energy to the commission and submitted a rough color study to *LOOK*'s art director, Allen Hurlburt, for approval to proceed with the illustration. After receiving the final version, Hurlburt instead chose to send the color sketch to press, the only time this occurred in Rockwell's career.

Rockwell's son Jarvis, on a visit from his San Francisco home, was the central model. Photoflood lights in the darkened studio simulated the glare of car headlights and created the threatening elongated shadows of the Klansmen. In an extreme expression of the artist's requirement for authenticity, he obtained a sample of human blood to guarantee the faithful appearance of the victims' blood-stained shirts.

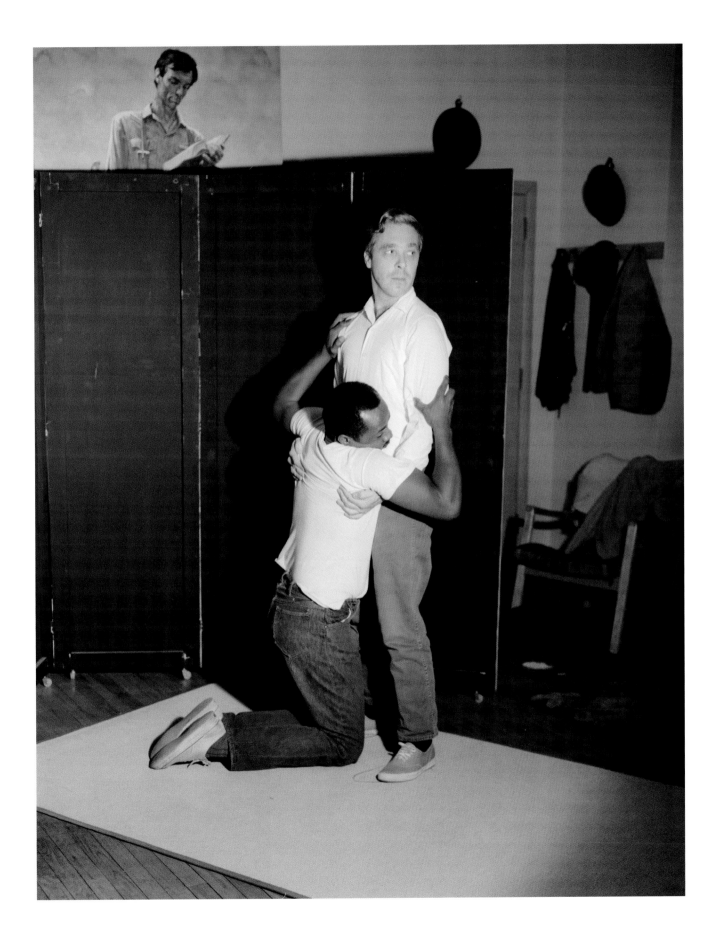

MURDER IN MISSISSIPPI, 1965

Intended for *LOOK*, unpublished. Norman Rockwell Museum

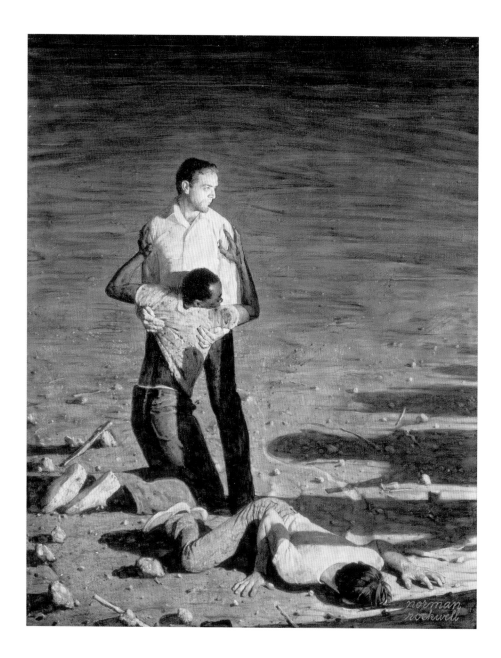

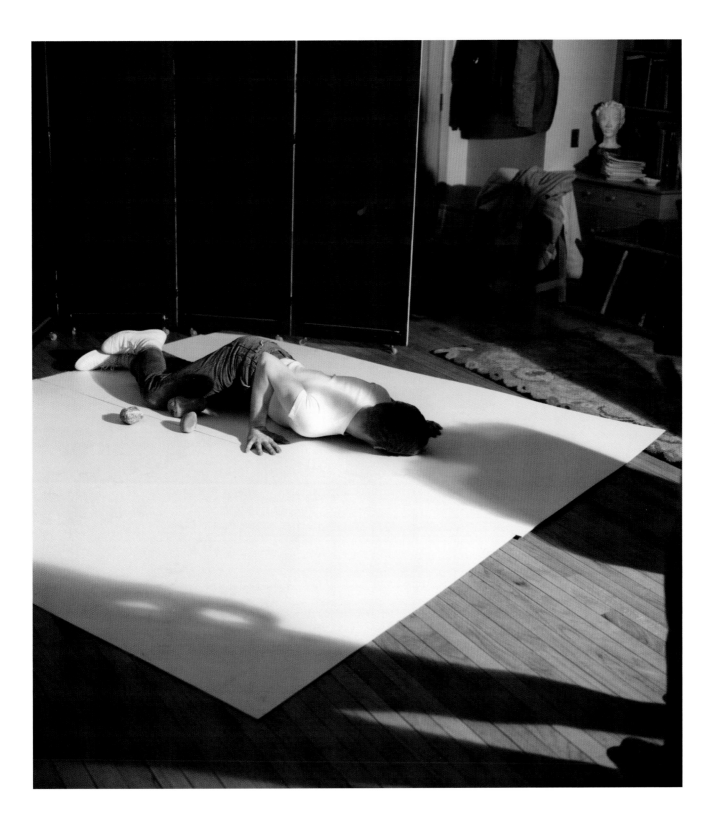

NEW KIDS IN THE NEIGHBORHOOD, 1967

LOOK article illustration for "Negro in the Suburbs," by Jack Star, May 16, 1967.
Norman Rockwell Museum, Norman Rockwell Art Collection Trust

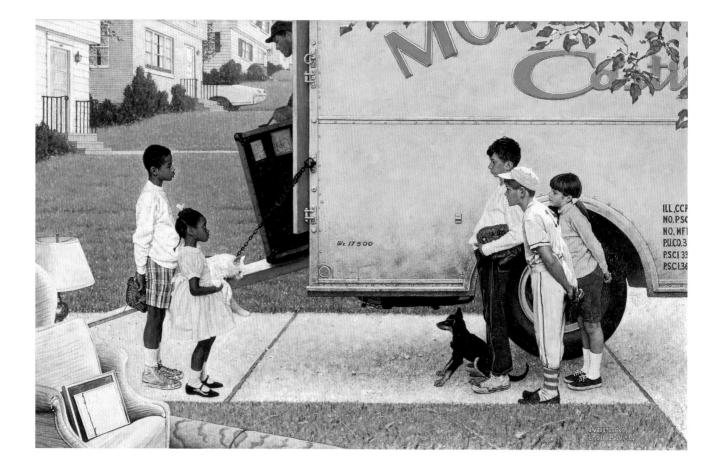

New Kids in the Neighborhood was Rockwell's third civil rights picture for *LOOK* magazine. Illustrating an article on the changing racial profile of America's suburbs, the piece gave him an opportunity to focus on children as his subjects, once the mainstay of his career.

Thirteen-year-old Wray Gunn and his younger cousin, Tracey, were the models for the "new kids." Rockwell frequently enlisted the aid of Gunn's grandfather to locate child models. "Mr. Rockwell would come by the house with his sketchbook [to] show Grandpa what he would need," as Gunn tells it. "It's Grandpa who chose us. I'm just now realizing how important that painting was back in those days."

Recalling a photo session that lasted "approximately six hours — the first two were spent dealing with the cat!"—Gunn says, "I remember it just like it happened yesterday." As *LOOK*'s publication date approached, Gunn boasted to his friends that he was about to be famous. "I was running it, man!...I'm quite sure nobody actually believed me." But at school on the day the issue came out, the picture was missing from the library's copies. "My friends got to school before I did and took out all the pictures....One was on the back of the library door, one was down the hallway, one was in the locker room and a couple other places. One of the few times I ever got upset with my friends at school and we had it out! But we got it together." Today Gunn is a Museum Guide at the Norman Rockwell Museum in Stockbridge, Massachusetts.

BLOOD BROTHERS (STUDY), c. 1968

Intended for *LOOK*, unpublished. Norman Rockwell Museum,
Norman Rockwell Art Collection Trust

Blood Brothers began as an idea for *LOOK* magazine,
though it was never published. The first version sub-
mitted to *LOOK* was a disturbing image of two young
men dressed in everyday clothes, possibly slain on the
streets of an urban ghetto. The magazine asked that
the figures be changed to represent Marines killed on
duty in Vietnam. Rockwell adapted his composition
and submitted a new version of soldiers lying side by
side, spilled blood pooling gruesomely around their
heads. For a second time *LOOK* rejected the work, one
of its editors finding the work "patronizing."

THE FINAL IMPOSSIBILITY: MAN'S TRACKS ON THE MOON, 1969

LOOK feature illustration, December 30, 1969.

National Air and Space Museum, Smithsonian Institution

APOLLO AND BEYOND, 1969

LOOK article illustration for "Apollo and Beyond," by Arthur C. Clarke, July 15, 1969

During his eight years with *LOOK*, Rockwell embraced the programs and concerns of John F. Kennedy's New Frontier and Lyndon Johnson's Great Society. Intolerance, the space race, and the Peace Corps were themes close to the artist's heart. Rockwell's many illustrations for *LOOK* during the years of the Apollo program required particularly elaborate planning, and NASA was obliging in its support of the artist's work. He borrowed authentic equipment, including helmets and space suits, to ensure accuracy of detail. And he obtained access to an Apollo Lunar Lander, where he posed his space-suited models. A tarp hung in the background substituted for what the Apollo astronauts often referred to as "the black velvet of space."

Afterword

The Museum Reference Center at the Norman Rockwell Museum, custodian of the Rockwell family's papers and ephemera, houses the artist's collection of photographs and negatives. Many work prints survive, bearing telltale wear and tear from their use as daily tools in the hands of the artist and his assistants. More than eighteen thousand of Rockwell's acetate-based negatives exist, albeit in deteriorating condition. With lead funding in 2006 from the federal Save America's Treasures program, the museum has digitized the negative collection, an effort that has not only preserved this precious resource but has, for the first time, made these images accessible. I am grateful to have been among the first to explore this digital archive, making possible this book, whose realization I have imagined for a decade.

The digital archive includes scans of negatives in formats ranging from five by seven inches to thirty-five millimeters. For selection and presentation in this volume, I have established protocols that respect both the integrity of the photographs and their function as working tools. Many of the images are reproduced full frame. In cases where the subject was photographed against a backdrop, commonly a folding screen, I have often framed the image at the edge of the backdrop, editing out extraneous information at the sides of the frame that the artist himself clearly intended to eliminate. The compositions of some images are so close to the finished work that I have adjusted their framing to allow the photograph and painting to align. And, finally, in several instances I have montaged details of separate photographs to illustrate how Rockwell combined images into a unified composition.

Norman Rockwell did not log the dates his photographs were created; dates given are publication dates of the final work. Except where such information is relevant to the story of a particular image, I have not attempted to identify Rockwell's many models. However, the memories many have shared with me in interviews conducted for this book have added detail and insight to my understanding of Norman Rockwell's working method.

PP. 216, 218: "NORMAN ROCKWELL SAYS 'PAN AMERICAN WAS MY MAGIC CARPET AROUND THE WORLD.'" 1956. Advertisement.
P. 222: FIRST SIGNS OF SPRING, 1947.
Saturday Evening Post cover, March 22, 1947.
P. 223: YOUNG BOY: YOUNG LOVE, 1963.
Calendar illustration.

Acknowledgments

The contributions of many people have made this book possible. John Rockwell, representing the Norman Rockwell Family Agency, has been unfailingly supportive from the beginning, and I thank him for his enthusiastic participation at every stage. At Little, Brown and Company, my editor and friend, Michael Sand, deserves great credit and my gratitude for seeing the possibilities from the first and for steering this book to a happy conclusion. The contributions of Barbara Nelson, Zinzi Clemmons, and Peggy Freudenthal at Little, Brown have been invaluable.

At the Norman Rockwell Museum, I thank Stephanie Haboush Plunkett, deputy director and chief curator, for her skillful shepherding of this endeavor through to publication and its parallel traveling exhibition, sponsored by the Norman Rockwell Museum. In the Museum Reference Center, Linda Szekely Pero's knowledge of all facets of Rockwell's work is limitless. I am grateful to Linda and Corry Kanzenberg for their collegial support, as well as to Rob Doane and Ellen Mazzer.

I appreciate the generosity of the Rockwell models who have shared their time with me in interviews for this book. Ardis Edgerton Clark, Dick Clemens, Wray Gunn, Maurice Leavitt, Ed Locke, Betsy Campbell Manning, Smitty Pignatelli, Edward Schreiber, and Charlotte Ripley Sorenson brought a personal dimension to my understanding of Rockwell's methods. I am grateful to Mary Whalen Leonard, who made me feel as though I were in the room as she posed in Rockwell's studio. Particular thanks go to Norman Rockwell's three sons, Tom, Peter, and Jarvis, for sharing their thoughts and recollections.

Doug Munson and Oleg Baburin of Chicago Albumen Works, creators of the Rockwell negative scans, generously provided technical guidance. Jennifer Brown at Sotheby's, David Blackmer of Curtis Publishing, Mary Seitz-Pagano at the Norman Rockwell Estate Licensing Company, Robert E. Livesey of Cortina Learning International, William N. Elam, III, Image Photos, Rosemary Schneyer and Barbara Allen of the Stockbridge Library, Kim von Tempsky and Ron Muromoto at Lahaina Galleries, Ronald Garmey of Nixon Peabody LLP, and M. Stephen Doherty of *American Artist* magazine each provided key elements for this publication. David Kassnoff

at Eastman Kodak made Norman Rockwell's Colorama photograph available, and Rachel Stuhlman, Kathy Connor, and Alison Nordström at George Eastman House helped unravel its history. Henry Sweets, curator of the Mark Twain Boyhood Home & Museum, and Michael Hendricks of MBI/Easton Press made possible the inclusion of Rockwell's *Tom Sawyer* illustration in my text.

My thanks to Aileen Bastos at the Wadsworth Atheneum, Rebecca Davis at the Butler Institute of American Art, Leanne Hayden of the Berkshire Museum, Kate Igoe at the National Air and Space Museum, Ruth Janson of the Brooklyn Museum, Mary LaGue at the Taubman Museum of Art, Susan Nurse at the Memorial Art Gallery of the University of Rochester, Pauline Testerman at the Harry S. Truman Library, and Jenny Wilkinson and Amy Kesting at the Columbus Museum of Art for their assistance.

I truly appreciate the skillful book design by Michelle W. Nix and Mark Nelson at Anthony McCall Associates; their sensitivity to the visual challenges of this material shines through in the final result. My personal thanks go to John Charles Thomas for his sound counsel and to Ken Werner for his advice and sharp red pencil. Finally, the greatest thanks go to my wife, Julia Van Haaften, and daughters, Madeline and Lauren.

Notes

1. Meyer, *Norman Rockwell's People*, 65.

2. Guptill, *Norman Rockwell, Illustrator*, 200.

3. Buechner, *Norman Rockwell, Artist and Illustrator*, 44.

4. Rockwell, *My Adventures as an Illustrator*, 292.

5. Ibid., 288.

6. Guptill, *Norman Rockwell, Illustrator*, 105.

7. Ibid., 200.

8. Rockwell, *My Adventures as an Illustrator*, 379.

9. Ardis Edgerton Clark, interview by Ron Schick, 2007.

10. Rockwell, *My Adventures as an Illustrator*, 292.

11. Ibid., 311.

12. Coke, *The Painter and the Photograph*, 5.

13. Rockwell, *My Adventures as an Illustrator*, 293.

14. Rockwell, *Rockwell on Rockwell*, 28.

15. Peter Rockwell, interview by Ron Schick, 2008.

16. Rockwell, *Rockwell on Rockwell*, 82.

17. Ibid., 44.

18. Lamone, self-narrative, c. 1983, Norman Rockwell Museum Reference Center.

19. Rockwell, *Rockwell on Rockwell*, 114.

20. Ibid., 91.

21. Scovill, interview by Pettegrew, 1988, Norman Rockwell Museum Reference Center.

22. Lamone, interview by Wood, 1987, Norman Rockwell Museum Reference Center.

23. Rockwell, *Rockwell on Rockwell*, 114.

24. Scovill, interview by Wood, 1987, Norman Rockwell Museum Reference Center.

25. Tom Rockwell, interview by Ron Schick, 2008.

26. Rockwell, address, Norman Rockwell Museum Reference Center.

27. Lamone, interview by Wood.

28. Rockwell, *My Adventures as an Illustrator*, 383.

29. Lamone, self-narrative.

30. Ibid.

31. Rockwell, *Rockwell on Rockwell*, 137.

32. Ibid., 117.

33. Ibid., 120.

34. Ibid., 167.

35. Meyer, *Norman Rockwell's People*, 26.

36. Scovill, interview by Wood.

37. Peter Rockwell, interview.

38. Scovill, interview by Wood.

39. Tom Rockwell, interview.

40. Jarvis Rockwell, interview by Ron Schick, 2008.

NOTES TO THE CAPTIONS

36. "relatively easy": Rockwell, *The Norman Rockwell Album*, 87.

39. "better illustrations": Ibid., 101.

44. "When I do": Guptill, *Norman Rockwell, Illustrator*, 90.

49. "discard all": Rockwell, *Rockwell on Rockwell*, 91.

51. "During the 1940s": Rockwell, *The Norman Rockwell Album*, 88.

52. Batten, Barton: Halsey, *Illustrating for the Saturday Evening Post*, 114.

56. "didn't attempt": Rockwell, *My Adventures as an Illustrator*, 328.

63. "the secret service": Ibid., 322.

79. "The setting": Guptill, *Norman Rockwell, Illustrator*, 192.

82. "I painted him": Rockwell, *My Adventures as an Illustrator*, 327.

87. "The cover artist": Guptill, *Norman Rockwell, Illustrator*, 87.

87. "some objected": Rockwell, *Rockwell on Rockwell*, 130.

95. "I like to do": Rockwell, *The Norman Rockwell Album*, 47.

95. "George Zimmer": Rockwell, *Rockwell on Rockwell*, 103.

99. "There were details": Rockwell, *My Adventures as an Illustrator*, 292.

99. "almost humorous marriage": Hennessey and Knutson, 185.

100. "the hottest day": Peter Rockwell, interview by Ron Schick, 2008.

101. "I do not work": Rockwell, *Rockwell on Rockwell*, 96.

106. "girl as cute": Rockwell, *Rockwell on Rockwell*, 135.

108. "I used my neighbors": Rockwell, *My Adventures as an Illustrator*, 378.

109. working photographs: Meyer, *Norman Rockwell's People*, 60.

112. "I inherited a lot": Ardis Edgerton Clark, interview by Ron Schick, 2007.

112. "he used me as a model": Wes Smith, "Razzing the Camera."

119. "he did it four times": Peter Rockwell, interview.

120. "This is the story": Mary Whalen Leonard, interview by Ron Schick, 2008.

121. "the best little-girl model": Rockwell, *The Norman Rockwell Album*, 138.

123. "and with that": Leonard, interview.

127. "because a little boy": Rockwell, *The Norman Rockwell Album*, 42.

127. fifty cents: Stoltz, *Norman Rockwell and "The Saturday Evening Post": The Later Years*, 111.

130. "Ironically": Leonard, interview.

134. "I did not understand": Ibid.

148. "Obtaining good photographs": Rockwell, *Rockwell on Rockwell*, 108.

149. "Gene Pelham": Peter Rockwell, interview by Ron Schick, 2008.

156. "a prim and proper": Betsy Campbell Manning, interview by Ron Schick, 2007.

163. "He had": Edward Schreiber, interview by Ron Schick, 2007.

174. "it was the cover": Scovill, interview by Pettegrew, 1988, Norman Rockwell Museum Reference Center.

176. "in theme": Rockwell, *The Norman Rockwell Album*, 142.

182. embarrassed: Meyer, *Norman Rockwell's People*, 188.

184. "I call this my": Ibid., 156.

186. "He would select kids": Ed Locke, interview by Ron Schick, 2008, and panel discussion, model reunion at Norman Rockwell Museum, July 2007.

188. "sit at the counter": Dick Clemens, interview by Ron Schick, 2008.

188. "sit in the cruiser": Ed Locke, interview by Ron Schick, 2008.

193. "You'll do": Aadland, "To Jim, From Norman Rockwell."

194. "Before a model": Rockwell, *Rockwell on Rockwell*, 91.

198. he did reluctantly: Claridge, *Norman Rockwell*, 450.

200. "paint the BIG picture": Rockwell, *My Adventures as an Illustrator*, 349.

204. human blood: Pero, *American Chronicles*, 220.

208. "Mr. Rockwell": Wray Gunn, interview by Ron Schick, 2008.

210. "patronizing": Claridge, *Norman Rockwell*, 472.

Selected Bibliography

BOOKS

Buechner, Thomas S. *Norman Rockwell, Artist and Illustrator*. New York: Harry N. Abrams, 1970.

Claridge, Laura. *Norman Rockwell: A Life*. New York: Random House, 2001.

Cohn, Jan. *Creating America: George Horace Lorimer and "The Saturday Evening Post."* Pittsburgh: University of Pittsburgh Press, 1989.

Coke, Van Deren. *The Painter and the Photograph: From Delacroix to Warhol*. New Mexico: University of New Mexico Press, 1964.

Finch, Christopher. *Norman Rockwell's America*. New York: Harry N. Abrams, 1975.

Friedrich, Otto. *Decline and Fall: The Struggle for Power at a Great American Magazine, The Saturday Evening Post*. New York: Harper and Row, 1969.

Gernsheim, Helmut. *The Origins of Photography*. New York: Thames and Hudson, 1969.

Guitar, Mary Anne. *22 Famous Painters and How They Work*. New York: David McKay Co., 1964.

Guptill, Arthur L. *Norman Rockwell Illustrator*. New York: Watson-Guptill Publications, 1946.

Halsey, Ashley. *Illustrating for "The Saturday Evening Post."* Boston: Arlington House, 1951.

Hennessey, Maureen Hart, and Anne Knutson, eds. *Norman Rockwell: Pictures for the American People*. Atlanta: High Museum of Art, 1999.

Hockney, David. *Secret Knowledge: Rediscovering the Lost Techniques of the Old Masters*. New York: Viking Studio, 2001.

Kleopfer, Kirstie Lane. "Norman Rockwell's Civil Rights Paintings of the 1960s." Master's thesis, University of Cincinnati, 2007. Available at http://www.ohiolink.edu/etd/view .cgi?acc%5fnum=ucin1179431918.

Marling, Karal Ann. *Norman Rockwell*. New York: Harry N. Abrams in association with the National Museum of American Art, Smithsonian Institution, 1997.

Meyer, Susan E. *Norman Rockwell's People*. New York: Harrison House, 1987.

Moffatt, Laurie Norton. *Norman Rockwell: A Definitive Catalogue*. 2 vols. Stockbridge, MA: Norman Rockwell Museum at Stockbridge, 1986.

Moline, Mary. *Norman Rockwell Encyclopedia: A Chronological Catalog of the Artist's Work, 1910–1978*. Indianapolis: Curtis Publishing Co., 1979.

Nordström, Alison, and Peggy Roalf. *Colorama: The World's Largest Photographs*. New York: Aperture, 2004.

Pero, Linda Szekely. *American Chronicles: The Art of Norman Rockwell*. Stockbridge, MA: Norman Rockwell Museum, 2007.

Rockwell, Norman. *Norman Rockwell, My Adventures as an Illustrator*. As told to Thomas Rockwell. New York: Harry N. Abrams, 1988.

———. *The Norman Rockwell Album*. New York: Doubleday and Co., 1961.

———. *Rockwell on Rockwell: How I Make a Picture*. New York: Watson-Guptill Publications, 1979.

Scharf, Aaron. *Art and Photography*. Harmondsworth, England: Penguin, 1974.

Sotheby's. *Norman Rockwell, Breaking Home Ties*. New York: Sotheby's, 2006. An auction catalog.

Stoltz, Donald R., and Marshall L. Stoltz. *Norman Rockwell and "The Saturday Evening Post": The Later Years*. N.p.: Four S Corp., 1976.

———. *Norman Rockwell and "The Saturday Evening Post": The Middle Years*. N.p.: Four S Corp., 1976.

Tebbel, John. *George Horace Lorimer and "The Saturday Evening Post."* New York: Doubleday, 1948.

Tebbel, John, and Mary Ellen Zuckerman. *The Magazine in America, 1741–1990*. New York: Oxford University Press, 1991.

Vaizey, Marina. *The Artist as Photographer*. New York: Holt, Rinehart and Winston, 1982.

Walton, Donald. *A Rockwell Portrait: An Intimate Biography*. Kansas City, KS: Sheed Andrews and McMeel, 1978.

PERIODICALS

Aadland, Gordon. "To Jim, From Norman Rockwell: How a Romeo Became a Rodin." *The Chronicle*, Centralia, WA, January 12, 2008.

Alexander, Jack. "Cover Man." *The Saturday Evening Post*, February 13, 1943, 16–41.

Hughes, Robert. "The Rembrandt of Punkin Crick." *Time*, November 20, 1978.

Jarman, Rufus. "Profiles: U.S. Artist." *New Yorker*, March 17 and 24, 1945, 34–45, 36–47.

Kanzenberg, Corry. "The Cold Facts: Preserving the Museum's Photographic Negative Collection." *Portfolio* (Norman Rockwell Museum at Stockbridge), summer 2007, 14–15.

McLaughlin, Peter. "Cover Boys." *Berkshire Living*, August 2007, 35–41.

Meyer, Susan E. "As American as Norman Rockwell." *American Artist*, July 1976, 40–45.

"Norman Rockwell, Painter for America's Millions." *American Artist*, May 1940, 11–16.

"Norman Rockwell 'Shoots' a Cover." *U.S. Camera*, November 1948, 31–3, 111.

Reeves, Richard. "Norman Rockwell Is Exactly Like a Norman Rockwell." *New York Times*, February 28, 1971.

Smith, Wes. "Razzing the Camera." *Orlando Sentinel*, April 27, 2008.

FILMS

Lacy, Susan, and Elena Mannes. *Norman Rockwell: Painting America*. New York: Educational Broadcasting Corp., 1998.

Stuart, Ken. *Norman Rockwell and "The Saturday Evening Post."* [N.p.]: Video Arts, 1986.

WQED (Television station: Pittsburgh, Pa.). *Norman Rockwell: An American Portrait*. New York: V.I.E.W. Video, 1993.

ARCHIVE

Norman Rockwell Museum Reference Center: Bill Scovill, interview by Annie Pettegrew, 1988; Bill Scovill, interview by David H. Wood, 1987; Louie Lamone, self-narrative, c. 1983; Louie Lamone, interview by David H. Wood, 1987; Norman Rockwell, address, Art Center College of Design, Pasadena, CA, 1949.

Credits

Photographer Credits

Norman Rockwell systematically archived his photographs, but he did not record the identities of his cameramen. Every attempt has been made to accurately attribute the photographs in this volume; future research may revise these assignments.

Primary photographers

Louie Lamone: pp. 2, 28 left, 139, 153, 167, 169, 170, 201–203, 205, 207, 209 211, 214, 215
Louie Lamone and Norman Rockwell: p. 28 right
Gene Pelham: pp. 6, 14, 22–24, 26, 27, 30, 31, 37, 39–41, 43, 45–49, 51 right, 54, 57, 60, 61, 64, 65, 67–73, 75–78, 81, 82, 85, 87–97, 99, 100, 102–104, 107, 109, 111 left, 113 bottom left and right, 115, 117–121, 123–125, 127–133, 135, 136, 141–143, 146–149, 152, 160, 162, 163, 166, 175, 176
Gene Pelham and Don Winslow: p. 111 right
Gene Pelham and Norman Rockwell: pp. 28 center, 145, 222
Bill Scovill: pp. 33, 155, 157–159, 161, 164, 165, 174, 179, 182, 183, 185, 187, 191, 194, 197, 216, 218, 223

Other photographers

Ralph Amdursky and Charlie O. Baker: pp. 150–151
Ollie Atkins: p. 198
John Stuart Cloud: p. 113 top
Brad Herzog: p. 213
Image Photos: pp. 186, 195
Ed Nowak: p. 101
Robert Scott: pp. 173, 192
Unidentified: pp. 50, 51 left, 52, 53, 59, 62, 63, 177, 181, 189, 193

PHOTO CREDITS

Norman Rockwell's *The Saturday Evening Post* illustrations. Curtis Publishing Company copyright © SEPS. All rights reserved. www.curtispublishing.com.

pp. 140 and 168: The Norman Rockwell Estate Licensing Company.

pp. 186 and 195: photographs copyright © Image Photos.

pp. 150–151: photograph courtesy of Eastman Kodak Company.

ARTWORK CREDITS

p. 5: *The Common Cold,* 1945. "There are times when you can't let a cold upset you!" Tearsheet. Norman Rockwell Museum, Stockbridge, MA.

p. 8: *Boy Photographing Self-Portrait,* 1925
Oil on canvas, 33 x 27 inches. Private collection. Courtesy Norman Rockwell Museum, Stockbridge, MA.

p. 17: *Tom Sawyer (Schoolmaster Flogging Tom Sawyer),* 1936
Oil on canvas, 25 x 20 inches. Mark Twain Boyhood Home and Museum, Hannibal, MO. Reproduced with the permission of Easton Press.

p. 20: *Freedom of Speech,* 1943
Oil on canvas, 45.75 x 35.5 inches. Norman Rockwell Museum, Stockbridge, MA, Norman Rockwell Art Collection Trust.

p. 20: *Freedom of Worship,* 1943
Oil on canvas, 46 x 35.5 inches. Norman Rockwell Museum, Stockbridge, MA, Norman Rockwell Art Collection Trust.

p. 21: *Freedom from Fear,* 1943
Oil on canvas, 45.75 x 35.5 inches. Norman Rockwell Museum, Stockbridge, MA, Norman Rockwell Art Collection Trust.

p. 21: *Freedom from Want,* 1943
Oil on canvas, 45.75 x 35.5 inches. Norman Rockwell Museum, Stockbridge, MA, Norman Rockwell Art Collection Trust.

p. 23: *Girl at Mirror* (study), 1954
Wolff crayon and charcoal on paper, 36 x 24 inches. Norman Rockwell Museum, Stockbridge, MA, Norman Rockwell Art Collection Trust.

p. 38: *River Pilot,* 1940
Oil on canvas, 44 x 58 inches. Private collection. Photograph courtesy of Sotheby's, Inc. © 2007.

p. 42: *Proud Possessor,* 1940
Oil on masonite, 14 x 10.5 inches. Private collection. Courtesy Lahaina Galleries, Inc.

p. 44: *Blacksmith's Boy — Heel and Toe (Horseshoe Forging Contest),* 1940
Oil on canvas, 40 x 75 inches. Courtesy of the Berkshire Museum, Pittsfield, MA.

p. 48: *The Common Cold,* 1945
Tearsheet. Norman Rockwell Museum, Stockbridge, MA.

p. 50: *Norman Rockwell Visits a Country Editor,* 1946
Oil on canvas, 40 x 66 inches. National Press Club, Washington, DC.

p. 52: *Maternity Waiting Room,* 1946
Private collection. Courtesy Norman Rockwell Museum, Stockbridge, MA.

p. 54: *Norman Rockwell Visits a Family Doctor,* 1947
Oil on canvas. 32 x 60 inches. Norman Rockwell Museum, Stockbridge, MA.

p. 62: *So You Want to See the President!* 1943
Watercolor, ink, and pencil on paper, 34 x 28 inches each panel. Private collection. Photograph: Louise Krafft, Alexandria, VA.

p. 64: *Norman Rockwell Visits a Ration Board,* 1944
Tearsheet. Norman Rockwell Museum, Stockbridge, MA.

p. 66: *War News,* 1944
Oil on canvas, 41.25 x 40.5 inches. Norman Rockwell Museum, Stockbridge, MA.

p. 72: *Man Charting War Maneuvers,* 1944
Oil on canvas, 35 x 33 inches. Private collection. Courtesy Norman Rockwell Museum, Stockbridge, MA.

p. 73: *Tattoo Artist,* 1944
Oil on canvas, 43.125 x 33.125 inches. Brooklyn Museum, Brooklyn, NY. Gift of the artist. 69.8.

p. 74: *Little Girl Observing Lovers on a Train (Soldier on Leave),* 1944
Oil on canvas, 22 x 20 inches. Memorial Art Gallery of the University of Rochester, Rochester, NY. Gift of Dr. and Mrs. Robert M. Boynton. Photograph: Andy Olenick.

p. 78: *Homecoming Marine,* 1945
Oil on canvas, 46 x 42 inches. Private collection. Photograph courtesy of Sotheby's, Inc. © 2006.

p. 80: *Back to Civvies (Civvies),* 1945
Oil on canvas, 39.5 x 30 inches. Private collection. Photograph courtesy of Sotheby's, Inc. © 2006.

p. 86: *Going and Coming,* 1947
Oil on canvas. Upper canvas: 16 x 31.5 inches; lower canvas: 16 x 31.5 inches. Norman Rockwell Museum, Stockbridge, MA, Norman Rockwell Art Collection Trust.

p. 98: *Shuffleton's Barbershop,* 1950
Oil on canvas, 46.25 x 43 inches. Courtesy of the Berkshire Museum, Pittsfield, MA.

p. 100: *Boy in a Dining Car,* 1946
Oil on canvas, 38 x 36 inches. Norman Rockwell Museum, Stockbridge, MA.

p. 102: *Fixing a Flat (Changing a Flat),* 1946
Oil on canvas, 22 x 20 inches. Private collection. Photograph courtesy of Sotheby's, Inc. © 2001.

p. 103: *Framed,* 1946
Oil and graphite on canvas and wood, 42.5 x 33 inches. Collection of the Taubman Museum of Art, Roanoke, VA. Acquired with funds provided by the Horace G. Fralin Charitable Trust. 2003.001.

p. 106: *Breakfast Table Political Argument,* 1948
Oil on canvas, 35.625 x 34.125 inches. Courtesy Harry S. Truman Library, Independence, MO. Photograph: Don Richards.

p. 108: *The Gossips,* 1948
Oil on canvas, 33 x 31 inches. Private collection. Courtesy Norman Rockwell Museum, Stockbridge, MA.

p. 112: *The Dugout,* 1948
Transparent and opaque watercolor over graphite on two sheets of conjoined cream wove paper, 19 x 17.8125 inches. Brooklyn Museum, Brooklyn, NY. Gift of Kenneth Stuart. 71.124.

p. 114: *Saying Grace,* 1951
Oil on canvas, 42 x 40 inches. Private collection. Courtesy Norman Rockwell Museum, Stockbridge, MA.

p. 116: *Soda Jerk,* 1953
Oil on canvas, 36 x 34 inches. Columbus Museum of Art, Columbus, OH. Bequest of J. Willard Loos. 1974.038.004.

p. 122: *Day in the Life of a Little Girl,* 1952
Oil on canvas, 45 x 42 inches. Norman Rockwell Museum, Stockbridge, MA.

p. 130: *Girl with Black Eye (The Young Lady with the Shiner),* 1953
Oil on canvas, 34 x 30 inches. Wadsworth Atheneum Museum of Art, Hartford, CT. Gift of Kenneth Stuart. 1973.112.

p. 134: *Girl at Mirror,* 1954
Oil on canvas, 31.5 x 29.5 inches. Norman Rockwell Museum, Stockbridge, MA, Norman Rockwell Art Collection Trust.

p. 144: *"Oh Boy! It's Pop with a New Plymouth!"* 1951
Oil on canvas, 27.875 x 24 inches. Private collection. Courtesy Norman Rockwell Museum, Stockbridge, MA.

p. 146: *Off to School,* 1952
Tearsheet. Norman Rockwell Museum, Stockbridge, MA.

p. 153: *Lincoln the Railsplitter,* 1965
Oil on canvas, 84.5 x 44.5 inches. Collection of the Butler Institute of American Art, Youngstown, OH. Museum Purchase 2006. 2006.061.

p. 154: *Family in Auto,* 1950s
Pencil on paper, 7.5 x 11.5 inches. Norman Rockwell Museum, Stockbridge, MA.

p. 156: *Circus,* 1955
Tearsheet. Norman Rockwell Museum, Stockbridge, MA.

p. 158: *Dinosaur,* 1963
Tearsheet. Norman Rockwell Museum, Stockbridge, MA.

p. 159: *Stockbridge Library Librarian,* 1962
Charcoal and watercolor on paper, 16.5 x 14 inches. Stockbridge Library Association, Stockbridge, MA. Courtesy Norman Rockwell Museum, Stockbridge, MA.

p. 170: *Liberty Bell,* 1976
Oil on canvas, 45 x 33 inches. Norman Rockwell Museum, Stockbridge, MA. Reproduced with the permission of *American Artist* magazine and Interweave Press.

p. 174: *Art Critic,* 1955
Oil on canvas, 39.5 x 36.25 inches. Norman Rockwell Museum, Stockbridge, MA.

p. 176: *Breaking Home Ties,* 1954
Oil on canvas, 44 x 44 inches. Private collection. Photograph courtesy of Sotheby's, Inc. © 2006.

p. 178: *The Discovery,* 1956
Oil on canvas, 35.25 x 32.5 inches. Norman Rockwell Museum, Stockbridge, MA, Norman Rockwell Art Collection Trust.

p. 180: *The Expense Account,* 1957
Oil on canvas, 31.25 x 29 inches. Norman Rockwell Museum, Stockbridge, MA, Norman Rockwell Art Collection Trust.

p. 184: *After the Prom,* 1957
Oil on canvas, 31 x 29 inches. Private collection. Courtesy Norman Rockwell Museum, Stockbridge, MA.

p. 188: *The Runaway,* 1958
Oil on canvas, 35.75 x 33.5 inches. Norman Rockwell Museum, Stockbridge, MA, Norman Rockwell Art Collection Trust.

p. 190: *The Marriage License,* 1955
Oil on canvas, 45.5 x 42.5 inches. Norman Rockwell Museum, Stockbridge, MA, Norman Rockwell Art Collection Trust.

p. 195: *Triple Self-Portrait,* 1960
Oil on canvas, 44.5 x 34.75 inches. Norman Rockwell Museum, Stockbridge, MA, Norman Rockwell Art Collection Trust.

p. 196 *Marriage Counselor,* 1963
Oil on canvas, 31.25 x 38.25 inches. Norman Rockwell Museum, Stockbridge, MA, Norman Rockwell Art Collection Trust.

p. 198: *Portrait of Richard M. Nixon,* 1960
Tearsheet. Norman Rockwell Museum, Stockbridge, MA.

p. 202: *The Problem We All Live With,* 1964
Oil on canvas, 36 x 58 inches. Norman Rockwell Museum, Stockbridge, MA.

p. 204: *Murder in Mississippi* (study), 1965
Oil on board, 15 x 12.75 inches. Norman Rockwell Museum, Stockbridge, MA, Norman Rockwell Art Collection Trust.

p. 206: *Murder in Mississippi* (unpublished final version), 1965
Oil on canvas, 53 x 42 inches. Norman Rockwell Museum, Stockbridge, MA.

p. 208: *New Kids in the Neighborhood,* 1967
Oil on canvas, 36.5 x 57.5 inches. Norman Rockwell Museum, Stockbridge, MA, Norman Rockwell Art Collection Trust.

p. 210: *Blood Brothers* (study), c. 1968
Oil on board, 10.5 x 21.5 inches. Norman Rockwell Museum, Stockbridge, MA, Norman Rockwell Art Collection Trust.

p. 212: *The Final Impossibility: Man's Tracks on the Moon,* 1969
Oil on canvas, 42.5 x 61.5 inches. National Air and Space Museum, Smithsonian Institution, Washington, DC. Courtesy Norman Rockwell Museum, Stockbridge, MA.

p. 224: *Norman Rockwell on Clipper,* 1956
Tearsheet.

TEXT CREDITS

Quotations on pp. 23, 24, 25, 29, 30, 49, 87, 95, 101, 106, 148, and 194 are taken with permission from *Rockwell on Rockwell: How I Make a Picture,* © Famous Artists School, division of Cortina Learning International, Inc. These excerpts are drawn from the following pages in the title mentioned above: 28, 44, 82, 91, 96, 103, 108, 114, 117, 120, 130, 135, 137, 167.

Index